349-2
56

THE CAMERA VIEWED

WRITINGS ON TWENTIETH-CENTURY PHOTOGRAPHY

Edited by PENINAH R. PETRUCK

A Dutton Paperback E. P. DUTTON · NEW YORK

For information contact:
E. P. Dutton, 2 Park Avenue, New York, N.Y. 10016

Library of Congress Catalog Card Number: 78-55776

ISBN: 0-525-47536-2

Published simultaneously in Canada by Clarke, Irwin & Company Limited, Toronto and Vancouver

10 9 8 7 6 5 4 3 2 1

First Edition

Grateful acknowledgment is made to the following for permission to quote from copyright material.

Edward Steichen: "Photography at The Museum of Modern Art." Reprinted from The Museum of Modern Art *Bulletin*, 19, no. 4 (1952). Introduction by Edward Steichen. All rights reserved. Reprinted by permission of the publisher.

Edward Steichen: "Photography: Witness and Recorder of Humanity." Reprinted from *Wisconsin Magazine of History*, 41 (Spring 1958): 159–167.

Henri Cartier-Bresson: Introduction to *The Decisive Moment*. Reprinted from *The Decisive Moment*. Copyright 1952 by Henri Cartier-Bresson-Verve and Simon & Schuster.

Ansel Adams: "I Am a Photographer." Reprinted from *Image* (March 1959), by permission. Copyright © 1959 by George Eastman House Inc. All rights reserved.

Herm Lenz: "An Interview with Three Greats: Lange, Adams, Cunningham." Reprinted from *U.S. Camera* (August 1955), by permission of the publisher.

Minor White: "Lyrical and Accurate." Reprinted from *Image* (October 1956), by permission. Copyright © 1956 by George Eastman House Inc. All rights reserved.

Frederick Sommer: "An Extemporaneous Talk at The Art Institute of Chicago, October 1970." Reprinted from *Aperture*, 16, no. 2 (1971), by permission of Aperture, Inc. Copyright © 1971 by Aperture, Inc.

Jerry Uelsmann: "post-visualisation." Reprinted from *Creative Camera* (June 1969), by permission of the author.

Duane Michals: "An Interview with Professor Gassan and His Students." Reprinted from *Image* (January 1971), by permission. Copyright © 1971 by George Eastman House Inc. All rights reserved.

Martha Rosler: "Lee Friedlander's Guarded Strategies." Reprinted from *Artforum* (April 1975), by permission of the publisher and the author. Copyright © 1975 by California Artforum, Inc.

Max Kozloff: "The Uncanny Portrait: Sander, Arbus, Samaras." Reprinted from *Artforum* (June 1973), by permission of the publisher and the author. Copyright © 1973, California Artforum, Inc.

v

This anthology was compiled in response to the growing enthusiasm for photography. Its aim is to stimulate serious looking at and thinking about twentieth-century photography.

This anthology brings together previously published primary and secondary sources from various publications. The idea for this kind of compilation is based on the landmark references: Beaumont Newhall's *On Photography: a Source Book of Photo History in Facsimile* (1956) and Nathan Lyons's *Photographers on Photography* (1966). I have tried to add to these books, to make available material more recently published by a wider range of authors and of an analytic and theoretical nature.

Divided into two volumes, the anthology is organized to follow a loose chronological reading of twentieth-century photography. The first volume focuses on photography before World War II, the second on more current developments. Each selection is introduced with a brief explanation of its significance and identification of its author. Both volumes contain photographs that highlight the author's viewpoint.

Criteria for selection of essays and photographs are admittedly arbitrary. Any such undertaking inevitably has glaring omissions and selections comparatively easy of access. I ask my readers' understanding in advance. Foremost in my consideration were quality of thought and expression, historical significance, and value as representative of different attitudes toward and developments of twentieth-century photography. Also I favored interpretative and theoretical rather than technical, biographical, and appreciative commentaries.

A review of the writing on photography suggests that its preoccupations do not mirror photography's history. My hope is that this anthology will help generate fresh and solid scholarship. The unevenness of attention to the various aspects of photography is surprising. For

example, photography's relation to the other arts, fashion and commercial uses of photography, and its role as a conveyer of psychological, sociological, and political information are areas that require further study in depth. Moreover the works of Steichen, Stieglitz, Strand, Weston, Atget, to name just a few, have not received treatment comparable to equally noted figures in the other arts.

Still, the writing on twentieth-century photography is as diverse as the medium itself. Photographers as well as writers known for their ideas on painting, sculpture, film, aesthetics, and culture at large contribute to that diversity. And in writing about photography, they pursue different, often conflicting, themes and approaches. The range covers specific and comparative studies on photographers and types of photography, essays on theory and technique, and personal statements.

The concerns of twentieth-century photography grew up with its invention. The ealiest writings on the "camera machine" are the seeds of the discussions in this anthology. Current questions focus on photography as a fine art, the distinction between fine and vernacular photography, the kind of printing process that effects a meaningful final image, the unique or varied potential of photography as a mimetic or symbolic expression, its relation to other media, and an appropriate vocabulary for its analysis and evaluation.

That there are no definitive answers, no one way to interpret what a photographer does and why, is a measure of photography's vitality.

My thanks go to the photographers and writers who permitted me to include their work in this anthology. Others whose cooperation was invaluable were the staffs of The Museum of Modern Art's Library and Photography Department, the Art Reference Library of The New York Public Library, and Light Gallery. I should especially like to acknowledge Michael Boodro, who helped to edit the manuscripts; Neal Slavin, who created the photograph for the cover; and Julie Van Haaften, who offered bibliographic and countless other suggestions.

Edward Steichen

Edward Steichen (1879–1972) was a presence larger than life. Steichen's career was multiphased. He was a painter, photographer, museum director, and filmmaker. With Alfred Stieglitz, he fought for the recognition of modern art and photography in America. Photography, however, was his favored medium. His photographs set the standards for soft-focus pictorialism at the turn of the century and sharply focused straight photography after World War I. Steichen's celebrity portraits, fashion photographs, and frank realistic nature and still-life compositions are included in Steichen the Photographer *(1929) by Carl Sandburg and* A Life in Photography *(1968) by Edward Steichen.*

Steichen was director of the department of photography of The Museum of Modern Art from 1947 to 1961. His tenure at the museum formalized his statesmanship of American photography after World War II. During this period Steichen made no photographs; curating exhibitions was for him a rich means of communication.

In the first selection written for The Museum of Modern Art Bulletin in 1952, Steichen emphasizes his enthusiastic commitment to developing photography's full range of styles and techniques. The second selection is a lecture Steichen delivered in 1957 on "The Family of Man" exhibition. An instant classic, the exhibition represented, Steichen often said, the culmination of his career. As he explained in this lecture, his intention was to prove visually the universality of human experience and photography's role in its documentation. For Steichen, photography realizes one of its essential potentials as a "record of human relations."

(See selections in volume I on Stieglitz and Steichen.)

Today's photography ranges from a meticulously precise naturalism to the completely abstract image; from the searching electron micrograph in the field of science to images expressing a highly sensitized emotional concept; the frozen action made possible by speedlights in contrast to the

* Reprinted from The Museum of Modern Art *Bulletin*, 19, no. 4 (1952).

blurred action of slow exposure or of superimposed images.

It is the artist in photography who beyond his own creative achievement establishes new standards, influences, and uses of the medium, whether it be in the service of science, education, or communication.

There is a new kind of aliveness in the melting pot of American photography. This aliveness is not based on novelty, slickness, or on any particular kind of technical skill or procedure. There are fine warm accents and sharp emphasis on the mirroring of human relations, and there is a boisterous gaiety, sly humor, and whimsicality as well as bitter or ironic comment. There is the aloofness of icy objectivity and the challenge of various approaches in the rendering of meaningful abstractions, and there is grace and wit in concrete elements of design and the magic of an exact instant.

Some of the work is still tentative and some consciously or unconsciously repetitious of much that has gone before. Along with photographs expressing the fulfillment of mature experience, we also find heartening encouragement in the restless seekings, probing aspirations, and experiments of younger photographers.

Good photography in any field becomes alive by virtue of the quality and integrity of the photographer's perception and feeling. When the photographer's emotional reaction is carried through the overall organization of the image and under the control of an informed intelligence, the resulting photograph takes on the incandescence of truth. The casual candid snapshot of people on the street, bus, or subway can be as dead, senseless, or "corny" as any sentimental silhouette against a sunset sky.

The photographer who is primarily interested in finding definitive approval for his favorite cult, cant, or ism, or some affirmation about the limitations of the medium is apt to find that modern photography is puzzling and contradictory, for our best photographers are attracted to the medium because it is young, elastic, and has elbowroom to grow in—lots of elbowroom!

Edward Steichen

Man's first knowledge of the world we live in and how it was fifty million years ago is based on images that are in fossil form preserved in rock. Man's first images, first means of communication, go back to the Stone and Ice Ages when images were painted on the walls of caves. Man's first nonoral means of communication was calligraphy—images.

Today we have this extraordinary new process for making images and a great world of photographers that is making them. Today, whether a piece of film is exposed in a cyclotron wherein neutrons and protons make self-portraits, or whether it is in the recording of the drama that took place in Budapest, photography is—in the historian's role peculiar to it—producing historical documents. Photography is many things, but this is one of its important phases. Any photograph that is made—the very instant it is completed, the very instant the button has been pressed on the camera—becomes a historical document. Its use as such will depend largely on historians.

I want to emphasize what I consider the most important service photography can render history, and that is in the recording of human relations, in the explaining of man to man. If, as Pope said, "The proper study of mankind is man," then it is the artist-photographer who in photographing his fellowman with understanding, with sympathy and warmth, gives us something that comes out of his pictures and remains with us; something that helps us to know and understand each other. When the camera is used by an artist, while retaining its mechanical objectivity, it becomes an additional tool for penetrating beneath the surface appearance of things. It is the artist with the camera who by his knowledge, sensitivity, and experience sees the significance of appearances. These influence him in the selection of what he photographs, in how he photographs it; and the result assumes an added meaning. In the photographing of human relations, it is the artist who gives us our real and enduring material.

* Reprinted from *Wisconsin Magazine of History*, 41 (Spring 1958).

As a result of a survey that was made, there are said to be forty million homes in the United States that have at least one camera. In that light, consider the potentialities and possibilities of this medium. That means there are at least forty million photographers, forty million potential historians. And there lies a responsibility: What to do about this? How to direct this? Above all, how to select the resultant material for preservation?

To illustrate what I mean by responsibility, let me draw on my own experience in two world wars. In World War I, I was in command of all aerial photography under Billy Mitchell, a former Milwaukeean like myself. I had fifteen photographic sections in my command, and thirty-two squadrons were employed in doing nothing but taking pictures. It was all very primitive; we had to improvise everything. But we made over a million photographs. Here was a kind of history of the war that could not be duplicated. Yet no one knows what became of all those photographs! I know they were packed carefully, section by photographic section with a record of the work of each, and they were shipped to Washington. But since then, no one has been able to find them. They may not be lost; they may turn up in some warehouse someplace, molded, or rotted, or bleached. But it is of importance to historians—a responsibility of historians—to see that such valuable documents are preserved.

During World War II, I was first in charge of a small photographic unit of six top-ranking young photographers whose duty it was to photograph naval aviation. During the height of operations the Secretary of the Navy placed me in command of the entire combat photography—four thousand photographers photographing everything from pictures for aerial maps to the shattered, hopeless look on a surgeon's face (and on the nurses') when they were operating on a boy who had been torn apart by shrapnel and they knew they could do nothing for him.[1] Those records have been carefully preserved; each photograph has been filed under the name of the photographer who made it; then cross-indexed for all purposes. This is very unlike the Brady photographs of the Civil War. We don't know who made them because Brady had a staff working with him.

[1] Edward Steichen, *The Blue Ghost: A Photographic Log and Personal Narrative of the Aircraft Carrier USS Lexington in Combat Operation* (New York: Harcourt Brace, 1947), and Edward Steichen, comp., *Power in the Pacific* (New York: U.S. Camera Publishing Corp., 1945).

The Navy, I believe, appreciates the importance of these World War II photographs and will take care of them for historians.

But responsibility does not lie solely in the preserving of photographic records. There is also a responsibility in the making of them, and it is my belief that scholastic and academic circles have been inordinately delinquent in the use of the image in educating our young. We have in photography a medium which communicates not only to us English-speaking peoples, but communicates equally to everybody throughout the world. It is the only universal language we have, the only one requiring no translation; but in all our universities it is a stepchild. We have elaborate courses in art in each university; sometimes there may be a camera club. But what we need are academic courses to bind the other resources of the university with photography in order to create better photographers than we have.

I plead for a greater use of photography. I plead for upsetting the conditioning which habits people to the word. The word and the book are our priceless possessions. But it is our duty to marry the image to the word and let them speak together. In the photographic exhibit, "The Family of Man," which I organized for The Museum of Modern Art, this—through the use of appropriate captions and quotations—is precisely what I tried to do.

Behind that exhibit lay a threefold purpose: to show the relationship of man to man; to demonstrate what a wonderfully effective language photography is in explaining man to man; and to express my own very firm belief that we are all alike on this earth, regardless of race or creed or color.

This conviction is something that began in my life as a young boy in Milwaukee. My mother had a millinery store on Third Street, and I came home from school when I was about seven or eight years old and as I closed the door of the store, I yelled out to a boy in the street, "You dirty kike!" My mother called me over to her—she was waiting on a customer—and asked me what I had said. I freely repeated it; and so she excused herself from her customer, locked the door of the store, and took me upstairs to our apartment. There for hours she talked to me about how wrong that was, because all people were alike; that I was in America because in bringing me to America she had hoped I would have a chance

in a world that didn't have that thing. She told me how distressed she was; how heartsick she was that I didn't seem to understand that.

That's where my exhibition really began—with a great woman and a great mother.

To assemble this exhibition, my staff and myself went through over two million photographs to select the material. This two million was boiled down through our preliminary selection to ten thousand, and then I took over entirely. Boiling it down from ten thousand to five thousand was relatively simple; but from then on it was a heartbreaking struggle to reduce it to the final five-hundred odd prints that constituted the final choice.

The exhibition, as those who have seen it know, opens with a vast panorama of water and sky, with captions from the Bible or its equivalent from five different religions or races. The first is an Egyptian inscription about creation. There is the Chinese, the Indian, and so on. While we cannot photograph the past, we did seek to bring to the exhibition a dimension of the past in the captions that go with the photographic groups. We searched through the Scriptures, the great literature, the works of philosophers and scientists of all ages to cull these captions. For instance, the caption on the picture of a baby being born is taken from Scriabin: "The universe resounds with the joyful cry I am." Then there are pictures of mothers and their babies. The babies start to grow, the children start to grow up and to play and to learn. There is a series of father and child, fathers and sons: a so-called savage in Africa teaching his boy to shoot a poisoned hunting arrow; a Negro father leaning with tenderness and care over a sick child; a father going off to war saying good-bye to his son; and finally a father and son, both of them stretched out on the sofa, reading the Sunday newspaper.

From there we go into a room of work; and in the center of that room—the focal point of the entire exhibition—is a group of families: a family from Bechuanaland, said to be contemporary cavemen; an American family photographed in Nebraska—a wonderful picture of good, hearty, earthy farmers posed around an old kitchen stove. In the center is a grandmother in a rocking chair, silver-haired, surrounded by her children and her grandchildren; and on the wall behind, a row of

grim-looking ancestors. Then there is an Italian family and a Japanese family and a Hungarian family. Wherever you turned in the exhibition, you saw this grouping of family and were reminded: "This is the root. The family unit is the root of the family of man, and we are all alike." All of these were posed pictures. All of the families were frankly having their pictures taken: all had the same bland expressions everybody always has when he is having his picture taken; but there was something very sweet and holy about this group.

There was a section on women's work in different lands. There was a picture from Austria; women doing their washing in a stream: lovely, buxom young women singing, pounding the wash with ladles on the rocks, as they do still in many parts of the world. And right next to it was a picture of a maze of wash lines in Harlem, extending between flats, looking like a million sheets and towels and shirts and pants hanging out on the line.

Then there was bread—food. On a field of wheat I placed the smallest picture in the exhibition; a tiny picture that I made years ago of my mother. The family was living at Elmhurst, Illinois, at the time, and I was visiting. I had the camera out in the yard, photographing the house and the porch. I was all set to make a picture of the porch, with grapevines growing over it and shrubs on either side. My mother opened the screen door, came out, and held forward a big cake she had just baked, saying, "Now here's something worth photographing." And I did. With the photograph I used an old Russian proverb: "Eat bread and salt and speak the truth." My mother didn't happen to know that proverb, but it sounded like her, and that's the reason I associated it with her picture.

Then there were people in all countries, eating. There was a Russian family—farmers—all seated around a table eating soup out of one bowl, all except the baby. The baby had a separate dish. This kind of warmth went through the whole thing.

There was education: an Arab child doing his alphabet; next, a picture of the hands of an old woman learning to write; then a group of scientists at the Institute for Advanced Study at Princeton. Beside the picture of Einstein I placed one of a small boy in Allentown, Pennsylvania, doing his sums at the blackboard—one and two make three. There were pictures of atomic scientists, and the last picture on the wall was of a blasted

city in Germany, crumbled in ruins, and in the foreground a boy going down a flight of steps with a knapsack on his back, a schoolboy going to school, beginning all over again to surmount man's monstrous stupidity.

We had things in the exhibition that none of us had ever dreamed of before as possibilities. We had the game of ring-around-a-rosy from sixteen different countries, and we placed the pictures all in a circle.

Then there was a room where human aloneness was stressed. In it was a picture of a woman, disheveled and only partly clothed, sitting crumpled on a bench in an insane asylum. There was a child on a beach, leaning against a post. The beach was empty except for two or three people off in the distance. The aloneness of that child was gripping. But the most alone picture in the series was of a man and his wife and daughter waiting for a parade. The woman was leaning on a bench in front of her, and she was the most alone of them all.

From loneliness we went to compassion, the emotion that carries with it the wonderful, warm, human gesture of putting your arms around somebody. To me, the climax of that series was a picture of a shell-shocked boy being comforted by an older soldier who had his arm wrapped around the boy.

And then came hard times, the hard times that happen to people all over the world. There was a picture of a gaunt American woman with three children. You could see that they were hungry and that she was worried. And there was a picture taken in another part of the country of a man with his two children, miserable because he had no work. Famine was depicted; people starving in India, in China; old, wrinkled women reaching out for a handful of rice; a hungry little Chinese boy with an empty cup.

From hard times and hunger the exhibition moved on to revolt, beginning with the picture of a little baby caught between two chairs and trying to fight his way out; ending with a picture taken at the time of the revolt in Eastern Germany—young men throwing stones at a heavily armed tank, the quintessence of the spirit of man in rebellion against injustice.

Another section dealt with voting, with a caption taken from Jefferson: "I know of no safe depository of the ultimate powers of society but the people themselves." All the pictures showed women voting along with

their menfolk—in Japan, China, France, the United States—a step toward universal human right that has been taken in my lifetime.

Then came a warning; the only place in the exhibition in which I overtly editorialized. There was a series of nine faces, three men, three women, three children. One was the photograph of a child perhaps three or four years old taken the day after the bomb hit Nagasaki—a Japanese child with a bleeding face, dry-eyed, looking straight at us and asking, as all the faces asked, "Why?" Captioning that series was a quotation from Bertrand Russell warning that "the best authorities are unanimous in saying that a war with hydrogen bombs is quite likely to put an end to the human race . . . there will be universal death—sudden only for a fortunate minority, but for the majority a slow torture of disease and disintegration."

From there one walked into a darkened room in front of which was the photograph of a dead soldier lying in a trench, taken on Eniwetok during the last war. In that darkened room was a great picture of the hydrogen test-bomb being exploded on that same island. There is, in such pictures of explosions, a kind of untruth, an untruth in many war pictures, because they look so beautiful. As I was going through that room, I once heard a man say, "It looks like a beautiful sunset. The last sunset." In that case, at least, I felt that the picture had told its story.

Leaving that room you came upon, saw facing you, ten pictures from different countries showing men and women who had lived their lives together, had never heard of Reno; and with these pictures was a quotation from Ovid: "We two form a multitude." On each picture the caption reappeared: "We two form a multitude." And they were all looking toward the darkened room that held the photograph of the hydrogen bomb. Then you saw the largest picture in the exhibition, a picture of the United Nations in session, also facing the room with the bomb; and across that picture was the preamble of the UN charter, beginning: "We, the peoples of the United Nations, determined to save succeeding generations from the scourge of war, which twice in our lifetime has brought untold sorrow to mankind. . . ."

Then you swung around and were in a forest of children. One portrait was of a Japanese girl-child with a basket of flowers; others were of children from many lands, experiencing the universal joyousness and curi-

osities of childhood. Here, the picture before the last, was one of the earliest photographs in the exhibition—a photograph by Lewis Carroll of the original Alice of *Alice in Wonderland.* The last picture was Eugene Smith's wonderful image of two little children walking out of a dark tunnel of leaves into the sunlight.

When The Museum of Modern Art made plans to send the exhibition around the world, I was greatly concerned as to what would happen in countries with an ideology entirely different from our own. I was particularly concerned about India and Japan. But I need not have been, for the exhibition is now in ten editions, three circulating throughout the United States, seven being circulated by the United States Information Agency throughout the world, while two small editions are still on exhibit in Japan. The largest attendance in any one day was in Calcutta where twenty-nine thousand people crowded into the exhibition hall on a hot, blistering day. Over three and a half million people have seen the exhibit; a million copies of the book, *The Family of Man*, have gone all over the world. In Holland, a country where they rarely sell books not having a Dutch text, thirty-five thousand copies were sold in two weeks.[2]

This is irrefutable proof that photography is a universal language; that it speaks to all people; that people are hungry for that kind of language. They are hungry for pictures that have meaning, a meaning they can understand.

Here is a great historic tour. Here is an exhibition that is making history. And it has been received with such love and reverence. I have seen it now in three countries, America, France, and Germany. I have seen it in nine cities. The reaction in each case is exactly the same; and I believe— at first I was puzzled—but I believe now that the answer is that people participate in the exhibition personally: they feel they are a part of it. As a Japanese poet said: "When you look into the mirror, it is not you that sees your reflection; your reflection sees you." These people look into the mirror of life and their reflection looks back at them and smiles.

[2] Edward Steichen, *The Family of Man* (New York: The Museum of Modern Art, 1955).

Henri Cartier-Bresson

Henri Cartier-Bresson (1908–) describes photography as an extension of his sensibility. He makes photographs as a means to capture a "decisive moment" as it unfolds before his eyes. His ideal instrument is the Leica, a small portable camera that facilitates his ability to discreetly record changing reality.

Noted as a pioneer photojournalist, Bresson's work, whether or not made on assignment, communicates his ideas about what is important. Fascinated with people and manners, Bresson composes reports of historical events that focus not on the action itself but on surrounding human incidents. His many books include The Decisive Moment, The World of Henri Cartier-Bresson *(1968), and* The Face of Asia *(1972).*

In this introduction to the celebrated publication The Decisive Moment *Bresson summarizes his aesthetic. In the tradition of Stieglitz and Steichen he understands that photography must deftly balance intuitive and objective perceptions.*

I, like many another boy, burst into the world of photography with a Box Brownie, which I used for taking holiday snapshots. Even as a child, I had a passion for painting, which I "did" on Thursdays and Sundays, the days when French schoolchildren don't have school. Gradually, I set myself to try to discover the various ways in which I could play with a camera. From the moment that I began to use the camera and to think about it, however, there was an end to holiday snaps and silly pictures of my friends. I became serious. I was on the scent of something, and I was busy smelling it out.

Then there were the movies. From some of the great films, I learned to look, and to see. *Mysteries of New York,* with Pearl White; the great films of D. W. Griffith—*Broken Blossoms;* the first films of Stroheim, *Greed;* Eisenstein's *Potemkin;* and Dreyer's *Jeanne d'Arc*—these were some of the things that impressed me deeply.

* Reprinted from *The Decisive Moment* (New York: Simon & Schuster, 1952).

Later I met photographers who had some of Atget's prints. These I considered remarkable and, accordingly, I bought myself a tripod, a black cloth, and a polished walnut camera three by four inches. The camera was fitted with—instead of a shutter—a lens cap, which one took off and then put on to make the exposure. This last detail, of course, confined my challenge to the static world. Other photographic subjects seemed to me to be too complicated, or else to be "amateur stuff." And by this time I fancied that by disregarding them, I was dedicating myself to Art with a capital *A*.

Next I took to developing this art of mine in my washbasin. I found the business of being a photographic jack-of-all-trades quite entertaining. I knew nothing about printing, and had no inkling that certain kinds of paper produced soft prints and certain other highly contrasted ones. I didn't bother much about such things, though I invariably got mad when images didn't come out right on the paper.

In 1931, when I was twenty-two, I went to Africa. On the Ivory Coast I bought a miniature camera of a kind I have never seen before or since, made by the French firm Krauss. It used film of a size that 35mm would be without the sprocket holes. For a year I took pictures with it. On my return to France I had my pictures developed—it was not possible before, for I lived in the bush, isolated, during most of that year—and I discovered that the damp had got into the camera and that all my photographs were embellished with the superimposed patterns of giant ferns.

I had had blackwater fever in Africa, and was now obliged to convalesce. I went to Marseille. A small allowance enabled me to get along, and I worked with enjoyment. I had just discovered the Leica. It became the extension of my eye, and I have never been separated from it since I found it. I prowled the streets all day, feeling very strung-up and ready to pounce, determined to "trap" life—to preserve life in the act of living. Above all, I craved to seize the whole essence, in the confines of one single photograph, of some situation that was in the process of unrolling itself before my eyes.

The idea of making a photographic reportage, that is to say, of telling a story in a sequence of pictures, was something which never entered my head at that time. I began to understand more about it later, as a result of looking at the work of my colleagues and at the illustrated magazines. In

fact, it was only in the process of working for them that I eventually learned—bit by bit—how to make a reportage with a camera, how to make a picture story.

I have traveled a good deal, though I don't really know how to travel, I like to take my time about it, leaving between one country and the next an interval in which to digest what I've seen. Once I have arrived in a new country, I feel almost like settling down there, so as to live on proper terms with the country. I could never be a globe-trotter.

In 1947, five free-lance photographers, of whom I was one, founded our cooperative enterprise called "Magnum Photos."

This cooperative enterprise distributes our picture stories to magazines in various countries.

Twenty-five years have passed since I started to look through my view-finder. But I regard myself still as an amateur, though I am no longer a dilettante.

THE PICTURE STORY

What actually *is* a photographic reportage, a picture story? Sometimes there is one unique picture whose composition possesses such vigor and richness and whose content so radiates outward from it that this single picture is a whole story in itself. But this rarely happens. The elements which, together, can strike sparks out of a subject are often scattered—either in terms of space or time—and bringing them together by force is "stage management," and, I feel, cheating. But if it is possible to make pictures of the "core" as well as the struck-off sparks of the subject, this is a picture story; and the page serves to reunite the complementary elements which are dispersed throughout several photographs.

The picture story involves a joint operation of the brain, the eye, and the heart. The objective of this joint operation is to depict the content of some event which is in the process of unfolding and to communicate impressions. Sometimes a single event can be so rich in itself and its facets that it is necessary to move all around it in your search for the solution to the problems it poses—for the world is movement, and you cannot be stationary in your attitude toward something that is moving. Sometimes you light upon the picture in seconds; it might also require hours or days. But there is no standard plan, no pattern from which to work. You must

be on the alert with the brain, the eye, the heart, and have a suppleness of body.

Things-as-they-are offer such an abundance of material that a photographer must guard against the temptation of trying to do everything. It is essential to cut from the raw material of life—to cut and cut, but to cut with discrimination. While he is actually working, a photographer must reach a precise awareness of what he is trying to do. Sometimes you have the feeling that you have already taken the strongest possible picture of a particular situation or scene; nevertheless, you find yourself compulsively shooting, because you cannot be sure in advance exactly how the situation, the scene, is going to unfold. You must stay with the scene, just in case the elements of the situation shoot off from the core again. At the same time, it's essential to avoid shooting like a machine gunner and burdening yourself with useless recordings which clutter your memory and spoil the exactness of the reportage as a whole.

Memory is very important, particularly in respect to the recollection of every picture you've taken while you've been galloping at the speed of the scene itself. The photographer must make sure, while he is still in the presence of the unfolding scene, that he hasn't left any gaps, that he has really given expression to the meaning of the scene in its entirety, for afterward it is too late. He is never able to wind the scene backward in order to photograph it all over again.

For photographers, there are two kinds of selection to be made, and either of them can lead to eventual regrets. There is the selection we make when we look through the viewfinder at the subject; and there is the one we make after the films have been developed and printed. After developing and printing, you must go about separating the pictures which, though they are all right, aren't the strongest. When it's too late, then you know with a terrible clarity exactly where you failed; and at this point you often recall the telltale feeling you had while you were actually making the pictures. Was it a feeling of hesitation due to uncertainty? Was it because of some physical gulf between yourself and the unfolding event? Was it simply that you did not take into account a certain detail in relation to the whole setup? Or was it (and this is more frequent) that your glance became vague, your eye wandered off?

In the case of each of us it is from our own eye that space begins and slants off, enlarging itself progressively toward infinity. Space, in the

present, strikes us with greater or lesser intensity, and then leaves us, visually, to be closed in our memory and to modify itself there. Of all the means of expression, photography is the only one that fixes forever the precise and transitory instant. We photographers deal in things which are continually vanishing, and when they have vanished, there is no contrivance on earth which can make them come back again. We cannot develop and print a memory. The writer has time to reflect. He can accept and reject, accept again; and before committing his thoughts to paper, he is able to tie the several relevant elements together. There is also a period when his brain "forgets," and his subconscious works on classifying his thoughts. But for photographers, what has gone, has gone forever. From that fact stem the anxieties and strength of our profession. We cannot do our story over again once we've got back to the hotel. Our task is to perceive reality, almost simultaneously recording it in the sketchbook which is our camera. We must neither try to manipulate reality while we are shooting, nor must we manipulate the results in a darkroom. These tricks are patently discernible to those who have eyes to see.

In shooting a picture story, we must count the points and the rounds, rather like a boxing referee. In whatever picture story we try to do, we are bound to arrive as intruders. It is essential, therefore, to approach the subject on tiptoe—even if the subject is still life. A velvet hand, a hawk's eye—these we should all have. It's no good jostling or elbowing. And no photographs taken with the aid of flashlight either, if only out of respect for the actual light—even when there isn't any of it. Unless a photographer observes such conditions as these, he may become an intolerably aggressive character.

The profession depends so much upon the relations the photographer establishes with the people he's photographing that a false relationship, a wrong word, or attitude, can ruin everything. When the subject is in any way uneasy, the personality goes away where the camera can't reach it. There are no systems, for each case is individual and demands that we be unobtrusive, though we must be at close range. Reactions of people differ much from country to country, and from one social group to another. Throughout the whole of the Orient, for example, an impatient photographer—or one who is simply pressed for time—is subject to ridicule. If you have made yourself obvious, even just by getting your light meter out, the only thing to do is to forget about photography for the moment, and ac-

commodatingly allow the children who come rushing at you to cling to your knees like burrs.

THE SUBJECT

There is subject in all that takes place in the world, as well as in our personal universe. We cannot negate subject. It is everywhere. So we must be lucid toward what is going on in the world, and honest about what we feel.

Subject does not consist of a collection of facts, for facts in themselves offer little interest. Through facts, however, we can reach an understanding of the laws that govern them and be better able to select the essential ones which communicate reality.

In photography, the smallest thing can be a great subject. The little, human detail can become a leitmotiv. We see and show the world around us, but it is an event itself which provokes the organic rhythm of forms.

There are thousands of ways to distill the essence of something that captivates us, let's not catalogue them. We will, instead, leave it in all its freshness. . . .

There is a whole territory which is no longer exploited by painting. Some say it is because of the discovery of photography. However it came about, photography has taken over a part of this territory in the form of illustration.

One kind of subject matter greatly derided by present-day painters is the portrait. The frock coat, the soldier's cap, the horse—now repel even the most academic of painters. They feel suffocated by all the gaiter buttons of the Victorian portrait makers. For photographers—perhaps because we are reaching for something much less lasting in value than the painters—this is not so much irritating as amusing, because we accept life in all its reality.

People have an urge to perpetuate themselves by means of a portrait, and they put their best profiles forward for posterity. Mingled with this urge, though, is a certain fear of black magic; a feeling that by sitting for a camera portrait they are exposing themselves to the workings of witchcraft of a sort.

One of the fascinating things about portraits is the way they enable us to trace the sameness of man. Man's continuity somehow comes through all the external things which constitute him—even if it is only to the ex-

tent of someone's mistaking Uncle for Little Nephew in the family album. If the photographer is to have a chance of achieving a true reflection of a person's world—which is as much outside him as inside him—it is necessary that the subject of the portrait should be in a situation normal to him. We must respect the atmosphere which surrounds the human being and integrate into the portrait the individual's habitat—for man, no less than animals, has his habitat. Above all, the sitter must be made to forget about the camera and the man who is handling it. Complicated equipment and light reflectors and various other items of hardware are enough, to my mind, to prevent the birdie from coming out.

What is there more fugitive and transitory that the expression on a human face? The first impression given by a particular face is often the right one; but the photographer should try always to substantiate the first impression by "living" with the person concerned. The decisive moment and psychology, no less than camera position, are the principal factors in the making of a good portrait. It seems to me it would be pretty difficult to be a portrait photographer for customers who order and pay since, apart from a Maecenas or two, they want to be flattered, and the result is no longer real. The sitter is suspicious of the objectivity of the camera, while what the photographer is after is an acute psychological study of the sitter.

It is true, too, that a certain identity is manifest in all the portraits taken by one photographer. The photographer is searching for the identity of his sitter, and also trying to fulfill an expression of himself. The true portrait emphasizes neither the suave nor the grotesque, but reflects the personality.

I infinitely prefer, to contrived portraits, those little identity-card photos which are pasted side by side, row after row, in the windows of passport photographers. At least there is on these faces something that raises a question, a simple factual testimony—this in place of the poetic identification we look for.

COMPOSITION

If a photograph is to communicate its subject in all its intensity, the relationship of form must be rigorously established. Photography implies the recognition of a rhythm in the world of real things. What the eye does is to find and focus on the particular subject within the mass of reality;

what the camera does is simply to register upon film the decision made by the eye. We look at and perceive a photograph, as a painting, in its entirety and all in one glance. In a photograph composition is the result of a simultaneous coalition, the organic coordination of elements seen by the eye. One does not add composition as though it were an afterthought superimposed on the basic subject material, since it is impossible to separate content from form. Composition must have its own inevitability about it.

In photography there is a new kind of plasticity, product of the instantaneous lines made by movements of the subject. We work in unison with movement as though it were a presentiment of the way in which life itself unfolds. But inside movement there is one moment at which the elements in motion are in balance. Photography must seize upon this moment and hold immobile the equilibrium of it.

The photographer's eye is perpetually evaluating. A photographer can bring coincidence of line simply by moving his head a fraction of a millimeter. He can modify perspectives by a slight bending of the knees. By placing the camera closer to or farther from the subject, he draws a detail—and it can be subordinated, or he can be tyrannized by it. But he composes a picture in very nearly the same amount of time it takes to click the shutter, at the speed of a reflex action.

Sometimes it happens that you stall, delay, wait for something to happen. Sometimes you have the feeling that here are all the makings of a picture—except for just one thing that seems to be missing. But what one thing? Perhaps someone suddenly walks into your range of view. You follow his progress through the viewfinder. You wait and wait, and then finally you press the button—and you depart with the feeling (though you don't know why) that you've really got something. Later, to substantiate this, you can take a print of this picture, trace on it the geometric figures which come up under analysis, and you'll observe that, if the shutter was released at the decisive moment, you have instinctively fixed a geometric pattern without which the photograph would have been both formless and lifeless.

Composition must be one of our constant preoccupations, but at the moment of shooting it can stem only from our intuition, for we are out to capture the fugitive moment, and all the interrelationships involved are on the move. In applying the golden rule, the only pair of compasses at

the photographer's disposal is his own pair of eyes. Any geometrical analysis, any reducing of the picture to a schema, can be done only (because of its very nature) after the photograph has been taken, developed, and printed—and then it can be used only for a postmortem examination of the picture. I hope we will never see the day when photo shops sell little schema grills to clamp onto our viewfinders; and the golden rule will never be found etched on our ground glass.

If you start cutting or cropping a good photograph, it means death to the geometrically correct interplay of proportions. Besides, it very rarely happens that a photograph which was feebly composed can be saved by reconstruction of its composition under the darkroom's enlarger; the integrity of vision is no longer there. There is a lot of talk about camera angles; but the only valid angles in existence are the angles of the geometry of composition and not the ones fabricated by the photographer who falls flat on his stomach or performs other antics to procure his effects.

COLOR

In talking about composition we have been so far thinking only in terms of that symbolic color called black. Black-and-white photography is a deformation, that is to say, an abstraction. In it, all the values are transposed; and this leaves the possibility of choice.

Color photography brings with it a number of problems which are hard to resolve today, and some of which are difficult even to foresee, owing to its complexity and its relative immaturity. At present, color film emulsions are still very slow. Consequently, photographers using color have a tendency to confine themselves to static subjects; or else to use ferociously strong artificial lights. The slow speed of color film reduces the depth of focus in the field of vision in relatively close shots; and this cramping often makes for dull composition. On top of that, blurred backgrounds in color photographs are distinctly displeasing.

Color photographs in the form of transparencies seem quite pleasing sometimes. But then the engraver takes over; and a complete understanding with the engraver would appear to be as desirable in this business as it is in lithography. Finally, there are the inks and the paper, both of which are capable of acting capriciously. A color photograph reproduced in a magazine or semiluxury edition sometimes gives the impression of an anatomical dissection which has been badly bungled.

It is true that color reproductions of pictures and documents have already achieved a certain fidelity to the original; but when the color proceeds to take on real life, it's another matter. We are only in the infancy of color photography. But all this is not to say we should take no further interest in the question, or sit by waiting for the perfect color film—packaged with the talent necessary to use it—to drop into our laps. We must continue to try to feel our way.

Though it is difficult to foresee exactly how color photography is going to grow in photo-reporting, it seems certain that it requires a new attitude of mind, an approach different from that which is appropriate for black and white. Personally, I am half afraid that this complex new element may tend to prejudice the achievement of the life and movement which is often caught by black and white.

To really be able to create in the field of color photography, we should transform and modulate colors, and thus achieve liberty of expression within the framework of the laws which were codified by the Impressionists and from which even a photographer cannot shy away. (The law, for instance, of simultaneous contrast: the law that every color tends to tinge the space next to it with its complementary color; that if two tones contain a color which is common to them both, that common color is attenuated by placing the two tones side by side; that two complementary colors placed side by side emphasize both, but mixed together they annihilate each other; and so on.) The operation of bringing the color of nature in space to a printed surface poses a series of problems extremely complex. To the eye, certain colors advance, others recede. So we would have to be able to adjust the relations of the colors one to the other, for colors which place themselves in nature in the depth of space, claim a different placing on a plane surface—whether it is the flat surface of a painting or a photograph.

The difficulties involved in snapshooting are precisely that we cannot control the movement of the subject; and in color-photography reporting the real difficulty is that we are unable to control the interrelation of colors within the subject. It wouldn't be hard to add to the list of difficulties involved, but it is quite certain that the development of photography is tied up with the development of its technique.

TECHNIQUE

Constant new discoveries in chemistry and optics are widening considerably our field of action. It is up to us to apply them to our technique, to improve ourselves, but there is a whole group of fetishes which have developed on the subject of technique.

Technique is important only insofar as you must master it in order to communicate what you see. Your own personal technique has to be created and adapted solely in order to make your vision effective on film. But only the results count, and the conclusive evidence is the finished photographic print; otherwise there would be no end to the number of tales photographers would tell about pictures which they ever-so-nearly got—but which are merely a memory in the eye of the nostalgia.

Our trade of photo-reporting has been in existence only about thirty years. It came to maturity due to the development of easily handled cameras, faster lenses, and fast fine-grain films produced for the movie industry. The camera is for us a tool, not a pretty mechanical toy. In the precise functioning of the mechanical object, perhaps there is an unconscious compensation for the anxieties and uncertainties of daily endeavor. In any case, people think far too much about techniques and not enough about seeing.

It is enough if a photographer feels at ease with his camera, and if it is appropriate to the job which he wants it to do. The actual handling of the camera, its stops, its exposure speeds, and all the rest of it are things which should be as automatic as the changing of gears in an automobile. It is no part of my business to go into the details or refinements of any of these operations, even the most complicated ones, for they are all set forth with military precision in the manuals which the manufacturers provide along with the camera and the nice, orange calfskin case. If the camera is a beautiful gadget, we should progress beyond that stage at least in conversation. The same applies to the hows and whys of making pretty prints in the darkroom.

During the process of enlarging, it is essential to re-create the values and mood of the time the picture was taken; or even to modify the print so as to bring it into line with the intentions of the photographer at the moment he shot it. It is necessary also to reestablish the balance which

the eye is continually establishing between light and shadow. And it is for these reasons that the final act of creating in photography takes place in the darkroom.

I am constantly amused by the notion that some people have about photographic technique—a notion which reveals itself in an insatiable craving for sharpness of images. Is this the passion of an obsession? Or do these people hope, by this trompe-l'oeil technique, to get to closer grips with reality? In either case, they are just as far away from the real problem as those of that other generation which used to endow all its photographic anecdotes with an intentional unsharpness such as was deemed to be "artistic."

THE CUSTOMERS

The camera enables us to keep a sort of visual chronicle. For me, it is my diary. We photo-reporters are people who supply information to a world in a hurry, a world weighted down with preoccupations, prone to cacophony, and full of beings with a hunger for information, and needing the companionship of images. We photographers, in the course of taking pictures, inevitably make a judgment on what we see, and that implies a great responsibility. We are, however, dependent on printing, since it is to the illustrated magazines that we, as artisans, deliver raw material.

It was indeed an emotional experience for me when I sold my first photograph (to the French magazine *Vu*). That was the start of a long alliance with magazines. It is the magazines that produce for us a public, and introduce us to that public; and they know how to get picture stories across in the way the photographer intended. But sometimes, unhappily, they distort them. The magazine can publish exactly what the photographer wanted to show; but the photographer runs the risk of letting himself be molded by the taste or the requirements of the magazine.

In a picture story the captions should invest the picture with a verbal context and should illuminate whatever relevant thing it may have been beyond the power of the camera to reach. Unfortunately, in the subeditor's room, mistakes sometimes slip in which are not just simple misspellings or malapropisms. For these mistakes the reader often holds the photographer responsible. Such things do happen.

The pictures pass through the hands of the editor and the layout man.

The editor has to make his choice from the thirty or so pictures of which the average picture story consists. (It is rather as though he had to cut a text article to pieces in order to end up with a series of quotations!) For a picture story, as for a novel, there are certain set forms. The pictures of the editor's choice have to be laid out within the space of two, three, or four pages, according to the amount of interest he thinks they are likely to arouse, or according to the current state of paper shortage.

The great art of the layout man lies in his knowing how to pick from this pile of pictures the particular one which deserves a full-page or a double-page spread; in his knowing where to insert the small picture which must serve as an indispensable link in the story. (The photographer, when he is actually taking the pictures for his story, should give a thought to the ways in which it will be possible to lay out those pictures to the most advantage.) The layout man will often have to crop one picture so as to leave only the most important section of it—since, for him, it is the unity of the whole page or of the whole spread that counts above all else. A photographer can scarcely be too appreciative of the layout man who gives his work a beautiful presentation of a kind which keeps the full import of the story; a display in which the pictures have spatially correct margins and stand out as they should; and in which each page possesses its own architecture and rhythm.

There is a third anguish for a photographer—when he looks for his story in a magazine.

There are other ways of communicating our photographs than through publication in magazines. Exhibitions, for instance; and the book form, which is almost a form of permanent exhibition.

I have talked at some length, but of only one kind of photography. There are many kinds. Certainly the fading snapshot carried in the back of a wallet, the glossy advertising catalogue, and the great range of things in between—are photography. I don't attempt to define it for everyone. I only attempt to define it to myself.

To me, photography is the simultaneous recognition, in a fraction of a second, of the significance of an event as well as of a precise organization of forms which give that event its proper expression.

I believe that, through the act of living, the discovery of oneself is made concurrently with the discovery of the world around us, which can mold

us, but which can also be affected by us. A balance must be established between these two worlds—the one inside us and the one outside us. As the result of a constant reciprocal process, both these worlds come to form a single one. And it is this world that we must communicate.

But this takes care only of the content of the picture. For me, content cannot be separated from form. By form, I mean a rigorous organization of the interplay of surfaces, lines, and values. It is in this organization alone that our conceptions and emotions become concrete and communicable. In photography, visual organization can stem only from a developed instinct.

Ansel Adams

Ansel Adams (1902–) is an influential spokesman for straight photography. In his photographs, writing, and teaching Adams shows that the photographer must respect reality. In the tradition of Strand and Weston, he is against the photographer's manipulation of the negative. The photographer, he argues, can depict nature's varied and sublime beauty without resorting to darkroom techniques.

Adams's love of nature is only equal to that of the science of photography. In fact, Adams developed a scientific system of photography—the zone system of planned photography—for the expression of nature's poetry. Adams's popular interpretations of nature are included in Ansel Adams—Images: 1923–1974 *(1974) and* Ansel Adams *(1972), edited by Liliane DeCock.*

In this lecture delivered at the International Museum of Photography at George Eastman House in Rochester, New York, in 1958 Adams rigorously attempts to refine the terminology of photography.

I appear before you this evening not as a scientist, aesthetician, critic or businessman. I am a photographer. After nearly thirty professional years I am increasingly concerned with the progress of photography and the enlarged understanding of the potentials of my chosen medium. I want this understanding to reach beyond a mere personal opinion and resource and be communicable and clear to everyone. I have decided to discuss "definitions," not with the attitude or intention of imposing gray facts upon you, but of proposing some constructive thought and investigation upon the general subject of: what do we know about photography and how can we talk to each other about it? I trust that what I have to say will provoke interest along some fresh avenues of approach in the various domains of photography.

Communication involves definitions; not so much the precise semantic terms, or the dogmatic facts, but related to the decisive meanings of the

* Reprinted from *Image* (March 1959).

basic qualities of the medium, the elements employed, and the effects obtained in the practice of photography both as a practical craft and as an expressive art. We should always bear in mind that photography is a language—a means of conveying thought, information, interpretation, and expression. All too often we find it is a confused jargon—confused because of the unclear mixtures and distillations of mechanics, concepts, tastes, habits, and expediencies.

Now, what is photography? Factually, it is the production of images through the agency of light. Cameras, lenses, films, and accessories, exposure and development, etc., are merely the tools used in manipulating light reflected from the subject to produce an image. But when we say *photography*, we usually imply far more than its factual definition. We mean a profession, or an art, or a business, or a hobby, or a way of life. And the term *photographer* becomes even more complex as the confusions of personality are imposed on the inherent confusions of the medium. The term *writer* is about as difficult to pin down as is *photographer*. He who goes into writing assumes a hard-to-define status, except that he can be known as an essayist, novelist, reporter, copywriter, or poet. In photography you are *professional, amateur, commercial, portrait, pictorial, creative* or even *transcendental*. Somewhat sharper distinctions may be applied: *medical, architectural, legal, glamour*, etc. But these terms are indeed inadequate for anyone who tries to get at the heart of the matter. John Dokes on Main Street does portraits, and so did Edward Weston in Carmel. So do the large multibranched organizations operating as chain stores in the likeness business. This is not just a matter of degree of quality or sensitivity; entirely different worlds are represented, and we just don't have adequate definitions to clearly and properly evalute them—as we are better able to do when evaluating a copywriter or a poet. Here we have a fairly clean-cut distinction, and I doubt that either would feel competitive with the other. But all too often in photography one group is intolerant of all other groups, and we do not have the cohesiveness in the profession which I believe must very soon be developed.

When I announced the fact, in about 1930, that I had decided to leave the piano and take up photography, my parents said, "My! you don't want to be only a photographer, do you?" If I had said I was going to be a poet, a painter, an actor or, an architect, I would have received warm en-

couragement as well as practical advice. Now, their alarm and their disappointment were understandable in terms of their particular experience; the only kind of photography they knew did not represent the highest flights of artistic or social accomplishment, or did it offer potential affluence. At this period few in San Francisco had ever heard of Stieglitz, Strand, Clarence White, Edward Weston, and others now recognized as superlative artists in their fields. They might have been aware of Steichen, Bruehl, Lejaran A. Hiller through the pages—editorial and advertising—of *Vogue, Vanity Fair,* etc. These were remote names not associated with the world of art, chiefly because they appeared in magazines. Arnold Genthe was, of course, recognized as a very erudite and gracious man, and his portraits were extremely popular. Following him there were Edward Weston, Johann Hagemeyer, Imogen Cunningham, one of our most versatile and experienced photographers, Dorothea Lange, maker of sensitive portraits but not yet associated with the inspired reportage for which she is justly famous, W. E. Dassonville, excellent portraitist and technician, Anne Brigman who combined in writhing heroics the well-fed and human-form-divine and the ancient junipers of the Sierra, Consuella Kanaga, Willard Van Dyke, and many others worthy of mention. But good patrons were few. Commercial photographers did fairly well. The artist was considered a bit "strange" and the photographer who attempted art "quite strange," and often the object of tender pity. The local painting of the period was thirty years behind the times and many of the artists looked and lived like "artists" in a most nauseating way. Indeed, in the public mind, there were few effective definitions about anything concerning the arts. The truth is that there were few really great photographers practicing anywhere then—and there may be even fewer today, proportionally speaking, in spite of our remarkable technological developments.

Photography remains to this day an exciting but somewhat unstable medium in the minds of average people. The average citizen sees mostly advertising photography and photoreportage, and the inevitable "likeness" productions of Fifth Avenue or Main Street. Work which might approach art is mauled and hash-browned in the photo magazines and journals, and embalmed in the salons. Apart from a few exciting exhibits in our larger centers, and in very few good journals and books, the art of

photography is rarely experienced in our land. It is only in very few centers that we find any interest at all in the more serious aspects of the art. Indeed, it is a great pleasure and privilege for me to appear here at George Eastman House—the most important center of photography in the world.

I have deviated a bit and expanded intentionally in the above remarks because I thought I might be able to infer a few definitions and lay a few planks to stand on in the remarks to come. There is one term which was born with a silver meaning in its mouth, but has ended with a furry tongue in its cheek. That term is *Pictorial Photography*. The present synonyms of *pictorial* include *art* and *salon* photography, and the antonyms include commercial, technical, purist, and nonpictorial photography. I know some Pictorial Salon people who have barely heard of Edward Weston—much less investigated his work. Is there any musician who has not heard of Johann Sebastian Bach? So, when we say *photographer*, we are deeply obliged to clarify, modify, and explain, at least in our own minds and hearts. For those who know, the simple term *photographer* suffices; when we speak of El Greco, John Marin, or Picasso as *painters*, there is no doubt what is intended. They are not house painters, sign painters, or commercial artists; they are creative artists in the fullest sense of the term. When we say *photographer*, we evoke a complex of meanings and connotations. Anyone who uses a camera for almost any purpose is designated a photographer. Until the public acquires more sympathy and experience, I believe we must be more explicit in our designations. So, let us consider a few definitions:

Professional—one who lives by his work. *Amateur*—one who loves his work but does not necessarily live by it (some of our greatest artists have been amateurs). *Hobbyist*—a do-it-yourself man, who has fun. Nothing serious intended. The dealers have fun, too. *Photojournalist*—a user of photography as a medium of event-and-situation communications. A good photojournalist often transcends the factual (witness the work of W. Eugene Smith), and some of the most important work of our time relates to sensitive and interpretative reporting. *Creative*—a bad term, because most think of it as representing only "art." A great inventor is creative, so can be a fine craftsman. *Expressive*—not good, not bad. *Interpretative*—ditto. *Aesthetic*—inaccurate and weak. *Art*—"Sorry, Miss

Harris cannot pose today." *Transcendental*—good in a way, but limited and clumsy.

So, what term can we use to describe the work of Stieglitz, Strand, Weston, Minor White, Callahan, and others of such direction? What word can you and I use to make clear to others what we confirm and feel about these men and their work?

Let us first dwell upon certain existing word structures which may give us a key. We have compound terms: *photojournalist, photoillustrator, photodocumentarist*, etc. These terms might have seemed clumsy at first but they have grown in simplicity and logical meaning; each defines both the medium and the speciality. Accordingly, I suggest *photopoet* for those photographers who explore, distill, and interpret the intangible essences of the world. I am sure we can agree that the master work of the great photopoets relates in basic intention, quality and achievement to that of the great painters, musicians, and poets. We must be generous and admit that the qualities of the photopoet may touch and vivify all other aspects of photography, just as the poetic approach may be applied to letters in general, to sermons, and even to advertisements. I am one who believes in the potential high-level response of people in general; I believe people will respond to beauty and intensity of spirit if we give them a chance. I believe that what the photopoet has to offer can well be applied to any expression of education, information, and persuasion and will not only render such expression more vital, but will also augment its integrity. Hence, I seriously propose *photopoet* as a specific definition.

When we see a spectacular moment of life recorded on a page of *Life* or *Look* we usually are not conscious of the photography in itself (unless we are photographers), but of the moment of experience represented. Should the photographer experience more than the surface excitement of the moment—and succeed in conveying this deeper excitement and understanding through his photograph, another and far more resonant world is opened for the spectator. It is not so much the intensification of the outer world, but a clarification of the inner world of the spectator; the photographer, instead of being just an informer, becomes a catalyst of consummate power. Here lies, I believe, a suggestion for a prime definition of art and especially of the art of photography.

I should now like to present a few definitions in the realm of the me-

chanics of photography. Unfortunately, there is a chasm between the world of the sensitometrist (God bless him!) and the practicing photographer (God bless him!).

The photographer must employ the fruits of sensitometry, which is an exact science. I should like to see a reasonable bridge established, whereby the sensitometrist could interpret theory in understandable practical terms and the photographer express his requirements to the sensitometrist in terms of images and the image controls so essential in his work. I can comprehend the general meaning of a characteristic curve, but the curve defines only a few of the important qualities of the actual image. I do not make a picture with a cable release in one hand and a characteristic curve in the other! But I should know what the curve represents; I must know how the negative emulsion is responding to the qualities, quantities, and distributions of the light falling upon it, and how it will respond to development. I must know about—but need not scientifically explain—such qualities as resolution, density, scale, and acutance.

Some years ago I worked out what is now known as the *zone system* as an attempt to establish this aforementioned "bridge." In expounding it, I employ symbols and present working definitions—sometimes to the despair of the pure sensitometrist! Sensitometry presents an exact interpretation of the performance of the sensitive materials in strictly physical terms. The zone-system approach is intended to give the photographer a functional command of his medium and to enable him either to simulate reality or to intentionally depart from reality in his work. I see no conflict whatever. The zone-system approach can be constantly refined and clarified; Minor White has done a wonderful job in this respect, and he and others are carrying on with it.

Now, let us start with a few definitions in the purely mechanical domains.

THE SYMBOLIC CHARACTERISTIC CURVE

This suggests that negative density increases as exposure increases (in a ratio expressed by the shape of this curve). All negative materials have curves of this general toe-straight-line-shoulder structure, but of quite considerable variation of proportion and "steepness." As we all know, the "steepness" of this curve is altered by the amount of development applied. Values in the toe are modified by lens and camera flare; values in the shoulder can be accurately measured—even calculated in advance, on

the basis of the general shape of the curve—but here we find a typical situation where the characteristic curve does not give a full description of the image from the photographer's viewpoint. For example, I can place the integrated brightness of a smooth white card and of a fine-textured wall on zone VIII or IX of the scale and I shall obtain areas of similar densities in the negatives. However, depending a little upon the structure of the emulsion and mostly upon the type of developer employed, I will achieve—or not achieve—a good textural rendition of the wall. Certain developers, such as Metol-sulfite combination, may "block" these high values; other developers, such as Pyro, will keep them "open." This latter effect is of great informational and aesthetic significance to the photographer. Generally speaking, the sensitometrist is not concerned with textures or other image qualities—only with the densities of the strips of film exposed in his sensitometer and measured on his densitometer. The curve represents all the letters of our tonal alphabet; it is our constructive problem to put these letters together to spell out our words and phrases in the photographic image.

A FAMILY OF SYMBOLIC CURVES

Here we have a graph which indicates the effects of varying amounts of development for a series of exposures. We note what I call the "plateau of optimum density (or opacity)," the heavy line in the middle. We see how, by placing our specific brightness on lower and higher zones of the scale,

and developing for different times, more or less, we maintain the same density (opacity) throughout. This also shows how we increase or decrease the contrast of the image in relation to the contrast of the original subject. Here we observe the application of mechanics to gain a desired result. I believe we can define *technique* as the appropriate and functional application of mechanics.

The photographer has to know some things about his materials that are not readily found in the published information from the sensitometrist. One should not depreciate the other. If it were not for the sensitometrist, we would not have film; if it were not for the photographers, we would not have sensitometrists. I plead for a better mutual understanding here. With unlimited time I should like to discuss *gamma, grain, reciprocity effect*, etc., in terms of actual photographs. I shall rest here with an attempt to define such terms as *subject brightness, exposure scale, resolution, detail, sharpness* and *acutance*. These terms are used as freely as confetti these days, and I think we should get down to some simple and direct clarifications.

SUBJECT BRIGHTNESS AND THE IMAGE

If we agree that the most realistic photograph is not reality at all, we are then obliged to make some bridge between reality and its symbols.

Visually we perceive the world in terms of different values and colors of reflected light. Occasionally the light source or direct reflections thereof are included in the field of view. It is quite possible to produce an image wherein all the reflected light values are proportionally rendered in varying values of gray. This photometric-equivalent accomplishment would probably be extremely dull and uninteresting. Not only would it fail to create aesthetic excitement, but it would not give much vital information. We see everything in terms of significant meanings and in even the most badly "informational" images we must exaggerate, enlarge upon, intensify, and accent the shapes, spaces, textures, and values of what we carelessly call "reality." This is why the so-called push-button photography may be a technological miracle but holds small importance for the serious photographer.

EXPOSURE SCALE

What do we mean by this term? A range of values 1 to 25, log 1.4, 1 to 256, long scale, short scale, etc? In some circles the term *dynamic range* is employed, which describes the differences of exposure to which the film will respond in terms of ordinary use and in relation to ordinary printing procedures—all controlled by the convenient capacity of the eye to differentiate image values—usually around 1-to-256 range with modern films. Now, it is often implied that we can place our lower value on the "1" point, and the brightest area on the "256" point, and we will have a fine image representing brightness differences of 1 to 256. But this would not be very satisfactory, picturewise, the "1" point and the "256" point would by no means represent substance or texture in the scene, only the extremes of tone near to pure black and pure white. Several steps of tone are required to convey texture and substance; hence, what I call the *textural range* would not represent a range greater than 1 to 64, usually less with conventional materials.

Resolution refers to the performance of the lens and also of the negative material. A lens may give very high resolution (that is a clear separation of x lines per mm) but the negative may—through light-scatter and grain characteristics—depreciate the performance of the lens to a considerable extent. *Detail* is a quality of the subject more than anything else—we say, "Look at the detail in that rock, etc." *Definition* is a quality of the image—we say, "There is marvelous definition in that photograph of the

cliff, etc." *Sharpness* is more precise than *definition*: it relates more to the physical quality of the image than to its visual quality. And then there is *acutance*. This relates, I am told, to the microdensity differences in the image. It is a very important quality indeed. In simple terms it refers to definite sharp differences of tonality; the higher the acutance the less "halo" and the more abrupt the juxtapositions of light and dark points and edges in the image. Certain developers—Pyro for example—yield higher acutance than developers containing much sulfite, etc., which "dissolves" silver and, while reducing apparent grain size, produces a haze across otherwise sharp tonal separations, and tends to "block" the high values of the image. Now, we can have an image of very high resolution, yet if the acutance is low, we have the impression of "un-sharpness." On the other hand, an image of inferior optical quality—low resolution—and high acutance will give the impression of great sharpness. An actual example lies in the early work of Edward Weston; he used a poor Rapid Rectilinear lens, and his images are not optically sharp. Yet, because of his use of Pyro and his extremely sensitive printing, one gains the impression of almost unbelievable sharpness. These negatives, however, could not stand a 2-times enlargement and retain optical clarity. The impression of sharpness may also be produced in enlargements of low-resolution images if the grain is rendered sharp and decisive in itself. Also an otherwise hazy image can be sharpened by the use of a brilliant fine-textured paper; in both cases the physical qualities of the image create the impression of sharpness which the optical image may not possess.

In evaluations of the photographic image I believe we must give full attention to the subjective interpretations of sharpness, detail, etc.—for it is only in the visual sense that photographs can speak to us, and the communicative, emotional, and aesthetic values depend upon what we see in the photograph—not in its physical qualities alone. I might add here that there should be no restrictions on the character of materials employed in the making of a photograph, providing the results reflect the intentions of the photographer. Edward Weston would say, "I don't care if a print was made on a bathmat—providing it is a *good* print!"

I do not employ rough or textured papers, simply because I want nothing to stand between the spectator and the silver image and I want the image to possess the maximum brilliance (maximum reflectance-scale).

However, as the work of Stieglitz and Strand shows so beautifully, there are other print qualities which support and intensify particular images: Stieglitz's platinum and palladium prints and Strand's rich prints on fine-textured papers such as Illustrator's Special, etc. Here I have used the term *brilliancy* in reference to the print. It is not enough to say that brilliancy is the arithmetic equivalent of the log reflection density. A print, in the reflection densitometer, may reveal a long scale of values; shown under ordinary conditions, it may appear quite flat. Why? Let us display a brilliant glossy print in a white room illuminated by bright but diffuse light. The print will appear both flat and dark.

The eyes have accommodated themselves to the general "surround" of brightness, and the image values become, accordingly, relatively dark. In addition, if we minimize the general scattered environmental light, we will find that the brilliancy scale of the print is greatly increased. Maximum brilliance would be achieved by illuminating the print with a strong light (say a 200-watt floodlamp at 6 feet distance) and completely shielding the print from all scattered light and environmental reflections. However, if the light is too strong and the intense blacks of the image appear slightly gray we know we are losing our brilliancy range, the light is actually penetrating the silver and also reflecting a bit from its surface. I suppose this could all be calculated on a physical basis, but it is far better to evaluate the optimum lighting of a print on a purely visual and emotionally satisfying basis. Once the optimum conditions are achieved, we can analyze them to perfection, and we can sometimes duplicate them to advantage. I have found, however, that the optimum display of prints is one of the most difficult and unpredictable procedures in the entire domain of photography.

I could continue for a long time laboring the refinements of definitions in the mechanical aspects of photography. Before I leave this subject, I should like to plead for some consideration of logical fixed meanings—film speed, for example. Once I have established a working speed for any negative material, I never change the speed as such because of filters, lens extensions, etc. The film speed remains the same, the exposure is modified by filter factors, extensions, etc. To use a film of 200 ASA speed at 100 speed just because a K2 filter is employed, while giving practically the same result involves a disjointed sequence of value awareness.

One of the most important facilities the photographer can acquire is the intuitive awareness of the basic response of his material to light. This should be a constant, and this constant used to determine the basic exposure. Then, the additional modifying factors are applied, to the basic exposure values—not to the film speed. I assure you, discipline in such procedures will prevent many disasters and establish a solid and accurate resource of technique.

I think we should carefully examine some of the fundamentals—terms so familiar and frequently used that their true meaning may escape us. Let us think about such simple terms as *form, textures, substance, luminosity,* etc.; how we throw these about with careless ease! For example: the word *form.* I believe we can speak of a Weston photograph of a rock or shell as being a "rock form" or "shell form." The important thing to realize is that the rock and the shell were, in themselves, only shapes—configurations in chaos. They became forms only when sublimated by the vision and visualization of the artist, and organized within the space of his picture, and appropriately exposed, developed, and printed.

The simulation of reality is only the first stage of the creative photographic process; reality transfigured by the imaginative processes departs constructively from itself. There have been thousands of photographs of rocks, shells, and landscapes which possess all of the superficial factual information and perhaps more than a Weston photograph may convey; yet this factual description is not enough.

The essential element of creative vision—a complex of time, space, and love—is absolute. We expect it in the fine arts, in great music, and literature. We are sometimes perplexed when confronted with it in photography. We ask, "How can something be both real and magical?" Magical a photograph may not often be. But one thing we know, it can never be truly real. I am reminded of the patron who at a Picasso exhibit said to the Master, "Mr. Picasso, I do not understand this painting entitled FISH; it certainly does not look like a fish to me!" Picasso replied, "Madam, why should it look like a fish—it is a painting!" A photograph can be nothing else but a photograph. We cannot define it as a counterfeit of reality—or even a reflection of reality. It remains, simply and inevitably, a photograph. Reality is just one element in the process of taking a photograph.

We, as photographers and artists, must have a mental, spiritual, and ethical attitude to begin with; if we are conditioned for the artistic (creative) experience and facing the world thus conditioned, we accost situations of reality as recognizable potentials for creative expression. We can say, simply, we "recognize." Now, the "drive to speak" rests upon the stimulus of recognition. What do we have to "say"? To the artist this comes with a clear-cut immediacy; we visualize the final picture, sometimes broadly, sometimes with extraordinary and acute detail. We now have a complex of definitions: condition, recognition, visualization. *Purpose*, the function of the work, probably rests in the domain of *condition*. Now, apart from the necessary mechanics, the picture is made, at the moment of visualization. Craft enters the scene, the command of mechanics—which we may term *technique*—must be available.

With our visualization well in hand, our craft procedures will probably be: first, to assume the optimum camera position. Second, to evaluate the brightness of the subject. Third, to organize these brightnesses on the exposure scale, and thereupon calculate the exposure and development required to realize our visualization. Sometimes this procedure is fully worked out in step-by-step detail; at other times it is swiftly and intuitively accomplished. Quantities and qualities of the subject must be related to the performance of the equipment and the response of the sensitive film and paper. The shutter is operated and then the negative developed. The negative can now be compared to a musical score. It is ready for its performance: the print.

We now enter a different room of the mansion of photography. We have our "score"; if properly composed, technically and aesthetically, it can be performed so as to re-create the original visualized intention. However, we find quite often that we can enlarge upon the experience projected at the moment of visualization; we approach the making of the print exactly as some fine musician modulates and refines the message of the score before him. Yet, we must always remain within the limitations and resonances of the medium itself. Here is where the manipulators make their fatal error: they build pyramids of foam rubber and interpret the grand calligraphy of God in squeezed and shallow patterns. What I think we can call the microscopic revelation of the lens is just an associa-

tive clarity of perception, mood, and communication. Above all, a thrilling relationship with that completely wonderful thing we call the World.

You might well ask, "What has all the above got to do with definitions of photography?" I think it has a lot to do with them. It helps define the definitions themselves! Let's go back and dissect some of the thought presented: subject versus the camera. There is a considerable difference in the organizational approach of a Weston to the external world of chaotic reality and the approach of a photographer who arranges his world and then records this arrangement in his camera. Quite often we see combinations of these extremes. The purely analytic nature of photography and the purely synthetic nature of painting, for example, are seldom realized. In the former case, the subject is untouched; only the camera moves into optimum position. Perhaps obstructions in the line of sight can be removed and even objects of obviously distracting character can be extracted from the field of view, without depreciating the "purity" of the statement. But when any arrangement in situ takes place, any figure is "posed," any condition of lighting is altered, something more than observation or pure analysis enters the pattern. We are now exercising some control of the world by establishing some elements of *form* within the matrix of chaotic shape. As this control expands, interpretation becomes modified by the flux of recording; finally, with total arrangement, we shall have only total recording. The creative qualities are found in entirety in the scene before the camera. There is nothing right or wrong in these various combinations—but it is, I think, important that the photographer recognize the basic differences involved.

Much contemporary work is poor because of this indefinite grasp of the fundamental concepts of the medium. Conflicts of reality and fancy, of the purely "natural" embroidered with threads of the artificial, etc., merely represent a confusion of style and viewpoint unless the purpose is clearly revealed. For example, consider an advertising picture where we have a well-seen and interpreted landscape in which two figures are arbitrarily positioned. The pseudoperfection of this placement and arrangement belies its character; this is not a "found" situation. On the other hand, recall the Cartier-Bresson picture of the little girl wandering down the tree-shaded street of a southern town. Everything here is "found"; the

sensitivity of the photographer creates organization out of chaos. But, on the other hand, recall the picture by Edward Weston of the Negro sculptor sitting in his work shed and beaming squarely at the camera. Here Weston re-created a real situation, which is both symbolic and actual. I can describe a picture I have made of the chief of police of Honolulu—an intentional symbolic composition—the figure placed against a vista of the city. I remember a portrait of Hauptmann by Steichen—a noble leonine figure placed against a backdrop of stars. This we might call a stylized environmental portrait which we should show along with the beautiful and tender photograph by Arnold Genthe of Edna St. Vincent Millay in the blossoming orchard. Perhaps we are now discussing definitions which transcend the power of words to clarify. But it is very important to think about them because we can enter upon dangerous grounds through insensitive attempts to be sensitive! There is nothing more sacred than the inner self, both of the perceptor and that of the spectator. To verbalize an image is to blight it. Here, in this important area of thought one must have sound definitions—but they must be his own. They must be realized not in words but in the terms of the medium itself.

Herm Lenz

In this interview Dorothea Lange, Ansel Adams, and Imogen Cunningham discuss the status and future of photography. These photographers evaluate influential photographers—Stieglitz, Steichen, Strand, and Weston—in terms of their own and others work on the East and West Coasts. Their viewpoints are valuable as each was an earnest and accomplished photographer.

Dorothea Lange (1895–1965) first received recognition for documentary work made for the Farm Security Administration photographic project. Subsequently she worked for the Office of War Information and contributed to an international range of newspapers and magazines. For Lange, photography was a means to express her concern and respect for people in unfortunate circumstances. Her most famous images are unsparing, explicit revelations designed to heighten the public's social consciousness. Her books include An American Exodus: A Record of Human Erosion *(1939), co-authored with Paul Taylor, and* The American Country Woman *(1968), commentary by Beaumont Newhall.*

Imogen Cunningham (1883–1976) is noted for her penetrating depictions of animate and inanimate subjects. Like others of her generation, her early photographs of soft-focused romanticized images contrast with the later sharp-focused realistic compositions. As a teacher she influenced young photographers to pursue their art in an energetic spirit characteristic of her career. Her books include Imogen Cunningham: Photographs *(1970), introduction by Margery Mann.*

See previous essay for notes on Ansel Adams.

Three photographers who have exerted a great influence on American photography are Imogen Cunningham, Dorothea Lange, and Ansel Adams. They are old friends and live just a few miles from each other in the San Francisco Bay Area.

* Reprinted from *U.S. Camera* (August 1955).

Our assignment from *U.S. Camera* was to conduct a symposium which would survey the careers of these three photographers, and get their views on the present trends in photography and who the people or organizations are who have brought about these trends.

Armed with an Ampro Celebrity tape recorder, we arrived at Dorothea Lange's studio a short distance from the campus of the University of California in Berkeley. After we had set up the Ampro, Ansel Adams began to talk about the preoccupation many people have with the history of art.

ADAMS: One of the things that's bothering me lately is that I have to keep pulling myself out of the swamps of connotation and false period classifications. We're too time conscious. Because a thing was done in 1870 doesn't necessarily mean that it has a nineteenth-century concept. The same thing applies to the present.

One of the great fallacies is to think that in the 1860s you had a purist, then you went from a purist to a factualist, and then you became very romantic, and after that you went back to purism.

Wasn't it Robinson and Rejlander who did some of the stickiest pictorial work imaginable? And some of the portraits of Cameron are magnificent.

LENZ: Whom would you number among the great photographers of the past?

ADAMS: When you look into the past of the western American photographers, you find that a man like O'Sullivan was the most powerful creative photographer of his group, and he also was the most intelligent. In other words, he had possibly the greatest amount of what we call character. I don't mean just moral character; he had force. Now Jackson was a terribly hard worker, but there are none of Jackson's photographs that have the quality of O'Sullivan's. And there are, of course, a number of perfectly obscure people like Bell and Phillips who came through with some pretty wonderful stuff. But whether we read into some of these things connotations because they are of the past or because the subject is tragic or important. . . .

CUNNINGHAM: What kind of connotations do you mean?

ADAMS: Ah, well, you have the connnotations of the unattainable past.

LENZ: Great because it's old?

ADAMS: Why, Jackson and his contemporaries never thought anything about switching negatives; they traded them. "You have one of the Canyon de Chelly; well, I've got two. I'll trade you one of them for one of the Little Colorado."

The old boys were apt to be superb. They had a very simple bread-and-butter job to do, and they did it well.

It's very hard to sit down and figure out in the past who is good, and who in the present is good. The thing that counts is the image that's before you and what it does to you in terms of the medium, not so much in terms of the subject.

I remember several years ago Willard Van Dyke was evaluating everyone on the basis of whether his work reflected the time in which he lived. I haven't got any particular desire to reflect most of the aspects of my time. I wish I could paint that side of the mirror black.

LANGE: You can't help it.

ADAMS: You can't help it in a sense. But to lay it on thick, as if to say, "This is the aspect of the times," and then self-consciously go about it without other considerations is not going to result in true photography.

LANGE: People are always trying to put photographers in a niche and categorize them. Now, everyone—I don't argue the point—everyone calls me a documentary photographer. I'm not. I did that for ten years and enjoyed it immensely. And I've done many other things and I intend to. But, Ansel, the same thing has happned to you. "Photographer of the California mountains," or "Landscape Photographer," or "Great Scenic Artist," unquote! How you struggle against that. And as far as Imogen is concerned, because she enjoyed photographing plant forms. . . .

CUNNINGHAM: Oh, people have forgotten that, Dorothea. They've forgotten that I ever did plant forms. You know, I've tried my best to sell people on the idea that I photograph anything that can be exposed to light. And the only person who ever appreciated those words was Minor White.

LENZ: And now I appreciate them too. Ansel, you said before that the thing that counts is the image that's before you and what it does to you in terms of the medium. What did you mean by that?

ADAMS: You either are right there and become part of the thing, or you don't. There are pictures and pictures and pictures. Once in a while, once in a while—there may be lousy technique, everything bad—but you suddenly realize you're standing right there; you're in contact with the thing. That's strong seeing.

CUNNINGHAM: You partake of photography.

ADAMS: You become one of the dimensions. O'Sullivan had that feeling of presence often.

CUNNINGHAM: I want to put in something now, Herm. George Bernard Shaw says the photographic portrait is about eighty percent the sitter and twenty percent the photographer; while the painted portrait is about seventy-five percent artist and twenty-five percent sitter. Of course, it gives you an argument about how expressive the photograph is. But we all know that the perceptive photographer behind the camera does something to the result.

LENZ: Now, Imogen, what influence of the past helped shape your career?

CUNNINGHAM: Well, the earliest impression on my own career was made by Gertrude Käsebier. Maybe perfectly unknown to any of you, and you may not think anything about her. Well, at one time there were some things of hers published in a magazine, *The Craftsman*. Oh, it's long since gone. That was about 1900; maybe before that. I saw these photographs of hers and afterward I kept thinking all the time, "I wish I could be as good as Gertrude Käsebier!" I didn't begin with people, but with scenery.

In 1909 when I went to London I visited Alvin Langdon Coburn. His mother drew me aside when Alvin went out to get one of his books, and she said, "You know, you never could be as good as Alvin." And I said, "Well, you know I can try."

When I came back from Europe, I met Stieglitz, and I was one of the earlier subscribers to his *Camera Work*. I filled myself with what was going on around me; but you must remember that there was less going on then than there is right now.

LENZ: Dorothea, are the same influences on your background?

LANGE: I don't have any photographic gods like other people do. I mean of the past. I never did have them, even in my earliest days. I don't

mean I didn't work and study and admire other people's things, but I always was stubborn, I guess. I can no longer, with any sense of returning to the source, go back to old photography. Though there was a technical quality in the old things that is better, I think, than what we have to work with now. And the images in that respect were richer.

LENZ: Would you agree with that contention, Imogen?

CUNNINGHAM: I don't think that's true, do you, Ansel? I think we've got everything now.

ADAMS: Yes, but what do we do with what we've got?

LANGE: The old papers were richer. I'm sure many photographers vaguely feel that since we have had really fast film emulsions, we have lost certain other things. And I cannot really say what that quality is. Can you, Ansel?

ADAMS: I think I can say that photography in the old days was sufficiently difficult to command attention. Now it is so glib that we become unconsciously superficial. When the old boys would make a photograph on a wet plate, they had to set up their darkroom tent near their tripod. It was quite a few hours procedure. Then the long sun-printing, plus considerable expense. Now we think nothing of going through a dozen sheets of double-weight paper just to make a proof. The thing is so easy that the attention is diverted from the quality. If we had only two films and three sheets of paper to go out and do a job, it might be better for us.

LANGE: That's part of it, but even beyond that the richness of the silver and the emulsion was there.

ADAMS: You could bring in this technical point. The wet plates had tremendous scale and high contrast. They were printed upon collodion papers, on which you preserved almost a straight line of tonal progression. This is impossible today with the ordinary negative and paper. That is one of the reasons we don't feel the extreme richness. I think it's because the visual range of the eye, the response of the eye, is not as well matched in the contemporary image as it was in the old.

LENZ: Imogen, what do you feel about the work you did with the old platinum paper?

CUNNINGHAM: As I look back on it, I believe it represents an era. Quite a little of what is in the negative was lost; and now we want every-

thing that is in the negative. You don't get that with the platinum paper. But it has something else; it has a quality beyond description.

LENZ: Who are the people who are exerting the most influence on photography today?

CUNNINGHAM: I put down Paul Strand, one of the first, to my way of thinking, and Stieglitz, and Weston. And then I put down *Life* magazine. What influence do you think *Life* magazine has had upon photography in general? There are a lot of very good photographers who work for *Life* . . .

LENZ: Margaret Bourke-White?

ADAMS: Eisenstaedt.

LANGE: Oh, if you start to list them all, there's a long list of very gifted and courageous people.

CUNNINGHAM: I think Strand has had a tremendous influence upon the exact image and texture.

LANGE: Of course Strand and some others are sort of the high priests. There's a certain hierarchy there. But when you're thinking about this democratic art, you can't discuss it in terms of a few people; and it's always the same handful. There are two wonderful photographers who died recently, and I think they have left a great photographic record. Werner Bischof has left a record on file. Among them there may be fifty great photographs, but there's a record there of a life's work, done by a man who took the camera seriously. And as far as Capa is concerned, he was no photographic adventurer; he was much more than that. You can't compare Paul Strand, who works in solitude, with aesthetic principles, to these fellows who go right out into the hurly-burly.

ADAMS: Certain workers like Strand and Weston and Stieglitz work as easel painters do with one picture after another, each one memorialized, framed for folio: "I made this statement; now I'll make another." To people who work on projects, like Dorothea, and to journalists, one picture doesn't mean very much. It's the theme, the continuing stream of pictures developing a theme. The job is the complete set.

LENZ: Do you think documentary photography has had an appreciable influence on younger people?

LANGE: Enormous, because it seems to fit a certain trend. There's a

large army of young, interested photographers who want to make what they call "social comment." They call that documentary photography, and there has been sort of a cult. I was associated with it in the early days, so I get the benefit of that.

CUNNINGHAM: Weren't you doing it under the Farm Security Administration?

LANGE: Of course. And that was the opportunity. There is no organized documentary photography being done today that I know of. There isn't any opportunity as we had in that project. One of the things I would like to do is to find some way for another crew of youngsters to go out on another big project. It would do more for documentary photography than anything else.

LENZ: What about f/64? Do you think it has any continuing influence on contemporary photography?

CUNNINGHAM: I only know that whatever its original influence, that influence has remained.

LENZ: What was it again?

CUNNINGHAM: Well, it was a group of people—I think it was mainly instigated by Van Dyke—don't you think he was the one who thought it up and gave it the name?

ADAMS: Well, for the record, I thought about it for two years before it happened. We formed it; he gave it the name; Weston agreed to be in it; and then it became more solidified, and a few others came in.

LENZ: Ansel, you said you thought about it?

ADAMS: It's usually mixed up, and I think it ought to be cleared up. I remember as early as 1930 trying to get a group together who would function with straight prints. Then I saw Willard Van Dyke one day with some of his prints. Henry Swift became interested. Imogen Cunningham joined us. Then Willard called up one day and said, "I think I've got a name for it." I said, "What is it?," and he said, "f/64."

LENZ: Why was it called that?

LANGE: It was a protest against soft focus, which was handled so badly. People didn't understand it anymore, and they used it for all kinds of poor purposes.

LENZ: Naming it f/64 didn't mean you were restricting yourself to that lens opening, did it?

ADAMS: Oh, no, that just means the sharp image. F/64 gave great sharpness with great depth. After a while Weston was convinced that it was bad for him to be categorized with the group. He was the first one who made the break.

LENZ: To sum it up, what is the truth about f/64?

ADAMS: I motivated it; Willard Van Dyke clarified it; Edward Weston subscribed to it.

LENZ: Ansel, will you say a few words about landscape photography? Many amateurs are camera clubbers, a number of whom believe that in order to have a successful landscape there should be some living or moving object in it. I notice your pictures are successful without that.

ADAMS: I don't see any great separation in the natural scene. I take a greater interest in natural phenomena than most other photographers. Dorothea made a wonderful statement that Edward Weston's nature poses for him. He approaches almost every object in an abstract sense, and makes it pose according to a preconceived concept of form. I work on quite a different basis; I have a great belief in what happens out there. I would like to see it develop its own form. I belong to a kind of Thoresque, semimystical group who are willing to believe in the qualities in external things.

LENZ: Dorothea, you worked with Steichen on the "Family of Man" project. Do you have any thoughts about the newcomers in photography?

LANGE: I don't know their names, but I'm tired of the recital of the old names. I don't understand why, year after year, the same names are included. Has it gone dead?

ADAMS: I've been blowing Ernest Haas's horn ever since those things came out in *Life*, as the best contemporary job I know of in color.

LANGE: There is a group of foreign-born refugee photographers in this country who work very well.

LENZ: Superior to the natives?

LANGE: Yes, I think they are superior. They're keener; they've gone through more. And it shows.

LENZ: Do you think there is more fomentive activity on the East Coast than on the West Coast?

LANGE: I think that on the West Coast there is more real photo-

graphic activity—photography for photography's sake. In the East they are scrambling for those big jobs. There's tremendous competition. A new name is made overnight, and then they wring him dry in six months. The competition there is for big money, big prestige quick, particularly in the last five years in New York.

LENZ: Do you feel Minor White has had a big influence on young photographers on the West Coast?

ADAMS: I'd put it this way: he was the only man in the history of photography who was consciously aware of and applied philosophical thinking to the art; the only one who taught photography philosophically. I don't know of anyone who could get the work out of people that he could.

Minor White

Minor White (1908–1976) enjoyed photography as a poetic evocation of feelings. His romantic theories derive from Stieglitz's notion of "equivalents"—the use of external imagery for the expression of emotional metaphors. In his photographs, writing, and teaching White attempted to realize the symbolic potential of the media. He advanced his own and other's ambitions for photography as founder and editor of Aperture *and through teaching workshops that stressed self-analysis. His books include* Mirrors, Messages, Manifestations *(1970) and* Visualization Manual *(1972).*

In this essay White defines photography's "tangible" and "intangible" characteristics. His definitions are based on a diversity of approaches.

Some photographers have always kept within the characteristics that are peculiar to photography ever since the daguerreotype introduced the precise image to the world and the negative-positive Talbotype made unlimited replicas a feature of the medium.

Before Peter Henry Emerson, physician and amateur photographer, published his book, in England in 1889, *Naturalistic Photography*, most of the photographers who practiced some form of pure photography did so unconsciously. Since Emerson they have been more conscious about it. Emerson battled against the accepted art photographers of the time such as Henry Peach Robinson who tried to make photography do what painting was doing; and in so doing brought to wide attention the fact that photography had a way of looking at the world peculiar to itself and an aesthetic well worth exploring in its own right.

The aesthetics of *naturalistic* photography that was propounded in Emerson's day is no longer sufficient because the developments of photography have added characteristics of lenses, shutters, and films unknown in the 1880s, the chief of which is speed. *Continuous tone*, of course, is still a characteristic of photography. *Differential focus*, which Emerson called "as the eye sees" (meaning pictures that were sharp where focused and the rest in varying degrees of unsharpness), is also still

* Reprinted from *Image* (October 1956).

in full effect. So is the *overall sharpness* obtainable by the stopped-down diaphragm. This point while long practiced was made a main issue by a group of West Coast photographers in the 1930s who called themselves f/64. This group preferred the term *straight* for the kind of pure photography that they advocated and practiced.

These five elements or characterisitics: precise image, limitless replicas, continuous tone, differential focus, and overall sharpness are still, old though they be, at the heart of any definition of photography in search of its own aesthetic. Others have been added. The Bauhaus group in Germany in the 1920s, notably under the guidance of Moholy-Nagy, thoroughly explored the photographic medium. Of all their discoveries the multiple image seems the most photographic. More than one image on a single negative, or two negatives printed together had been possible since 1839, but it was not until the 1920s that *multiple exposures* became purposeful rather than a mistake. Also in modern times the development of high-speed films has brought the degree of *movement blur* under the control of the photographer. Motion, frozen or blurred, is now a matter of the photographer's own choice and has thus become a tangible characteristic of photography. Fast lenses and films have also made the transitory gesture a characteristic of pure photography. Gesture or glance, however, are not so tangible as the seven just discussed and so belong in the collection of *intangible* characteristics. Seven of these will be listed—to fill out the definition of pure photography.

THE INTANGIBLE CHARACTERISTICS

The first pair of intangible characteristics is *the sense of presence* and its close associate or twin, *the sense of authenticity.* Both of these originate in a great clarity of image, and both border on a nearly embarrassing visibility of everything in sight. The sense of presence can be recognized when the illusion of reality is so strong that it seems to be your eyes gazing at the subject unhindered by the glass eye of the camera and unmindful of the eye of the photographer. You are there. This is the way that the viewer is transported by the photograph to a different place and a different time.

Just where presence merges into the sense of authenticity is impossible to say. Because you feel that you are there, you feel that what is seen must be true. This is the reason that the photograph is accepted as a document.

The sense of authenticity in a photograph is so effective it can seduce some persons who reject abstraction in painting to accept what looks like abstraction in a photograph.

Innocence of eye is doubtlessly the most intangible of all the characteristics of unique photography. Yet, when we think of photographs such as Jackson, Hillers, or O'Sullivan made in the Rocky Mountains in the 1870s, or Atget in Paris during the first quarter of the present century, innocence of eye is essential to this definition. This characteristic is difficult to identify in a photograph because when it is most effective it is the most unobtrusive. Nevertheless, innocence of eye has a quality of its own. It means to see as a child sees, with freshness and acknowledgment of the wonder; it also means to see as an adult sees who has gone full circle and once again sees as a child—with freshness and an even deeper sense of wonder.

This quality is not at all rare, almost any beginner with a camera displays it for a short time. Older photographers who lugged their heavy cameras all over the American West, all over Europe, or into ports all across Asia usually had it. They came, they saw, they photographed.

Selection—An Attitude

All photographers select their subject matter and those that are artists invariably recognize almost instantly the significant form in the selected subject matter. Therefore *selection* is a characteristic of photography when it is used as an art medium.

First, the *act* of selecting is to be considered as the photographer's equivalent of the painter's *act* of composition. Obviously, selecting the significant from the stream of random happenings in the world is a far cry from composing significance out of pigments. The one is a form of near instantaneous analysis and the other a form of synthesis. Notice it is the act of selecting and the act of composing that are being compared: a photograph exhibits composition as fully as a painting, if composition is defined as the organization of lights and darks, forms and shapes, near and far.

Second, selecting is an act of choice and therefore reveals some degree of the personality traits of the photographer.

Third, selection may be long and deliberate, during which all of the

photographer's background is drawn into the experience; man, crafts-man, designer, visionary are all summed up at the instant of exposure. Or all this may happen so quickly that everything that the photographer is, past and present, is caught up in the sweep of a moment or instant of rec-ognized significance.

Fourth, selection is confined to the world as the photographer finds it. He alters nothing, he only waits, he only *recognizes* significance.

Fifth, selection is an attitude of mind, complex and at the same time simple. And while the term *selection* is overloaded with meaning here, in practice it is simplicity itself. It is an attitude of mind that is receptive, passive, an attitude of mind that can be compared to a ripe fruit. The fruit does not drop of its own accord, but because pushed by a passing breeze.

Selecting is an attitude in which the highly paradoxical reverse of the usual relation between photographer and subject can happen—the sub-ject selects the photographer.

Since all this goes on in the head of the photographer, it is impossible to find an illustration directly applicable.

Previsualization—A Discipline

Compared to what is meant by *selection, previsualization* is active where the former is receptive; and a discipline where the former is an attitude. The two characteristics complement each other and between them make photography as an art form practical to an unusually wide variety of temperaments behind cameras and films.

According to spokesmen for the f/64 group, previsualization means *imagining the print while looking at the scene.* To do this effectively re-quires that the photographer know how the camera transforms the visual occurrences that we usually accept as "real" into a two-dimensional, cramped illusion of the original. As a photographer's knowledge of the tangible characteristics of the medium increases, he will find that every-thing he looks at will look more like a print than ever. Some cameramen say they cannot tell what a thing is all about until they see a photograph of it.

To the f/64 group previsualization was no more than a point. In our definition of straight, pure, unique photography, previsualization is given more importance. It is featured because previsualization is a discipline by which all of the tangible characteristics built into lenses, films, and shut-

ters are brought into the circle of unique photography. For instance the members of the f/64 group insisted on allover-sharpness yet in-and-out-of focus is an absolute characteristic of lenses. Or another example: if a person can imagine or predict what exposures of two different subjects can do on a single sheet of film, he has every right to call the photograph his own. If, on the contrary, he uses multiple exposures as another way of putting random happenstance through its paces, without previsualization, he effectively postpones the moment of *selection* until he can look over the prints.

Previsualization developed to the point of a discipline by an individual takes the accidental out of both his seeing and his pictures. And as a discipline it makes the difference between a man that photographs something because he likes the object and the one who transforms an object with photography because he knows that he will like the photograph.

The Concept of Essence

In practice, fusions of characteristics occur. So far as they are fusions they can be called concepts. There are two such concepts at the heart of unique photography. The concept of *essence* is one, the concept of *experience* is the other.

Essence refers to that underlying strata of meaning from which all secondary characteristics radiate. Hence it is the core, the heart, the central motive, in short the essence of a person, place, event, or gesture from which the whole of person, place or event may be reconstructed.

To reach essence photography cannot work as painting does. Whereas the latter can pile up characteristics until an essence is synthesized, photography must wait until a face, gesture, or places goes "transparent" and thereby reveals the essence underneath. Such "transparency," or "aliveness," or "exact instant," or however called is normally transitory and rarely, in fact never, never, repeated exactly.

The Concept of Experience

This is perhaps the newest concept to be applied to pure photography. Because the concept allows a direct approach to the photograph itself, it is a useful concept when trying to come at the problem of a particular photograph's relation to a work of art. If the photograph evokes the experience of beauty, or of truth, or of goodness, or what the spectator associ-

ates with the aesthetic experience, then the photograph fulfills one of the functions of a work of art.

Lyrical and Accurate

Many photographers use photography faithfully yet force it to serve the purposes of the poetic temperament whether that be epic, comic, lyric, or tragic.

Frederick Sommer

Frederick Sommer (1905-) uses photography to discover the hidden levels of meaning in ideas and objects. For Sommer art is a means to achieve insight into the inaccessible. This surrealistic orientation encourages his experimentation with varied materials, printing processes, and chance occurrences. Also a painter and landscape architect, Sommer is interested in cultivating the common characteristics of the arts and clarifying the relationship of the arts to other disciplines. His books include Frederick Sommer: 1939–1962 *(1963).*

In this talk given at The Art Institute of Chicago in 1970, Sommer explains his involvement in photography. His thinking is similar to Stieglitz's and Minor White's: that is, photography verifies the interrelatedness of subjective feelings and external imagery.

I hope you will permit me to sit down, I don't feel comfortable standing up. Like water, I always try to find the lowest level of things.

It wouldn't be my style if I really knew what I was going to tell you. I discovered a long time ago that it isn't my style to be comfortable within things that I know. I have a feeling that as I get a bit more acquainted with the things with which I'm dealing, or happen to find myself surrounded by, I get imprinted with them (to use a common expression, very common these days, but nevertheless very real). The things that we are, are environment-making toward us. We reinforce that. But to live comfortably within the kinds of things that are happening, it's terribly important to slip off that little button . . . that little chair. So it's a question of how far you dare to venture from the thing that you think is your thing. It's a question of taking some chances. Yet let me assure you that nobody ever goes into far country. If you find yourself going to a zoo too often, it's because you belong in a zoo in the first place; you're at home there. We never go to strange places. Maybe the fare is expensive, and so, after some kind of expensive travel, we think we're in exotic country. But, if we

* Reprinted from *Aperture*, 16, no. 2 (1971).

are somewhat comfortable there, it's because we took a chunk of ourselves and found something of ourselves again. There is nothing at all to *East shall never meet West.* The world is not a world of cleavages at all; the world is a world of bonds. Circulation of the blood is always circumnavigation of the world. We do not have it in our guts to misplace ourselves in such a way that we are uncomfortable where we go. This, from a photographer's standpoint, is a tremendously important clue. I know now (and I should have known earlier) that we are completely incapable of ever seeing anything. Consequently, we would never photograph anything unless we have become attentive to it because we carry a great chunk of it within ourselves. As we go around, whether we are painters or whether we are concerned with something we are only paying attention to, those things which already have busied us, occupied us, or, better still, are so much a part of us that we lean into another situation which is already ourselves.

How does growth take place? How does the so-called *new thing* happen? Perhaps it is just like a biological chain. A cat has kittens, and then more kittens, and more kittens. And there is nobody to tell us that kittens do not change and that cats aren't occasionally different. So a little mutation takes place. But cats do not become dogs; apples are not oranges. You never find out anything about logic as long as you are adding up apples and oranges. So it's kinship; it's where we can go and find things that make us somewhat comfortable. Perhaps we walk around with a camera. We find something that we want to photograph. We have photographed something of that already, we may have already lived that kind of feeling; and what we are really doing is intensifying that feeling and carrying it further. What then are we doing? We go on an excursion; we are not looking for the new, the different, the exotic. When we talk in those terms, we are only propagandizing ourselves. Growth is only modification; it is not change. It is important to make that distinction.

So, we are trying to reinforce our moods. We underwrite feelings in other people and in other conditions which are congenial to us. You don't ever see anything that is not already something of you. Although, how you go about this, the techniques of this, may vary with people.

How do you do something? How do you get involved in something? The answer is that you don't get involved with something in which you

are not already involved. What appears to be a new exciting condition you recognize as such because it is alive to you already and a great part of you. You find a chance to let your feelings grow and enrich themselves in this new condition; you're basking in a new country. But you bask in this new country because you are already there. This is to the taste of your taste buds. This is something that is congenial to you. We live in a world of sense perception. More and more every day we know this; we're beginning to respect our own feelings and to respect the possibility of extending our own feelings. As photographers, of course, we use photography as a tool to implement, and perhaps to lock and bring to a stabilized condition, an image. The image that we make is hopefully some transformation, some extension of an image within us and an image that we find. Images are not about thoughts; images are always about images.

It seems that the world breaks into two facets: one of them is thinking about thinking, the other is images about images. The world of art and the world of science deal with images about images, while the world of metaphysics and the world of religion deal very much with thinking about thinking. Thinking about thinking can get so watered down, and the confusion can be so tremendous that I don't have to paint the picture for you. Some of the things that you are living through now, that you are reacting against, are the result of metaphysics, theology, and all other ways of avoiding dealing directly in images.

People use the word *image* very loosely; it's been very handy for all kinds of people who use persuasion in one form or another. But, that's not what I mean by image. By image I mean display, display in the finest sense. Display is position. A mathematical formula makes the finest use of position. Musical scores, in their own way, make very fine display of position. It is the logic of position that is the strength of symbolic logic. The strength of a musical score rests more in the logic of position than in its burden of musical idea. We are talking about graphics: images about images are truly display and position is truly inventiveness in display.

If we had to deprive ourselves of the feeling that we have the support of vision, we would really feel lost. Many of the things that we think about seem to be laid out in our minds. This relationship of things to each other positionally is king in logic, and is something that is comparatively new

because the world of thinking about thinking is not really geared to handle it.

The world of art and the world of science are interested in evidence and verification. They do not live off hearsay. You never see artists really; you see only art . . . if you see anything. Nature itself respects only evidence; nature is a continuation of evidence; offspring are a continuation of evidence. It is interrelationships of many chains that make for the powerful, alive abundance of nature. In this tremendous overlay of many pursuits, many activities are served. So then, we have art; we come to a meeting of this sort because we are interested in art. But I want to allay the fears of any of you who, for various reasons, may not feel too friendly towards science. The important thing to consider is that art knows that it is much less interested in good intentions than it is interested in evidence. What are the young saying today to the social order? The young are saying today: "Show us evidence! Don't tell us about your good intentions! Don't tell us about what we should do! We see only what you are. We see not what you tell us you are. We are not interested in theories. We are interested in facts. Facts are not dead objects; facts are interrelationships of interrelationships endlessly carried down to their consequences." It is this long involvement with our senses that has to be honored.

I am not against metaphysics; I am not against religion; I am not against theology, but in terms of our society, our structure today, these things have become inadequate to deal with our concerns. If you serve images beautifully, you are living an aesthetic path of things. *Aesthetics* is only the Greek word for sense perception. So there is no real mystery; do not be afraid of the word *aesthetics*. It is what you feel; sense perception is interested in what you feel. At this point we could say that science is also interested in feeling. If I think of any shortcomings of science, I would tend often to find them on the side of technology. Not because I don't like beautiful gadgets; I buy the best cameras if I can afford them, and generally speaking, I do this with most things. I look at science as a feelingly pursued hunt for the extension of sense perception, perhaps in a way formulated to serve validity and verification in a broader sense. I do not see any fundamental difference between art and science. They are both serving our feelings, they are interested in respect for reality, and they are heavily weighed (I almost heard myself say heavenly weighed) on the side of sense perception.

But now we also know that the world has been very heavily loaded in terms of thinking about thinking. Am I saying that we are going to get along without it? No. But thinking about thinking is only a tool kit. You can either separate two elements with a tool kit, or you can bond them with a tool kit. And, in that sense, thinking about thinking is marvelous to have around; to be a handyman in thinking about thinking is not to be despised. But it is not the *thing* itself. It is only a means, though not an unimportant one, in the hands of a great philosopher. We know of very few individuals in the history of humanity who have used thinking about thinking beautifully. If we want to do it reasonably well, we will have to limit ourselves and know that we are using thinking about thinking only as a means to cement images, without the flourishes of metaphysics. The life that we are living, the thing that we are serving, is images, where the phenomenon of position is terribly important as display of structure. You cannot change the strength or disturb positional relationships in works of art or in scientific formulations. In many things involving precision you can say, "I am going to have something else in this place; I'm going to change the value of the thing." But you cannot change the position under a certain given tenseness of relationships.

Years ago I got into making musical scores by very devious back doors, since I knew nothing about music. Musicians who kindly, and sometimes not so kindly, tried to play them would say to me, "But you did not clearly indicate what should happen here." For quite a while I tried to be accommodating and I thought to myself, "It would probably be helpful to them if I were clearer about what should happen here." But, after a while, it was the very fact that I was not in a position to be clear about what should happen here that led to the real breakthrough! That clarified to me the distinction between where a thing happens and what happens there.

More and more things in science, many more things in daily life, the arts, your attitude towards things are being graphically displayed. The empathy is not to the sheet of paper; it is not to the act of doing. If it is to the spiritedness or to the dignity of the thing, it is because the empathy is to position. This is the function of position. Mathematics is full of it. When Archimedes got interested in levers and fulcrums, he was laying down some of the first foundations for the wider knowledge of these things. It is interesting that we forget that science is, in mathematical constructions and related areas, a latecomer to the awareness of the

power of position. And where do you suppose the home was for that kind of thing? Naturally, in the arts. The arts never knew that they were practicing science long before they became art. Science and art are one; nature and art are one. In what way are they one? They are twin conditions. They are images of images. They are somehow at times tenuously related; and if we were to trace down these links, we would have to make good use of thinking about thinking.

Let's go back to Archimedes. What was he doing with a lever? What is implied? If you have a fulcrum, you have a position somewhere. The position could be on a sheet of paper, or the position could be a relationship of concepts. If you see a fat man sitting close to the fulcrum of a teeter-totter, you'll see a little boy, somewhere way out, having to be way out on the other side of the beam to hold his own. So relationships of masses and distances are the clues to many, many things. Should the fat man move from the fulcrum, you will see that the little boy will have to hustle to maintain his balance so that the beam will again equal the horizontal or the level of water. I don't want to give anyone the impression that I'm obsessed with science. I'm obsessed with the power of position, and the power of position is everywhere. Newton was very interested in certain relationships that turned out to be key concepts in mathematical physics. They were questions that, in another way, are very beautifully stated mathematical concepts about action at a distance. All of us know that some very small planets move at the extreme limits of larger interrelated sets of orbits. So, if you are very small, you will have to move away from a great influence or be pulled into it and disappear. If something is too influential, it will gobble us up in a lifetime, or it can happen in a flash. We can get gobbled up by ideas that are too big, and ours will disappear within them. I may be straining the concept of position. I'm beginning to play with thinking about thinking; I'm being funny. Forgive me. Thinking about thinking is a tool, but it is not the thing that we are serving. We are serving structure, and structure comes to us and is understandable to us only as position.

Why did I get into all of this? Why this complicated state of affairs? Just because of photography? I think that if I had simply stayed within painting, or a few other related things, perhaps I would have understood

other things a bit better; but I don't think that I would have gotten as involved with, and been as flattened by, these ideas, or so overcome by their importance. We were considering a while back that science and art are interested, not in ideas, but in evidence. They deal with evidence by way of position in a harmonious flow of linkages of images to images. You go out with a camera and partially find yourself saying yes to something that you see, so you set up your camera. When one starts, there are always notions of great originality. I hope I have forgotten much of that. We are always infected by this idea. But that's not as important as to beautifully serve the things for which we really have feelings. At first, maybe for years, there is a notion that you're going to select some particular something as a privileged condition. You're going to think, that evening when you come home and develop this thing, that you really did see it beautifully. Maybe you don't quite say it; you don't beat yourself quite that hard, but you are pleased in a cunning kind of way. You came away with some of the cream. Well, you'd better bet that nothing of the kind happens. You are utterly at the mercy of that camera. After some years, you no longer ask it to do anything. You are glad that you bought yourself a decent lens, and that the sensitized surfaces serve projection nicely, so that eventually some of this, or most of it, is well stated. But what do you get then? Suppose that you do this as I say; you really get a reasonably one-to-one image of an image. The blessing of the whole thing is that the damned photographic processes aren't that good, and the seeing isn't that good, and everything is wrong somewhere. And it's that discrepancy that, in spite of everything, becomes the work of art. That is why I, feeling this way about the hopelessness of perfection, still buy the best equipment. Because when the best equipment fails, it fails a little bit less. I like better lenses than poorer ones. If you're going to go to the store and buy paints, buy the best ones. If you're not going to go to the store and buy paints, use shoe polish. I accept that too. But, whatever I do with any intention of coherence, I do in the hope that, as I take a loss at every move, additive discrepancies which perpetuate themselves will not wipe me out. But let me not diverge too much. What I'm saying is that I've come to value photography not as a moment of truth, but as truth before the fact. You don't have to wait for the steer to die. There isn't anything that you can do about taking a good photograph; you can't get into the act and say, "I

don't want this shape to be this way." You have to accept an involved set of circumstances. And this involved set of circumstances is extraordinary and great for the simple reason that you don't understand it. If you understood it truly, you wouldn't care to do it; you would know that you were through with it. So we do whatever we do (and we're talking about photography) by the means available to us, which are means we cannot interfere with. We have to accept the consequences of what the camera presents; we have to learn to deal with it properly. We have to print it reasonably well. There may be fads; you may want to print the thing this way or that way. These are maneuvers to try to evade the fact that there is not much difference between them.

Then, you might ask, is it legitimate ever to arrange something? Yes. Suppose that you have arranged something; you then have to work with the consequences of what you have done. Why would you prefer to arrange things in a certain way? Because the positions that would be the underpinning of your new state of affairs would be the ones that you would care to serve. But the problems arise when you have not accepted the consequences of what you have already done. Perhaps this is best seen in apprenticeship, which all of us know is the real way of learning. What is the nature of the problem? It is that you learn not from what anyone tells you; you learn in the presence of other people's living. If we use the big word and say that a man is a master of something and that you are serving an apprenticeship with him, you are learning only one thing: the attitude that he has toward his task. This is image as environmental learning. It is not set up by a committee which says that it is more valuable to teach young people or old people this or that. In the presence of facts, in the presence of things that you are tangled with, you simply respect their condition. There is nothing wrong with photographing any set of things; but once you have made a collection, you have to respect evidence as the final thing that is seen. When evidence is evidence, it is dignity.

In working very carefully, we have to accept discrepancies in linkages. If there were such a thing as perfection in this world, there would be a true and eternal one-to-one relationship. And this eternal one-to-one relationship would be that evil exactly equals good. We are not in a position to come down to that yet. We can never focus on an image and say, "Well, it's probably sharp." What do we really know? We lose a little bit

here and we gain a little bit there, and we have to be lucky that some loss here is compensated by a fortunate gain there. So it's a balance of things. There is a variation in the next thing; the kitten is not exactly like the cat. So everything is gradually changing. It may be that the miracle of a work of art, if any, exists in the fact that a little bit of change is suggested in a comparatively short span of time, which, in a biological state of affairs, would mean aeons. Maybe the reason that we are interested in art is that it gives us the great sense of the aliveness of change, growth, development, revelation; all these things in half an hour. Maybe the only trouble with our times is that people have been trying to reduce the half hour to a half minute.

Why have I given so much of my concerns to photography? I want to make a distinction: I don't just do photography as one of the things that I do, like painting or drawing, or this or that. I have seen more and more the reasons why I have been using photography as a funnel to a final condition. I say *final* in a tentative way. I'm interested in sensitized surfaces. In an age where sense perception is the thing that is either making us all or killing us all, we are obsessed with it in one way or another.

We favor situations and relationships that enable us, through sensitized conditions, to play on ourselves as instruments. Since we are involved in many ways in instrumentation, why not carry this instrumentation onto the final surface? Of course, in our case, that is the photographic surface. All of you know how many sensitized processes are in use today, and apparently there is no end to what their application will be. It is with sensitized surfaces, rather than with photography itself, that I am concerned. The sensitized surface has an honesty, an inevitableness; it just can't do anything else. It shows you what some process showed to it. We are building bridges. It is almost like kinship.

The lesson in back of all this for me has been that when I am about something, when I am doing it, when I'm in the midst of it, I don't even know that I'm getting anywhere, because that is of no consequence. You've got to do *something* during the day! So, more and more, since I want to be relaxed about this involvement, I don't care if these things carry me as though I were a cripple. It doesn't mean, of course, that to do justice to these very wonderful processes, one doesn't have to be somewhat precise. But that is easy enough to come by, if you don't spend many years saying to yourself every morning, "I've got to do less well today

than I did yesterday. I want to do less well than I can do. I want to give less for more." These are things that you recognize as part of the scene, and empires have been built on them. That's not the kind of empire I'm obsessed with. I think that the day I was born, I was born lucky; I was born lazy. When you think how fast a plane takes you these days, what is the sense of rushing from one chair to another? It doesn't make any difference what you do, the important thing is that you give consent to what you are doing.

Since I've been singing the praises of photography, obviously as being a better state of affairs, I am really telling you that sensitized surfaces can't do wrong. To make a drawing you have to whip yourself up to a frenzy to get started at all. And you have to do this even if you are going to make a bad drawing. But with a camera, if you are not careful, you might just have it focused properly. You press a button and you're bound to get somewhere with it, unless your meter was terribly wrong. So I have over the years begun to feel that the so-called more *personal* ways of imposing oneself upon one's own feelings are not less good; they are just harder, they take a hell of a lot more out of you. You paint. You stretch a big canvas. You make a few moves. You say, "Aw gee, it's not really all it should be." You can, in a way, kill yourself over it. What I like about photography is that it is episodic. Bang! Bang! Bang! There is nothing wrong with this as long as you don't go on clicking! The important point is that it is congenial to me to work with something that keeps track of itself. I don't have to look at an image; I know that an image makes another good image. Nature is out there; the camera is in between. If you're just a midwife, this thing comes about. It is less the *I*. I find that photography is terribly rewarding because I realize that I am mostly the bystander in practicing art. What I am really getting into is the world of aesthetics, and aesthetics is the generalized condition of art. Art is the condition that you and I bring about. If we are artists and make a few good moves, maybe this is art. But we cannot make aesthetics. Here is the peculiar phenomenon: these deadly machines, which everyone knows have no feeling, can be feelingly taken into our concerns. So I've been impressed with the real asset, with the real advantage, and with the real comfort that comes with simply accepting that certain processes work for me. And they work for me best when I quit masterminding them.

The thing to do is no longer to hope that things will obey; nothing will

ever obey. My commitment to this point of view has had me naturally concerned with how I could transfer a little bit of this ease, this natural-ness of doing things, to the guy to whom this might be happening. And so I've tried not to give up painting, not to give up drawing, not to give up making musical scores. I've tried to figure out a way in which all of these things could be a stage to becoming a photograph. And at every one of these stages I would not be making that which would be the thing seen. So, I still practice painting and drawing, and some of these things get seen sometimes; but that isn't the point. I'll give you a cross section of linkages. I prefer now, when I make a drawing, to take a piece of aluminum foil; I lay this foil down and make a drawing on it. And in making quite a few of them, I get some of this need for making drawings out of my blood. But then I have a few pieces of aluminum foil that may have some handsome little drawings on them. And so the next move (since I'm not going to show them—they're too fragile) is to take some of these foils and smoke them over a candle. Having deposited soot on the foil, the next step is to grease, very lightly, with a roller, a piece of glass. And once I have done this, and have a trace of grease on it, it becomes easy to take the soot that is on the aluminum foil and press it onto the glass with a piece of cotton, or with a probe of some kind. When I have done this, freely and quite with dispatch, I put this thing aside to look at as it is. Later I can go into the darkroom, put it into an enlarger; and I will have a *negative*. If all goes well (and sometimes it does), the definition is magnificent; there are no grain problems because soot can outperform silver images any day. There is a whole series of things, you see. This is a short chain, in a way. Suppose that I got tired of making drawings on foil. Suppose that I take a big sheet of paper, and the paper comes off a roll. It's a wrapping paper and it has a curl in it. So I lay it down on a board and very freely, with a knife, make a very sensitive-looking drawing. This makes a beautiful line, with a flow, with a precision, with a quality that you would not suspect. I lift this thing up and hang it on a couple of clips, and being a well-organ-ized guy as I am at times, I have a camera already standing there. I find myself photographing this sheet which, by then, has all sorts of paper coming out of it. It is natural to photograph it in diffused light, but at times I can implement this by adding some side light and give people the notion that I am also interested in drama. But in any case, I do it for my own feelings.

I should like, at this point, to convey to you that I am more and more, at every stage, not making the product which is admirable for its representing that stage. Once a photograph is made, there are many things that can be done with it. But, generally speaking, I am at all times very much under the impression, without being overawed by it, that I accept what happens. I don't say to myself, "I wish this had not happened." If I am uninterested in the totality of the thing as it lies there, I leave it alone. I make hundreds of drawings; I can afford to throw some away. In fact, I throw most of what I make away. I do it without willfulness and not by saying, "This is better than that and therefore I like only this." I see some things more quickly, and I haven't got time to do all of them. I don't want to store them, so they disappear. I hope I am presenting all of this in terms of involvement with something that isn't arbitrary. Arbitrariness is really a key thing because there is nothing in art that is arbitrary, as there is nothing in science that is arbitrary. If you say that something is arbitrary, that something happens in a work of art that is arbitrary, you are really saying that credibility has been strained; fiction has been overworked. We are not comfortable if we are cultivating arbitrariness and exception. Which reminds me of what my unfortunate position was years ago. Many people were saying, "Must you do this?" So I have, for a few years, suffered under that. I saw eventually that it was really a good thing. It was a clue to what was involved; that credibility does not like to be strained. And I know now, of course, that I didn't really strain people's credibility too much, they just weren't flexible. That's another thing.

The responsibility to an image is to follow through, and to some degree to underwrite, those moves which are the first parts of the commitment. That doesn't mean that we cannot mix all kinds of things. But suppose that you have mixed some things; you haven't really worked up any confusion if these things have some sense of wanting to work together. The very fact that one is concerned with this notion of things wanting to work together implies, already, that the initial premises are far apart. Otherwise you wouldn't say *together*. It takes strength both to observe the innate things that naturally have to be respected within a procedure and to imaginatively graft on a few departures. If a thing is just one-to-one observance, it could be drab, but to the degree that departure does take place, fully respecting conditions, dignity of means is its cohesion.

If we can feel that whatever finally happens was not done at the expense of the thing photographed, we are OK. But many things, not only in the arts, not only in photography, in many walks of life, get us rudely tangled with the awareness that one thing has been done at the expense of another. Something was skinned to the bone; something was absconded with.

I'm a lazy guy, so the next time I work it would be better to do something else. I will go back to a negative if it still holds fascination. If somebody was seriously considering acquiring a print, I might think about it, but I am certainly not going to make a print just to store away; that's the distinction. Sometimes I have two or three prints of one thing. It may be that the first or second time I try to make a decent print, I'm lucky to get two or three that are acceptable. What I mean by acceptable is that I will accept prints that look different if in their differences they may be serving some other aspects of their possibilities. I have ceased thinking that all prints from the same negative should look alike. I find that the alive creators of images in the past, like Rembrandt and others, had no qualms about making prints that could hardly be recognized as having been made from the same plate. I haven't pushed my things to that length because when a photograph is underprinted too much, it looks like hell; when a photograph is overprinted too much, it looks like hell. Drawing paper, without anything on it, is more to look at than an empty spot on a piece of photographic paper; the very black ink of a fine etching, which is nothing but soot, is a richer thing than the black in a photograph. So there are some innate limitations. But, apart from that, I tend to favor variety between prints if this also favors a wider range of possibilities. Beautiful variations between prints are assets, not discrepancies. But suppose someone has seen a print of a certain thing and has gotten excited about that print being a certain way (it's amazing how retentive people are about characteristics they have admired), if he should see a print that is just a little different, he might feel like hell. So, for the sake of human relations, if a person sees a certain print, I make sure, if possible, that he gets the print that he saw.

All of us are collectors. We are not only collectors of prints or drawings, we are really collectors of comfortable, interesting moments. You

buy something, you want to surround yourself with something, just because it extends a set of feelings, an involvement, which perhaps you had on first viewing that condition. Is it at all possible, then, to hold on to something like that? No. You really can't hold on to a thing in that sense, but you have the initial stage, to some degree, locked. You have a print in your own collection, or know where it is and can go to see it. Those of us who go out and look at paintings are not really going out for the possession of those conditons. If we are alive, we saturate ourselves within states of affairs that we can underscore. We are putting ourselves in the mood of things and mood is everything. Given certain moods, we can put up with almost anything; and, if we can put up with anything, it means that we are in a creative state of mind. This is strange because a lot of people worry about interrupting and breaking their moods. I think that only conflict, only confusion, is ultimately the great creator. Though we are living through a long moment of conflict and confusion, these are yet very creative times. It is going to take some perspective to let us see, in time, just what is happening. But you can be sure that something is happening. The days of cost accounting, guilt about guilt, the hoarding of guilt, the hoarding of guilt as value are numbered. What's the difference between the guy who hoards guilt and a miser? These things will not come to the absolute end of their days; but there will be less and less of them, because more and more there is feeling about feeling. And when I say feeling about feeling, I am again saying images about images.

What I've really been emphasizing is how sensitive we are, and how we sell ourselves with the rightness of certain things. We like something, and then we begin to think that this represents a state of finality. This finality is fiction. Shall I support what I find in life, or shall I take exception? Shall I become *creative* and say, "I only like this, I don't like that?" You know you could go to the world's greatest banquet, a feast for gourmets, and have a miserable night if you were going to be a specialist about liking this or not liking that. Each thing that you would eat would interfere with the next thing.

You go out. You see a state of affairs. This state of affairs is an interrelationship. It's truly embedded in its situation there. Nowadays people think of these things as being environmental, but so many people have operated as if they wanted to unseat this thing, this condition, from where

it occurs. And they have mistakenly called this *working selectively*. If you do that, you haven't selected anything! I have no idea of what is more valuable than anything else. In total acceptance, almost everything becomes a revelation.

I might want to go into the country. I won't see beautiful walls as Aaron Siskind sees beautiful walls, but I might see beautiful trees. I'm going to see interrelationships that are peculiar to that area and to that situation. But notice what people will do when they specialize at certain kinds of environments or states of affairs. They will go somewhere else; and, if they find something there that was very much like where they came from, they make sure to peel it out of that conditon.

I could take a cow and implant a camera in it and let it amble around in the city or in its own domain (I say a cow because a human being I would not trust). If the camera was programmed to go off at an indeterminate series of moments, the samplings would be fantastic.

We're not so damned inspired every day! If we rely on what we meet, some inspiration will arise. As an example, if I go into a grocery store, no matter how beautifully stocked or lush it is in terms of display of fruit and edibles of all kinds, if I am smart I will take home what is best that day. I will not say that I want to buy apples today or that I want to buy oranges today. In planning a meal, I plan from all the things I find there. I don't have a list with me even if planning a banquet (something I seldom do, believe me); but nevertheless, I practice this every time I go into a grocery store. I buy the best of what there is that day. If the beef looks good, I'm not going to buy lamb. I buy the best of the beef; if the best of the beef is expensive, I buy less of it. I buy it carefully, so you can be sure I get a hell of a lot for my money; I always do. The store may have the kind of thing that you think you want that day. You are looking for pears. There may be pears, but those pears may not be at their best. Confusion is very enriching if you don't try to unravel it. It is unraveled confusion if you impose yourself upon what is available and come back with bad meat and bad fruit. You take the thing that is *really* there, and gradually build from it. You build your meal, your banquet; it's always a banquet when a few things are beautifully related.

The point of this is: if you work this way, if you live this way, if you just exist this way, you will find that by some strange coincidence (which I

now know is not so strange) you will have brought together a number of things which make a magnificent meal. You consume this thing with champagne if you can afford it, and if not, you consume it just with enthusiasm.

Jerry Uelsmann

Jerry Uelsmann (1934–) challenges the aesthetic of straight photography. In his photographs, writings, and teaching Uelsmann advocates the use of various techniques. His intention is to grant the photographer whatever means necessary to extend our visual imagination. Like his teacher Minor White, Uelsmann develops photography as a symbolic language of feelings and ideas. In his photographs, he delightfully exploits multiple-print techniques to create images of humor and fantasy. His books include Jerry N. Uelsmann: Silver Meditations *(1975), edited by Liliane DeCock and* The Persistence of Vision *(1968), edited by Nathan Lyons.*

In this essay Uelsmann encourages photographers to manipulate the negative, to experiment with various darkroom techniques—post-visualisation. For Uelsmann the photographer creates an image by working before and after the actual picture-taking. His argument is based on the belief that technique is an instrument subordinate to artistic expression.

Edward Weston, in his efforts to find a language suitable and indigenous to his own life and time, developed a method of working which, today, we refer to as "pre-visualisation." Weston, in his daybooks, writes: "the finished print is pre-visioned complete in every detail of texture, movement, proportion, before exposure—the shutter's release automatically and finally fixes my conception, allowing no after manipulation." It is Weston the master craftsman not Weston the visionary that performs the darkroom ritual. The distinctively different "documentary" approach exemplified by the work of Walker Evans and the "decisive moment" approach of Henri Cartier-Bresson have in common with Weston's approach their emphasis on the discipline of seeing and their acceptance of a prescribed darkroom ritual. These established, perhaps classic, traditions are now an important part of the photographic heritage that we all share.

For the moment let us consider experimentation in photography. Al-

* Reprinted from *Creative Camera* (June 1969).

though I do not pretend to be a historian, it appears to me that there have been three major waves of open experimentation in photography; the first following the public announcement of the daguerreotype process in 1839; the second right after the turn of the century under the general guidance of Alfred Stieglitz and the loosely knit Photo-Secession group; and the third in the late 1920s and 1930s under the influence of Moholy-Nagy and the Bauhaus. In each instance there was an initial outburst of enthusiasm, excitement, and aliveness. The medium was viewed as something new and fresh, possibilities were explored and unanticipated directions were taken. Unfortunately, these initial creative outbursts were not sustained. As certain forms of experimentation met with tentative success, formulas developed which in turn discouraged the constant revitalising of thinking necessary for the experimentation to continue along fresh paths. Perhaps the comforting security of a formulised approach will always cause experimentation in photography to follow this cycle.

It is interesting to note that much of the experimental photography that we revere today has been done by individuals whose commitment to photography is but one aspect of their commitment to art. This seems to be true for such workers with the medium as Alfred Stieglitz, Edward Steichen, Man Ray, Moholy-Nagy, and Frederick Sommer. It is of further interest to note that with the possible exception of Alfred Stieglitz, who championed all art with his words and deeds, these gentlemen are multimedia artists. In addition to photography, they are concerned with painting, design, graphics, and sculpture. Perhaps it is because they are accustomed to the creative freedom encouraged in these other areas that they have intuitively challenged the boundaries of photography.

Since the turn of the century, all other areas of art have undergone a thorough reinvestigation of their means. The contemporary artist, in all other areas, is no longer restricted to the traditional use of his materials or to the exclusive use of traditional materials. In addition, he is not bound to a fully conceived, pre-visioned end. His mind is kept alert to in-process discovery and a working *rapport* is established between the artist and his creation. Today the work of art has become a more complete and involved extension of the artist.

Our predilection for the straight photograph is perhaps a natural one. Certainly pre-visualisation with a prescribed darkroom ritual is the most

widely practised approach in photography today. The popular expression "taking a picture" implies this approach. I do not wish to minimise the importance placed on the act of seeing which this approach requires. I do, however, feel that the general attitude of unquestioning acceptance of a prescribed darkroom ritual, which this approach requires, has kept us from important visual discoveries and insights. While it may be true, as Nathan Lyons has stated, that "the eye and the camera see more than the mind knows," is it not also conceivable that the mind knows more than the eye and the camera see? Cannot the mind, when introduced to the possibilities of in-process discovery, stretch the boundaries of the preconceived image? George D. Stoddard, Chancellor of New York University, in his essay "Art as the Measure of Man," states:

> We should not over emphasise the technique of vision. We cannot think with our eyes, and we may think without them. Vision brings in the data, the raw materials, and the cues that guide our steps. The eye is an invaluable sense organ, a true part of the brain through its optic nerve, but the frontal lobes preside over the problems created and they are not to be denied. The artist is a man seeing and thinking—both at once; his cunning is in his brain.

It seems to me that for the most part young photographers are encouraged to use their minds and eyes for the purpose of making important aesthetic and technical decisions only at the beginning and end of the photographic ritual. With the squeezing of the shutter, the creative consciousness is put to rest, only to be resurrected when the finished print is ready to make its debut. That many photographers avoid the darkroom as much as possible may perhaps be due in part to the fact that the mind is relegated to basic technical decisions. Some are even hostile towards it. Walker Evans has said: "Cameras . . . are cold machinery, developing chemicals smell bad and the darkroom is torture." An indifferent attitude toward the darkroom is further reflected by the fact that many distinguished photographers do not do their own processing and printing. I should like to encourage more young photographers to get off the streets and back into the darkroom. It is my conviction that the darkroom is capable of being, in the truest sense, a visual research lab; a place for discovery, observation, and meditation. To date, but a few venturesome souls have tentatively explored the darkroom world of the cameraless

image, the negative sandwich, multiple printings, the limited tonal scale, etc. Let us not be afraid to allow for "post-visualisation." By post-visualisation I refer to the willingness on the part of the photographer to revisualise the final image at any point in the entire photographic process. Let us not delude ourselves by the seemingly scientific nature of the darkroom ritual; it has been and always will be a form of alchemy. Our overly precious attitude toward that ritual has tended to conceal from us an innermost world of mystery, enigma, and insight. Once in the darkroom the venturesome mind and spirit should be set free—free to search and hopefully to discover.

The criterion for art is no longer just the visual world. One of the major changes evidenced in modern art is the transition from what was basically an outer-directed art form in the nineteenth century to the inner-directed art of today. The contemporary artist draws upon new levels of consciousness, creating a span of aesthetic that is without precedent. To date, photography has played a minor role in this liberation. We have kept blinkers on our eyes, restricting the potential imaginative freedom that photography is capable' of. Edward Weston, commenting on his own creative freedom, states: "I never try to limit myself by theories. I do not question right or wrong approach when I am interested or amazed—impelled to work. I do not fear logic, I dare to be irrational, or really never consider whether I am or not. This keeps me fluid, open to fresh impulse, free from formulae." He further states: "I would say to any artist—don't be repressed in your work—dare to experiment—consider any urge—if in a new direction all the better."

It is disturbing to discover the number of leading figures in photography today who believe the "decisive moment" or slice-of-life form of photography to be the only natural form, all other approaches being somehow affectations. In this rapidly changing world of ours there is a real need to free the teaching of photography from the long-standing dogmas that tend to restrict rather than encourage growth. The serious photographer today should constantly be seeking new ways of commenting on a world that is newly understood. Constant creativity and innovation are essential to combat visual mediocrity. The photographic educator should appeal to the students of serious photography to chal-

lenge continually both their medium and themselves. The visual vocabulary of the young serious photographer should allow for a technical and imaginative freedom that permits him to encounter our complex transitional world in a multitude of ways. Let the inner needs of the photographer combine with the specifics of any given photographic event to determine for that moment the most applicable approach; be it straight, contrived, experimental, or whatever. Furthermore, let him feel free, at any time during the entire photographic process, to post-visualise.

Duane Michals

Duane Michals (1936–) is enthusiastic about photography's narrative potential. The stories he tells in a series of photographs or "sequences" are no ordinary events. Influenced by the Surrealist painter René Magritte, Michals uses the camera to dramatize the mysteries of his private imaginings. Not committed to recording reality as we normally know it, Michals's compositions contain distorted and superimposed imagery. His books include Sequences *(1970) and* Journey of the Spirit After Death *(1971).*

In this interview Michals advises students to create in their photography their version of reality. Michals's attitude exemplifies the modern photographer's insistence that individuality is what counts in art. For Michals, photography literalizes the perceptions of his inner world.

The following transcript is from a tape recording made by Professor Arnold Gassan of Ohio University at The Museum of Modern Art in New York City in October 1969. The dialogue took place between Professor Gassan, his students, and the photographer Duane Michals.

MICHALS: If you haven't any experience in photography, as far as I'm concerned, what is important is that it happens out of your own experiences. And, unless you're some kind of a bloody genius, you know, you wouldn't be here [as a student]. You know what I mean (*laughter*). So it just takes a lot of living before you have something to do with your photographs, other than photographing water with petals and things like that. There's a great deal to be said for getting older (*laughter*). So don't worry about anything, just let everything happen to you; I mean, all the good and bad things. But use everything that happens to you—every single thing, even if you don't know today what you're going to do with it. It may come out five years from now. So nothing is lost, and just be very patient, but let everything happen to you.

Anyway, the series are my big concern, a thing that I'm most involved

* Reprinted from *Image* (January 1971).

in. Again, I wouldn't have conceived of these five years ago. Five years ago I would have done something else and five years before that I wouldn't have conceived of that. So like five years from now you all may be doing something that you can't even imagine—something beyond your wildest dreams. So again, you know, just keep yourself completely open and try everything. You know; make lots of mistakes.

A lot of young people come by . . . well not a lot, maybe once a month somebody calls me up, some student wants to come over. And the trouble is that I don't see any mistakes; I don't see any outrageous mistakes. I see very nice photographs in a number of predictable styles but I don't see somebody doing something really way out, and ridiculous and done "all wrong." At least then you feel that there's a mind operating, you know, and maybe wrong now but next year it may be right. So don't be afraid to do ridiculous things; and, try anything that comes to your mind.

All these series things I'm doing—I don't even know what they're all about, they just occur to me. And because they occur to me that's about enough reason for me to try to do something with it. And sometimes I look back on something I did two years ago and I see something in it I never had thought of, or something that seems very simple ends up more complicated than I realized. So there's a whole thing in your mind going on that you're not aware of. But let it happen to you; don't be uptight about anything; just be very loose.

Anyway, I've done about twenty of these at this point. They're all done on various subjects of things that have occurred to me or ideas that have moved me; I don't know why I'm always pleased when people respond to them because that means that out of my, you know, personal thing somebody is also grooving in that same direction. Anyway, I've also taken to titling them, which a lot of photographers are very much against, and I have been too, but the reason I titled them is because I have a very specific idea in mind. I don't care if anyone else digs that idea, that's their business; whatever you get is your own business. But, I wanted you to know what my idea was.

I don't know the best way to do this . . . Tell you what, I'll put them around the table and you can all walk by and look at them. And try not to take the whole thing in at one glance. The titles are on the top of them.

They're all very specifically worked out; there's very little action, but generally you would just . . .

GASSAN: Matter of fact you're functioning more as a director than a photographer.

MICHALS: Yes, you're essentially taking the picture, but a great deal of "making people perform for you" becomes involved.

GASSAN: I mean you're working as a director's cameraman, almost with a stand camera.

MICHALS: People always ask if I'm interested in making movies, and I'm not at all. I consider this kind of thing as still photography. I mean like I couldn't do this in a movie, like this is really . . . I think is more haiku where in an instant you suggest something happening between two people. To expand it to ten minutes would destroy it. This is really all it is, you know, I won't make any more out of it.

And I don't do it in single images because . . . this device permits me to show an idea fuller than, more fully than if I would do it in one image. If I could do it in one image or fewer pictures, I would do it in fewer pictures.

GASSAN: You have more control over this than you would . . .

MICHALS: More nuance in terms of—but I like the idea that, you know, it's very sparse, down to this (you know), like the minimum number of photographs suggests the idea (*tape unclear*).

GASSAN: Do you mount them all together, on one board, when you show them?

MICHALS: Well I had a show last year and they were mounted like in a storyboard one after another. But I won't do that anymore because . . . I like it better to see one picture, than to have space and see the other picture. Because, your eye tends to take in the whole thing at once and zoom to the last one. Doubleday is doing the book on them and there will be one picture on each page so that, you know, each . . .[1]

STUDENT: You mean the show was like the *Camera* presentation where you . . . ?

MICHALS: Yes. I won't do that ever again. Except it's such a drag to mount these, to organize for a show. It's just . . . I'm very lazy and the whole idea of printing all these things . . .

[1] Duane Michals, *Sequences* (New York: Doubleday Projection Books, 1970).

STUDENT: Would you print it on one piece of paper or would you print the sequence as separate images?

MICHALS: Well, now they will be separately shown. They're all separate images. But I usually run people through these two or three times and then piece them together, you know, like the fourth one here. The person understands then what I'm talking about, but at first it's very difficult to tell somebody what I want to do.

GASSAN: Have you ever tried to do like Peter Kubelka, the filmmaker? Which is to print the films twice, then show them twice in an exhibit, so the person has to go through it and view them twice.

MICHALS: No, no. Sounds like a lot of work! Do you have any questions about any of the ideas?

STUDENT: You said each shot was preconceived. The whole thing was, and then you went out and shot it or did you shoot some and then had to go back . . .

MICHALS: "The Kiss" I had to redo twice because the first girl I had was very nervous about it. It was more like a peck on the cheek than an embrace—so I had to dig up another girl. That's the only one I've ever redone. I don't like to redo things. What I like about photography is a certain spontaneity in when you see something and "go" with it; and I don't like to work things over, you know.

I have a number of ideas which I haven't been able to do just because I haven't been able to get the people and . . . the situation. They're sitting in my head but I haven't been able to get them down on film yet. These social landscape photographers up till now operate too much with their eyes. You know, like they've always got things like textures, or fascinated by little psychodramas found on the street, two old ladies gossiping—you know, all those traditional things. I think photographers should work more with their heads.

Photographers should not be 90 percent eyes and 10 percent brain, I think they should be 90 percent brain and 10 percent eyes. And I think that my big complaint is in most photographers today . . . don't know what they're doing. I mean they're so hung up on photographing like Ansel [Adams] or photographing like [Robert] Frank or doing social documenting. I mean you can do Harry Callahans; they just fall into categories; you can just see them. I don't "see" anybody; when you look at a

lot of students work . . . you look at their pictures and you see a lot of them, and they all end up being other people's work, but I don't see the student in them. I mean I don't sense their life in them, like you know I can sense Robert Frank's work and everybody else's, but I don't sense you. I don't. And that's the beautiful thing, to look at somebody's work and know that nobody else in the whole world would have done that particular thing.

Robert Frank's my favorite photographer and I remember the first time I saw *The Americans* . . . it just completely knocked me out. I didn't take photographs then and he impressed on my mind such fantastic poetry that although I don't work like him at all I still remember the tremendous impact he made on me. Nobody else would have done that, or like Diane Arbus, the same way, it's just a fantastic point of view. The only thing that's different between any of us is ourselves—not the equipment, not the film or the paper—all of that's negligible. What we really have to offer . . . I have to offer myself and you have to offer yourself. What you have to do is find out who you are; or what you have inside of you to offer. And that's really where the beauty is in photography. Not so you make passport pictures of people's faces. I don't care what they look like. I'd much rather see a portrait suggest something about somebody without actually showing what they look like, you know?

STUDENT: But all this . . . thinking . . . about the picture . . . I don't know, it just sort of takes away from it.

MICHALS: Why does it have to be spontaneous? When I say that I meant I like the directness of being able to do . . . I rolled these through the camera in less than an hour, moving very quickly and responding like that. Ah, you see you're operating under the point of view we've been functioning under the last twenty years and that's the Robert Frank, [Henri] Cartier-Bresson point of view. The reality or the truth of the street. "Something really is valid only when you catch the instant that the thing happens in front of your eyes," you know. You get locked under a question of "reality." That's one kind of reality, there, but you know reality is really a fantastic problem. I mean you really get into this with photography. My pictures are as valid, or maybe even more valid, in their contrivedness; they have their own reality. It's two different points of view. But all I'm saying is that people should start considering this point of view as being as valid as the "truth of the street."

STUDENT: I'm sure you're familiar with [Julia Margaret] Cameron, Julia Cameron? (Michals: *Yes*.) We had a discussion in class about her work, and I think your pictures are very much like hers. We have just seen some slides on her in Art History—the first time I'd seen any of her work (and every time I open my mouth I show my ignorance). But to me that's the difference. . . . That is that this is different because you have an idea, a preconceived idea. To me this is good because like if I go out and shoot and I'm looking for one thing, or I have these hundreds of things running through my head, and any one of them will do if I can just capture somewhere this scene. And this will be my expression of it. But I'm a victim of circumstances because I . . .

MICHALS: You have to wait for it to happen.

STUDENT: Yeah, that's right, that's right. Whereas in this difference, the different things like what you're doing here, and I think, are like the work that she did (of course, its own period). But the idea is beautiful to me.

MICHALS: Also photographers are always cast as spectators. They're always walking down the street responding to something they see on the street. They never make things happen themselves. Well, what I'm doing is really creating my own private world and making my own thing happen. I'm not relying on that accidental event. And to me that's a more beautiful direction to go into.

STUDENT: You don't think these photographers walking down the street aren't making things happen? This is something that I've been . . .

MICHALS: Oh yeah, but still, the fact that you were there to respond to something—that's not enough. Also, when you look at it, it all depends on what you want out of your photographs. If you look at a photograph, and you think, "My isn't that a beautiful photograph," and you go on to the next one. Or "Isn't that nice light?," so what! I mean what does it do to you or what's the real value in the long run? What do you walk away from it with? I mean I'd much rather show you a photograph that makes demands on you, that you might become involved in on your own terms or perplexed by. Or I'd much rather suggest something that explains something. I think that, so you see a picturesque picture of a lady standing on a corner with a grumpy face wrapped up in an American flag . . . well, that's an interesting photograph; but two minutes later it's not an interesting photograph. Ah, where are all those private head

images that are all sitting here at the table? You know, everybody's waiting for something outside to happen for them to record. You know, what's going on inside of you? Why are you ignoring yourself?

STUDENT: Let me ask you this. If you feel that way, I am curious as to why you give titles to your pictures? In other words, you understand why I said that because of what you just said? In other words, you said you wanted to suggest not to explain.

MICHALS: Yeah, I'm not explaining. All I'm saying is "The Human Condition," there's nothing more ambiguous than a title like that.

STUDENT: I mean like the "Fallen Angel," I mean to me I could see that in the photograph without too much time.

MICHALS: Well, you see, I'm crossing the line again. A lot of photographers have an automatic response. They break out into a rash the minute you suggest, like you're not pure anymore, or something, when you start doing something like this. Why can't you expand the idea of photography . . . to involve a literary concept? Why do you keep restricting yourself, why don't you open yourself up?

STUDENT: Is it an extension or is it just another crutch?

MICHALS: Well I don't think of it as a crutch. I think of it as a flowing out—an expanding. I don't think of it as a leaning on.

STUDENT: Ultimately it depends on whether it works or not.

MICHALS: Yes, I said they're completely mine. I don't care if anybody pays any attention to them. I'm having the conceit of telling you what I had in mind. Whatever you get out of it's your own business. But ah, it's myself telling myself, telling you about me, my idea.

STUDENT: I'm interested in this series, the one with the movement blurred. And to me . . . a little while ago I didn't like that at all, in any of my photographs. Yet it's so effective as far as producing a sense of time; and I was just trying to imagine though as if they weren't blurred, you know?

MICHALS: I think photographers should use what a camera can do, like a painter uses what the paint can do. I mean cameras can blur, you can double-expose, you can do all sorts of things technically with the camera. People don't use that on purpose, you know what I mean? And I think you should use all the things that people consider as mistakes or the

negative aspects of the camera. I think you should keep yourself open and work with blur—you can do many beautiful things. Outside Ernst Haas, that sort of thing, but using it, not accidentally the way he did. Using it for your own means, to suggest a vague impression of an event. So I think people should use the camera as a machine. I hate cameras myself—I don't really like cameras. I'm not a camera buff; I'm not interested in cameras. I always feel like a writer "hung up" on his typewriter. The camera is just . . . like you should know your camera thoroughly and then you should forget about it completely. And it should not be a thing between you and the person or what you're doing.

GASSAN: What about this thing you said about Ernst Haas? about his use of blur?

MICHALS: Well, when Haas does those beautiful blur things, like at sports events, he can't control what the guy is going to do; he's at the mercy of the event. Whereas, these things here are contrived ideas; I'm controlling each gesture to . . .

GASSAN: To give value to the conscious?

MICHALS: Yes. This is much more conscious than Haas. Haas is the spectator, hoping to catch something . . . because you just can't make the man slow down for you in the middle of a sports event. Where, in this one ("The Kiss"), I had the people run through it a number of times, to control the blur. Sometimes it blurred too much, and sometimes . . . Anyway, what I'm saying is that you should use the camera for all sorts of things. What is it except an instrument? Take double exposure. I first came across double exposures by accident. I was very thrilled by it. Then I did a portrait of Magritte in front of one of his canvases, which I felt was very successful. A conscious use of double exposure.

STUDENT: I can see you sometimes coming out with double exposure and seeing that it is good. But, it's harder to think ahead, and try to think of two images that go together!

MICHALS: Well, of course, that's part of the problem! If it were easier than that, there wouldn't be any problem! You have to work at it. I'm thirty-seven years old. I've been working on these for three years trying to make them work. Before that I was doing documentary things, documenting empty rooms. I like empty rooms very much.

GASSAN: I was thinking about something else in your work: there's a real change in the way you are seeing, a change from your earlier work. That was almost always, formally speaking, totally centered.

MICHALS: I still function that way. Basically I still see things that way. I didn't start taking pictures until I was twenty-six, and went to Russia. I borrowed someone's camera and I didn't know anything about it. Not even what kind of film to take. I borrowed a light meter. Everything. I learned how to say in Russian "may I take your picture?" But I worked out of having been taught to stand there and take a picture. I learned to function that way. And, basically, that's the way I see things. It's using everything that happens to you. I'm more inspired by painters than I am by photographers. Like Magritte and de Chirico, and Balthus.

STUDENT: Why these?

MICHALS: Because they function philosophically in areas I'm interested in. Magritte, for example, deals in mystery, which I am much interested in. As I get older and older, everything makes less and less sense. I'm a kind of walking miracle, for example, and it's really beautiful to know that. I don't know any photographer who does that. Well, [Bill] Brandt. Brandt does that, has that; but not that much. All I'm trying to say is that you must stay very loose, and use yourself. It's almost bad, going to photography school. At first I used to think (never having gone to a photography school), "how great because you're given all these people. You're given Cameron and you are given [Eugène] Atget." Now I think, "how terrible." Because, you are given them too young in your life. You are crowded in with all these images. Sometimes I wish I had never seen a photograph, that I could forget them. Sometimes it's better to try to forget everything you've ever seen, to just do what you've felt like doing. Or not doing anything.

STUDENT: The hard thing young people seem to have to do is to free themselves from the things they've seen, and from what they think they should be doing.

MICHALS: It's harder to do when you are older.

STUDENT: Oh, really? I thought it would be easier.

MICHALS: Once you get in your thirties, most people start solidifying, don't you think? Right now, it's the most beautiful time. Because you can afford to make terrible mistakes.

STUDENT: Can't you afford to later?

MICHALS: You can, but most people don't, they get terribly afraid they are going to get put down. I'm just beginning to open up, myself.

GASSAN: There's two kinds of closing down, too. There's the blocking of the mind, and there's the continuing on the line on which you have begun. . . .

STUDENT: I'm thinking of people of my own age getting narrow.

MICHALS: I hate to hear that. I think of people your age being more open. There goes another illusion!

GASSAN: This is one reason for this class. Because so many of my graduates were closed and tight, but thought they were at the boundaries of what was possible.

MICHALS: The most beautiful thing is to stay as naïve and childlike as possible. It's impossible, of course, because once you become aware of it, you blow it. I think of [Constantin] Brancusi, who was such an incredible personality, who always maintained . . . I think all great artists have this kind of thing about them. It's not something you can instill; it's just there.

STUDENT: It seems to me that if you have someone else's view, you can move faster.

MICHALS: There's nothing wrong with seeing other work. There'll be a time when everyone is making pictures like Atget, or Robert Frank. That's all right, as long as they keep moving! Or, take from it and bring something of their own.

STUDENT: I feel like starting all over again, after seeing all this work.

MICHALS: It's all right to look at other people's work. But take from it whatever you need, but lean on your own intuition.

STUDENT: But you can get so involved in the thinking about the pictures, you never get the pictures made.

MICHALS: I've had that problem. There are a couple of ideas I have, and I've had problems getting the people together, or something hasn't worked out; eventually you begin to think you've made the picture, and you have not even done it yet.

STUDENT: Do you feel a great sense of satisfaction when you have done one of these things?

MICHALS: Enormous. Because I'm learning about myself from what I'm doing, too. I thought I knew myself, but every year I discover more. I am really learning a lot about the things that interest me.

GASSAN: On a mechanical level, I am curious . . . when I see a set of eight prints like this, how much work does it entail?

MICHALS: I can do it in about three of four rolls. Sometimes there's more trouble. Then I go through them and pick out the ones I think work. This one I spent two days printing, and it was a big pain. But, it's not that awful.

STUDENT: What if you didn't know, but that other people were doing it too, and you went on like that, and then found out you were doing the thing that everyone else had done . . . only they had done it better!

MICHALS: We've all done something someone else has done. When you start doing nudes, someone says "oh everyone has done nudes." But I haven't done nudes! Whatever you want to do, you have to do. If you want to do Atget kind of things, fine. But the point is that if someone else did it better . . . so what. That's no reason for you to stop. But, I can be disappointed at nineteen or twenty . . . big deal. It's not important. So be disappointed, and go on from there.

STUDENT: There's a big question in my mind. I think my photographs are shaped by my impressions of other people's photographs, along the lines of what you're saying. In other words, I'm just regurgitating what I've seen. And the question comes up, do I have an art at all, AM I AN ARTIST WITH THE CAMERA?

MICHALS: That's all right. I don't see how you can be—you must be about twenty, twenty-one, or so? how can you know anything at that age? I mean, like Bill Brandt . . . he was in his thirties before he was sure. How can you be sure at that age, how can you know about yourself? How can you be sure you're an artist? I'm not sure I'm an artist. Work, and don't worry about things like that.

STUDENT: Like she said, though, I could be totally wasting my time.

MICHALS: You'll know, if you are still taking the same dumb pictures over and over four years from now, you'll know, and go on to something else.

STUDENT: But isn't that four years wasted?

MICHALS: No, nothing is lost. Everything is used in your life. It's not a problem. We tend to make problems that don't need to be made. I mean, there are enough problems.

STUDENT: Will you talk about your ideas, on what these series mean?

MICHALS: OK. I'm pretty much interested in the idea of death. And the afterdeath. It's not important at your age. But at thirty-seven you are very much aware of life having a beginning and an end. And this thing that you are experiencing. When you are in your twenties, you are immortal. It just doesn't enter your mind that it ends. Unless you are sitting in Viet Nam.

I am very much concerned with the philosophical idea of death. It becomes all very philosophical. But I think we are essentially spiritual creatures, and I think when you die (this is my idea), I think you literally walk away from the body. I think you leave the body like you leave a pair of shoes. So this series results.

A friend of mine was killed a couple of years ago. Murdered. And when someone you see on Wednesday, on Thursday doesn't exist, you know . . . It's not like your grandmother passing away! It makes you realize how fragile you are. So, the "Fallen Angel," for example, has to do with . . . loss. Of something. Profound loss. Virginity, perhaps. Something which causes you to be profoundly changed.

This . . . the "Human Condition" (which comes from a title Magritte used a lot): I wanted to photograph somebody in a very mundane situation, like on the street. And then transport them, and suggest that they were more than somebody filling a hole in the ground.

I don't even know that I even like people anymore, very much. Yet I feel that people are miracles, quite beautiful, and . . . bittersweet. I just wanted to suggest that we are more than we appear to be.

GASSAN: Are you trying to limit the meanings?

MICHALS: No, all I ask is that . . . all I hope is that somebody would get something from it or that you would walk away from it at least remembering it.

STUDENT: Last night I was talking with someone about this sort of problem . . . death. And I said that I thought that this life was sort of preparation for what follows after.

MICHALS: I don't think it's a preparation, I think . . . I'm a big here-and-nower. I mean, I think we are spiritual, but we are also animals, and that we should indulge all our senses; that we should eat a lot and do a lot of everything. We should get a great joy out of being alive; and that means feeling all the "bad" things as well as the "good" things. We

should completely experience ourselves. Whitman comes to mind. He had the right idea. It's not to be worried about the fact that you are not awake? I think it takes . . . I think it's a very exciting prospect.

"The Kiss" I like. I think it's fascinating. I have, as I said, a preoccupation with rooms. And, sometimes you enter a room that you might not have been in for a long time; something very beautiful happened to you in that room. And if you stand there for a moment, it reminds you of that, just for an instant. And that's what "The Kiss" is based on: the memory a room can contain for you.

STUDENT: When we are in school, we are . . . forced into thinking "what's going to be good in the critique."

MICHALS: You have to remember that you're always talking about the pictures from the point of view of being in school. But, you are not going to be in school all your life! And what you think about being an artist, being a serious photographer: it's just there. It'll take care of itself.

Nobody tells me to do these things. I have to do these things, because I have a need to do them, and because they are a natural response. In school you are working in a situation where you are solving problems and . . . learning. School isn't the end; it's such a minor part of your life!

STUDENT: What if your pictures don't work for a lot of people, but you feel really strong about them? I mean, just listening to you, I wonder . . . how do you feel then?

MICHALS: I don't care. I know you'd like to have everyone flip out and whistle when they see your pictures. But if they don't . . . that's OK. Because, to me they work.

STUDENT: You're in a nice position, too, because you are established. I'm a student, and when one is trying to establish oneself . . .

MICHALS: What do you mean, establish?

STUDENT: Ah, discover a more . . . comfortable atmosphere . . . being exposed, and doing work that has brought acclaim.

STUDENT: I don't think that's what you should be striving for!

MICHALS: You can't be concerned about that. You'd like it to be that way. If even my mother doesn't like it, that's pretty bad! But even that has to be faced, and I don't really care. Because, I know, and that's a luxury that only comes with time. It doesn't happen. I didn't involve myself in

photography until I was nearly twenty-nine. So it's eight years. Anyway, it just takes care of itself in time.

GASSAN: One reason I had the seminar read the Castaneda *Teachings of Don Juan* was that he says there are as many ways as there are hearts; and you must find a way that accords with your heart.

MICHALS: You know what you should do, really? You should start working those closest to you, with your own family. When I go home . . . I take pictures all the time. I drag in everyone and they do everything with them. (They won't strip, but that's OK.) But you are at such a beautiful point in your life: anything is possible. Like in ten years from now it'll be 50 percent less possible, and ten years after that . . .

STUDENT: Don't scare us like that!

GASSAN: You put yourself in an interesting position with these pictures. You are at least 50 percent verbal here. Syl Labrot talked once about "as soon as you tie yourself to the word you are making an illustration, and limiting the possibilities of the picture."

MICHALS: I feel that these are illustrations. In *Camera* I said, "I illustrate myself." I think of these as illustrations. There's nothing wrong with that. That's why photographers are always making limits: like it's "not pure" if it didn't happen on the street. And you shouldn't do this, and you shouldn't talk about that. I write about them, but these happen to be very verbal things; they are more complicated pictures than my Aunt Sady looking cute. There are more complicated ideas. We are talking about them because we are in a talking situation. Normally I don't talk about them!

STUDENT: When you say that photographers' supply limitations, don't you also make limitations?

MICHALS: Yes, but these are my own limitations.

GASSAN: You mean, you're not imposing these limitations on other photographers.

MICHALS: I think I'd like to see as many styles of photographs here as there are people sitting in this room. Unfortunately, photography is a very difficult medium, because it is so easy. That makes it so very difficult. It is deceptively simple looking. It's really incredibly hard. I mean . . . most photographers bore the hell out of me. Because there is nothing happening with them. They are just showing me versions of everything I've seen before. There aren't that many people, who . . . in-

trigue me, or make demands on me, or who I feel make me . . . like I like Dianne Arbus and Robert Frank very much. I don't know too many other people. . . .

STUDENT: This may sound ridiculous, but . . . do you teach? How do you make your living?

MICHALS: I work as a professional photographer. I work for magazines. *Esquire*, different magazines.

STUDENT: What kind of photography?

MICHALS: Mostly portraits. I do a lot of work. I'm busy. But, you know, it's a great luxury in having money from doing jobs that permits me to do everything else.

STUDENT: Do you think that there is a definite line between this work and the work you are doing for magazines?

MICHALS: There's no commercial market for this . . . I like to do portraits. That's what I do well, but no one would hire me to do a beer ad. I can't do beer ads, but they hire me to do portraits. I do what I can do. I don't consider myself a business. I don't have an agent . . . And I get paid fairly well. And that gives me the luxury of doing my own work. It keeps me from starving. You know, people kind of think of the pure artist living in starvation . . . but it's nicer, you can work more comfortably, when you can work without worrying about buying the film.

STUDENT: So many photographers say they don't want to contaminate their art.

MICHALS: I once shared a plane ride with a well-known photographer, whom I know comes from a well-to-do family, who said "how can you possibly do jobs for money?" Well, I have to eat! It's a fabulous thing to take pictures and be paid for it. I'd probably do it for free. I have the best deal in the world. I don't know anyone else who has a better situation. I could double my income if I wanted to, but I don't really care to. I am not financially ambitious. It's beautiful. I hope that you all can work out something like that. Try to find work that is close to your natural ambitions. I'd take pictures for nothing, and the fact is that people pay me to do it!

STUDENT: Do you have any idea how to get started?

MICHALS: I don't have any idea, so don't ask me how it works. I think it's mostly personality. . . . With those last words . . . of wisdom . . . I'm going to pack up my tent and . . .

Martha Rosler

Lee Friedlander (1934–) reconstructs everyday life in his photographs. Unlike documentary photographs of the 1930s and 1940s, his do not intend to raise social consciousness. Rather Friedlander's concerns are personally directed toward what a photograph can do. Fascinated with the visual ambiguities that a photograph can reveal Friedlander enjoys representing mirror images and shadows. His books include Self-Portrait *(1970) and* Work from the Same House *(1969) with Jim Dine.*

In this essay Martha Rosler identifies Friedlander as representative of recent critical questioning of art. Both photographers and Pop painters are testing the capabilities of their media. Rosler explains that Friedlander, along with Diane Arbus and Gary Winogrand (see following essays), makes idiosyncratic work that coolly violates pictorial conventions.

Martha Rosler is a video artist, critic, and teacher who works on the West Coast. She has taught at the University of California at San Diego and at San Diego State College.

I

Lee Friedlander's photos are in a sense exemplary. Their cool, gentle disdain places them at a crossing point between photography and high art, where meaning can be made to shift and vanish before our eyes. In 1967, when The Museum of Modern Art showed photos by Diane Arbus, Garry Winogrand, and Friedlander, the exhibit was called "New Documents"; at the recent MOMA exhibit of fifty of Friedlander's photos curator John Szarkowski termed the photos *false documents*. Szarkowski's rhetoric about Friedlander has undergone the corresponding shift from asserting that the work represents a kind of device for improving our vision of the commonplace to asserting that it represents the outcome of personal "hedonism" while stemming nonetheless from "an uncompromisingly aesthetic commitment." The overriding assertion now is that Friedlander's concern is both "disinterested" and "artistic," and

* Reprinted from *Artform* (April 1975).

the corollary disclaimer is about instrumentality. That is, the work is firmly claimed as part of an art tradition and distinguished from the documentary photography of the 1930s and earlier, which was meant to "change the world."

Quite a few of the photos in the recent show had appeared either in Friedlander's book *Self-Portrait* or in the joint *Work from the Same House*, which coupled Friedlander photos with hairy, somewhat pudendal etchings by his friend Jim Dine. The ones exhibited at the Modern were those closest to elegance, geometry, cleanness, and high-quality camerawork, and, among the humorous photos, those displaying pure-minded irony and wit untainted by lowness or sexuality, which the book done with Dine had plenty of. All the rawest photos, in both subject and handling, were absent.

Friendlander's work provides some of the first and best examples of what has become a widespread approach to photography. It was part of the general reorientation of the 1960s within American art. Within photography his work violated the dominant formal canons not by inattention but by systematic negation. High-art photography had had a tradition of being directed, by and large, toward some "universal" message. It had aimed to signify a "transcendental" statement through subtraction or rationalized arrangement of elements within the photographed space, dramatic lighting, expressive intensity of glance or gesture, exotic or culturally loaded subjects, and so on. If Friedlander uses these devices, it is only to subvert them, to expose their arbitrariness. But in shifting the direction of art photography, Friedlander has not rejected a transcendental aim—nor has he specifically embraced it. Instead, his attention is on the continuum whose poles are formalist photography at one end and transparent, or information-carrying, photography at the other. Imagine a mapping system for photographic messages: the continuum formal versus transparent is at right angles to the continuum transcendent versus literal. (A photo of a fiery helicopter crash in combat, for example, is "transparent" and literal when it functions to document the particular crash; it is moved toward the formal if the style of the photograph or the "oeuvre" of the photographer becomes an issue, but it may still be a literal document. It is moved toward the transcendent range of meaning if it is taken as embodying a statement about, say, human inhumanity, heroism, or the tragedy of war, and into the formal-transcendent

range of its efficacy as a bearer of this message is held to lie with its formal rather than strictly contentual features.) Without insisting on this device, we can observe that even if an artist locates his work near the formal end of the one continuum, his messages, no matter how commonplace or "vernacular," are still free to wander anywhere along the other, from literalness to transcendence.

In moving toward "vernacular" photo images, photography has had to confront some of the issues behind realism, such as whether a photograph is in any sense a document and, if so, what kind. Is it "about" what it shows concretely, metaphorically, representatively, allegorically? Does it refer to a moment alone? If so, how long a moment? Does it reveal only that moment, or does it indicate past and future as well? Or, is a photo a record of sensibility, or, is it most specifically about photography itself? These are metacritical questions about the range of messages a photo can convey as well as about how it signals what it signals. These questions are both contentual and formal, and they are all at issue in Friedlander's work.

The meaning of a photographed instant is pivotal, although the problem is not flamboyantly explored. Among the reasons why it is unwise to compare Friedlander's photos to "snapshots" the most telling may be that they are not commemorations of a moment; once you have seen more than one, his critical concerns clearly emerge. His conscious presence assaults the notion of transparency, breaking our experience of the moment photographed while at the same time alluding to it. Whereas the photos display the look and the subjects of literal and transparent photography, Friedlander's use of these commonplace features shifts their meaning to another plane.

In commenting on E. J. Bellocq's straightforward photos of New Orleans prostitutes[1]—photos that Friedlander had "found" and carefully

[1] Bellocq was a local New Orleans commercial photographer working around 1912, a primitive in a sense, whose work was basically unknown until Friedlander came across it after his death. Bellocq seems to have photographed the women as friends, with aspirations neither to art nor to profit. A book of the photos, reprinted by Friedlander in a style he tried to match as closely as he could to Bellocq's own, was published as *Storyville Portraits* in 1970 by The Museum of Modern Art. Most of the remarks quoted here were drawn from the book's introduction, a peculiar jigsaw puzzle of conversational remarks ascribed to various persons and recorded at various times and places, all finally selected, edited, and arranged by John Szarkowski into an imaginary "conversation."

reprinted—Friedlander calls Bellocq an "ultraclean realist."[2] He continues: "I think in photography that's even more artistic than making [everything] romantic and fuzzy."[3] Friedlander uses the word *magic* to describe the camera's ability to render things "in astonishing detail," as he phrased it elsewhere. In Friedlander's framing discussion of Bellocq, and in Szarkowski's of Friedlander, the literalist image is somehow transformed into art-magic, but it seems that the only acceptable topic of discussion is the image—only the image is subject to control. Photography is something you do; magic is an ineffable something that happens. Friedlander has remarked that "the pleasures of good photographs are the pleasures of good photographs, whatever the particulars of their makeup."[4]

The locus of desired readings is, then, formalist modernism, where the art endeavor explores the specific boundaries and capabilities of the medium, and the iconography, while privately meaningful, is wholly subordinate. Whatever meaning resides in Friedlander's photographs, and it is more than the image management of the Modern has let show, this set of claims allows Friedlander and the hundreds of young photographers following the same lines to put playfulness and pseudopropositions forward as their strategy while identifying some set of formal maneuvers as the essential meaning of their work. The transiency or mysteriousness of the relations in their photos suggests the privatization of the photographic act. The result is an idiosyncratic aestheticizing of formerly public and instrumental moves.

Yet the ambiguity of presenting a set of familiar images while simultaneously denying both their exoteric reference and their commonly understood symbolic meaning is problematical in such work, as in Pop art in general. Friedlander shares with Pop the habit of converting instrumental uses of a medium into formal and metacritical ones, using the techniques and images of naïve photography where Pop might use those of graphic

[2] *Storyville Portraits*, Introduction, p. 11.
[3] *Ibid.*
[4] *The Snapshot*, Jonathan Green, ed., special issue of *Aperture* magazine, 19, no. 1 (1974), p. 113. This collection, mostly of photographers' work with short accompanying remarks, has almost nothing to do with snapshots and represents another step in the attempt by Minor White and others to assimilate all photographs to their particular technomystified version of photographic history.

art. "Composition," control of pictorial elements, isn't really enough to distinguish work that quotes naïve imagery from what is being quoted, especially in photography, where the format and the framing of art and nonart are basically the same (in painting and sculpture there is usually at least a medium or a scale change). What is required in such work is aggressively conscious, critical intelligence (as opposed to sensibility or expressiveness), signaled by aesthetic distancing.

Friedlander's presentation is exhaustive yet cool, the effect markedly distanced. The voraciousness of a view that yields, in good focus and wide tonal range, every detail in what passes for a perfectly ordinary scene, the often kitschy subject handled in a low-key way, the complete absence of glamour, and the little jokes, these put intelligence and humor where sentiment or anger might have been. Distancing is everywhere evident in the palimpsests of shadow, reflection, and solidarity, in the fully detailed, small-town-scapes empty of incident, in the juxtapositions and the carefully composed spatial compressions and sliced reflections that are significant only in a photo. Art-making here entails a removal from temporal events, even though the act of recording requires a physical presence, often duly noted. Friedlander records himself passing through in a car, standing with eye to camera, and so on, in widely separated locations, always a nonparticipant.

Control is evidenced by Friedlander's hardheaded, patiently systematic formal moves. Most of the issues of painterly "design" within a rectangular format turn up in his photos. There are echoes of Analytical Cubism in the deconstruction, crenellation, fragmentation, and other deformations of space and image. He gives, too, the look of collage—the (apparent) joining of disparate elements and image fragments—filtered through the attitude toward stylistics, and even in the homeyness of the subjects. When Friedlander breaks the rules of "good" photography, his doing so amounts to an insistence on photography as photography. These rules are violated by a broader set of pictorial conventions. Take the compression of foreground and background fairly common in Friedlander's photos. It violates the tacit rule that a representational photo should suggest space as we perceive it in the world, with any deformations being easily decodable. Friedlander's deformations rarely result from the optics of lenses, which we have learned to cope with. Rather, he arrays the pic-

torial elements so that they may connect as conceptual units, against our learned habit of decoding the flat image into rationalized space.

More importantly, spatial compression is a possibility peculiarly inherent in photography, where such junctures can happen accidentally. Friedlander characteristically locates the issue in the domain of control, which he equates with insisted-on consciousness. Once you accept that photography need not rest on the history of painting (where, before the heavy influx of photographic influence, at least, there had been no concept of chance imagery, only accident or better or worse decisions about intentional juxtaposition), you can accept as the outcome of conscious and artistic control photos that have the look of utter accident. Friedlander's work may make us think of naïve photos that incorporate unwanted elements until we inspect a body of his work, when his habitual choice becomes evident, and chance and accident can be seen to diverge.

Chance imagery figures in the wider strategy of juxtaposition and collage. Collaging in Friedlander's photos, no matter how it is accomplished, once again points out the nature of photography, its impartial mapping of light-dependent images at a single instant in time. All types of visual phenomena have essentially the same "weight" in a photo, formally speaking—but conceptually that is obviously not true. Friedlander's collages involve not just spatially disjunct imagery but a conceptually based welding of elements of different time scales into a unitary image. He tends to go for the dryly humorous junction, as in "Knoxville, Tennessee, 1971," a rather typical naturalistic collage: a perky little cloud seems to sit like cartoon ice cream atop the back side of a leaning "Yield" sign whose shadow angles down the unremarkable street. The sign is a long-term, weighty, manufactured element, the shadow is a natural, regularly recurring light-produced image that moves only gradually, and the cloud is a natural, randomly appearing visual element not as substantial as the sign but much more so than the shadow. Clouds, shadows, and signs feature fairly often in Friedlander's iconography, along with clumsy statues and telephone poles, as types of phenomena marked for duration, solidity, provenance, and iconicity. Reflections and mirror images, like shadows, also appear often, and all are, in a sense, protophotographs. All raise questions about the immediacy and the validity of the photographic document.

Friedlander's reflection photos tend to be less casually humorous than some of his more naturalistic ones. Window reflections, a subset of light-dependent chance images produce superimposed collaging that often is so strong it is Hofmannesque in effect. The substrate of the reflection is a manufactured surface, usually a commercial one. Images of people are cut by or paired with other images, often without any possibility of their consent. The high number of partial inclusions in these photos makes it difficult to determine exactly what is depicted—do we see, for example, a person's reflection (is it the photographer's or someone else's?) on a storefront window or a person standing inside? Images of signs, of material objects, of natural phenomena, and of shadows—as well as of photos—are as much there as straightforward images of people. We grow confused. In a regionally marked photo, "Los Angeles, 1965," photo cutouts of two implacably smiling TV stars, conspicuously taped on a storefront window, are the only clear elements, against ripply reflections of palms, clouds, and cars. They are only the simulacra of people we see without obstruction and must, on some level, respond to as though they were photos of people, unmediated.

A photo of a mirror image, like one of a photo, provides no superimposition and so is like a direct photo of the thing mirrored. The importance of the instant is subordinate to the cognitive tension about what is seen and which side of the camera it's on. In some photos, large car-mirror reflections disrupt the unity of the image, turning the photos into diptychs or triptychs. Whether they form part of the ostensible subject, modify it, or subvert it, these images box in the space and provide a "fourth wall." Such closure is accomplished in other photos by an obstructing foreground element. Like the oblivious passerby who ruins a snapshot, these elements obtrude between camera and ostensible subject. The fronted barrier provides a cognitive, not a formal, tension like the annoyance you feel when your theatre seat is behind a pole or your view out the car window is blocked by a passing truck. Friedlander's famous shadow or reflection, in virtually every photo in "Self-Portrait," also is a closing element. It is not a stand-in for our presence in the real-world moment referred to by the photo but an appropriation of it.

Some photos are falsely lame apings of genre, like the regional stereotype (the parking lot at the Lone Star Café, El Paso, composed into a pyr-

amid with a pickup truck seemingly on display with the café sign on its roof, and with cacti, gravel, and a neon star against the sky); individual or group portraiture (a flash-lit photo of potted flowers or, not in the show, a grinning group of firemen quickly posed class-portrait style before a smoking ruin); nature photography (pathetic, scraggly flowerbeds or trees); or architectural tableaux.

Portraiture is extensively undercut; people are opaque. We are kept mostly at arm's length or further. The closer shots at the Modern were party photos in which several people pressed together across the picture plane or formed a shallow concavity. They seem to be ordinary youngish middle-class urban or suburban people—the kind of people who look at photos. Their expressions, although sometimes bizarrely distorted, say more about the effects of flash lighting than about personality or emotion, except the most conventionalized kind. The close-up is a form suggesting psychological encounter, and Friedlander uses it to negate its possibilities. People shown interacting with things often look unwittingly funny, or sometimes peculiarly theatrical, bringing a suggestion of seriousness to the irony of their situation. This is perhaps clearest in the photos with statues.

In "Connecticut, 1973," a statue of a soldier, rifle at the ready, crouches on a tall pedestal in a small clump of greenery bordering a street of stores. Two women, one pushing a child in a carriage, have just passed it. The child, a small image at the right, is looking back. We are separated from the horizontal tableau by an almost-centered telephone-pole shaft and a street sign. In this photo are images of the immovable and noniconic (the pole), the iconic immovable looking movable (the statue), the fleeting human (the walking women and the child), and the stationary human (women seated at the statue's base). Can we extract any transcendent message? If so, it is not about war but may be about human durations—perceived durations relative to those of icons. The humanly produced statue has a potential "life-span" far longer than that of any person and exists in a different time frame: everyone in these photos ignores the statues, which remain fixed against a changing backdrop of temporal events. And the time frame of the photo is that of the statue, not that of the people. Or suppose this photo is more centrally about interaction. Its dominant vectorial geometry seems to tie the gazes of statue and infant, but no interaction occurs. The child's back is to its mother, hers is toward the

woman behind, and the other women in the foreground look off at right angles.

The possibility of such heavy metaphysics, despite its ordinariness, at first seems rather remote. The viewer must make some observations and decisions before considering it. The facticity of the image is in doubt; unquestionably the elements were present in the real world and the photo was not set up like a Michals, a Meatyard, or an Uelsmann photo. But it was set up like a Cartier-Bresson, in which the architecture required the presence of a human figure falling within a range of specifications in order to elicit the desired internal comparison between figure and ground. That is, Friedlander presumably positioned himself in the right spot and waited for someone to appear. And of course the irony is only in the photo—it is the photographer, with his prevision of a flat representation, who can present the people as transient self-absorbed entities enclosed in a humanly created space that has gotten away from its creators. The viewer recognizes that the statue's impingement is unreal; its iconicity fools us into considering that it might be implicated, whereas we know it is no more so than the street sign or the telephone pole. The viewer can decide that the photo conveys something truer than the commonplace apprehension of reality, putting the photo within the bounds of Surrealism. The viewer is unlikely to accept the as-if proposition that the statue is invested with more than the surface appearance of the real and can in fact interact with the people. (The backward-glancing child is tantalizing; is he a Wordsworthian creature with trailing memories of immortality, that is, of nontemporality, or is he, impossibly, conscious of the statue's false menace? Is he not yet fully human and paradoxically not yet fully unconscious? Or is he just glancing back at the woman we assume to be his mother?)

The viewer accepts the simile that the statue looks as if it were engaging with the passersby only on the level of aestheticized experience, or storytelling. We do not imagine that the photo is a literal document about this particular spot in Connecticut or the figures in a townscape who appear in it. We assume the photo is synecdochic, intended to convey, if anything, something about people in general, or about some class of people, or about some class of images, or most attenuatedly, about some class of images of images.

The particular conjoinedness of images can be taken as a witticism

rather than as a serious assertion about the real world. Interpretation, if it occurs, is a private task of the viewer's. Grossness or fineness of interpretation is a covert issue in Friedlander's work, just as grossness or fineness of looking is an overt one. It is likely that Friedlander doesn't care to decide at what level his photos are to be read. He presents tokens of the type that might be called "significant pseudojunctures"; his images function like the mention rather than the use of a word, noninstrumentally. Ultimately we are unjustified in associating the statue with the people just because their images share the same frame. This metamessage applies as well to photos of people with people; that is fairly clear in the party photos, for example, where you can't tell who is associated with whom, except for the one in which a man is kissing a woman's neck, and what does that signify at a party, anyway?

We can't know from a single image what relation the people in it have to one another, let alone whether they communicate or what they did before or after shutter release, and the photos rely on our presuppositions to bias them toward a reading. The general lack of such personal markers as foreignness, poverty, age, and disability allows Friedlander an unbounded irresponsibility toward the people he photographs. His refusal to play psychologizing voyeur by suggesting that a photo can reveal some inner or essential truth about an individual or a stereotyped other is admirable. But it is part of the larger refusal according to which photographic propositions have truth value only with respect to photos, not to what is photographed. Even this refusal is unstated. Friedlander has laid vigorous claim to control over his camerawork but has omitted any active claim to control over reading. His work can be taken by casual viewers as value-free sociology and, because of his denial of photographic transparency, as artful construction for photography buffs.

II

Friedlander's work has antecedents in the small-camera photography and street photography of such people as Eugène Atget and Walker Evans, to mention only two, but both Atget and Evans appear serious where Friedlander may seem clever, light, or even sophomoric. Atget and Evans photographed people of various classes, in their work roles and out. They cannot be accused of making their subjects the butt of jokes,

whereas Friedlander does so almost always, although not the savagely involved ones of Arbus or Robert Frank. For both Atget and Evans, photography's ability to convey hard information was not much in doubt.

In Evans's *American Photographs* there is a deadpan photo, a Friedlander precursor, of a similarly deadpan statue of a doughboy on a personless street in a Pennsylvania town. He follows it with a Vicksburg statue of an unmounted Confederate officer and his horse, a monument to heroism in defeat; Evans's framing of the image and its isolation against the sky exaggerate the transcendental histrionic gesture enough to kill it by overstatement. Next in the book are some pretty unappealing portraits of men and boys wearing uniforms. The sequence narrows down the range of meanings of the photos to the subject of war and violence and how they are represented in the world. Evans, like Friedlander, is not psychologistic, but his photos are seated much more firmly in their social context; even his captions are more informative: "Coal Dock Worker, 1932," and "Birmingham Steel Mill and Workers' Houses, 1936," are more than the bare bones of place and year. Evans, too, used collage, including in a photo both "positive" and "negative" cultural elements: heroic statues and clean streets meeting up with prosaic power lines, icons denoting beauty or sleek commercial messages embedded in degraded human environments, people in rags lying in front of stores. Like Evans's collages, Friedlander's may preserve the impression of simple recording and mass-produced iconography at the same time as exquisite awareness of both formal niceties and telling juxtapositions. But Friedlander's collages, hung on chance and ephemera, are not consciously invested with social meaning and may or may not aspire to universal import. What for Evans occurs in the world occurs for Friedlander in the mind and in the camera. The emerging cultural icons in Evans's photos that represent the directed message of the haves imposed on the have-nots are solidified and naturalized in Friedlander's. The have-nots have disappeared.

In Friedlander's books Friedlander comes across as a have-not himself—significantly, though, one psychosocially rather than socioeconomically defined—a solitary guy who slipped around with a camera in a crazy-clockwork world, fantasizing with mock voyeurism about sleazily sexual targets while never forgetting the meaning of a photo. More recently, as in the latest exhibition at the Modern, selected by Szarkowski,

Friedlander has shown us a sanitized if unglamorous but uniformly middle-class world. His human presence has been submerged under his professionalism, and nothing is serious but the photographic surface—he is approaching the status of classic in his genre. Minute detail in these photos does not add up to a definitive grasp of a situation or event; it would be an ironically false presumption to suppose we can infer from the photo something important about the part of the world depicted in it. Yet making connections is an ineradicable human habit, and the meta-message of framing is that a significant incident is portrayed within. Looking at his photos, we are in the same situation as Little Red Riding Hood when she saw dear old Grandma but noticed some wolflike features and became confused. Our pleasant little visit has some suggestion of a more significant encounter, but we don't have enough information to check. The level of import of Friedlander's work is open to question and can be read anywhere from photo funnies to metaphysical dismay.

Max Kozloff

Max Kozloff writes about photography as part of his interest in how images convey psychological and sociological information. In this essay Kozloff explores the kind of portrait situation that lures the sitter into revealing himself. He develops his ideas about portraiture in terms of the photography of August Sander, Diane Arbus, and Lucas Samaras. Their photographs of people uncover private psychologies rather than record pretenses of poses.

Max Kozloff writes art and photography criticism for numerous periodicals. His books include Renderings: Critical Essays on a Century of Modern Art *(1969),* Jasper Johns *(1972), and* Cubism/Futurism *(1974).*

August Sander (1876–1964) ambitiously attempted to portray the entire range of the German people. Unable to finish his major project "People of the Twentieth Century," still he defined German society, connecting its private and public domains. His photographs penetrate the individuality of his subjects in varied occupations and classes. His books include Faces of Our Time *(1929),* German Country—German People *(1962), and* August Sander, Photographer Extraordinary *(1973).*

Diane Arbus (1923–1971) was fascinated with society's outsiders. Influenced by Sander and her teacher, Lisette Model, her photographs of unusual and bizarre people are intimate descriptions. Arbus's art rests on her ability to empathize in a dignified manner without eliciting pity or embarrassment for her subjects. Her books include Diane Arbus *(1972).*

Lucas Samaras (1936–) is noted for his inventive use of varied materials and combined techniques. The basis for his photography—auto-Polaroids and photo-transformations—as well as his painting and sculpture is always self-referential. Enthusiastic about unconventional expression Samaras favors grotesque and fantastic imagery. His intentions are Dada in spirit. Samaras challenges the boundaries of acceptable art. His books include The Samaras Album *(1971) and* Lucas Samaras: Photo-transformations *(1975).*

* Reprinted from *Artforum* (June 1973).

In its reception of the human face, photography increases the mystery that always results from its freezing of movement and the receding of the present of its actual images from our present. The snap of a shutter distances a real landscape or parade: these things are still "there" for us, yet cut out from everything they were once in. "Our face," though,

> is where we are. We kiss, eat, breathe and speak through it. It's where we look, listen and smell. It is where we think of ourselves as being finally and most conclusively on show. It's the part we hide when we are ashamed and the bit we think we lose when we are in disgrace (Jonathan Miller, "On the Face of It," *London Sunday Times*, May 24, 1966).

To look at people's faces in still photography is, then, to look at analogues of our own—with a curiosity that must be lessened when switched to any other subject.

Who can deny that on first meeting another, we often busy ourselves in making from his or her face an imaginative portrait, however it may be contradicted by later knowing? But one's features are ostensibly readable, not as a clock, but as a mask, whether consciously imposed or not. This enigma, with its high, personalized stakes, is impacted by what I have just said about the conditioning of photography. All camera portraits have guaranteed interest on such a level. Yet most of them—and certainly all commercial ones—have been taken in sympathy with the individual's self-projection of status. That is, they are images of pride, enhanced by clothing, attitude, expression, and lighting, all dutifully accentuated by the photographer. Examples can be found in the work of Yousuf Karsh, Cecil Beaton, Arnold Newman, and Berenice Abbott. Doubtless, the last three have exhibited many intriguing aspects of people's style, character, and even thought within a mode designed more to compliment than to reveal. Avedon and Penn, coming out of this tradition, have soured it a little by a certain sarcastic urge. Their art could not help but satisfy by its gentle deflation of celebrities. Still, they would tell us what we already know: that the famous are imperfect.

How much more gripping is the portrait that remains indifferent to, or works against, the sitter's pride, striving in this dissonant way to reach his humanity and to touch ours. And how much more incisive when a pho-

tographer treats the mask as something objective, a thing by itself, not a pose whose world view the spectator is asked to share subjectively, at least for the moment. For then there is heightened that distancing that makes no pretense at respect nor at clearing up the mystery, yet comes closer to both because more conscious of the hauntedness of photography itself.

Three photographic campaigns perform this mission with an almost dreadful yet variable accuracy. They are the work of August Sander, Diane Arbus, and Lucas Samaras. They probe in common the psychology that exists behind the playing of roles, and that would, if possible, convert role into true identity. With their every shot, the subject, for our eyes, is on the verge of losing face, or has lost it. "The term *face*," writes the social psychologist Erving Goffman,

> may be defined as the positive social value a person effectively claims for himself by the line others assume he has taken during a particular contact. Face is an image of self delineated in terms of approved social attributes. . . . A person tends to experience an immediate emotional response to the face which a contact with others allows him: he cathects his face; his "feelings" become attached to it (Erving Goffman, *Interaction Ritual*, New York: Doubleday Anchor Books, 1967, pp. 5–6).

What is involving in this photography may perhaps be a process of exposure, for we run the danger of feeling superior to its subjects who look, or are indeed, compromised. A more specific response, however, may reflect one of two further possibilities. In Sander's work, the individual tends to balloon too much for our taste with a self- or socially awarded status. We wish to lower it. In Arbus's pictures those who pose frequently possess insufficient face, and we seek to restore it to them, though with some uneasiness.

In either instance active exchange between viewer and subject is prevented even as it is graphically solicited by the simple photo. If we had been dealing with casual snapshots, our reactions would have been more elementary, for then it would have been a question of seeing matters sent "accidentally" askew: those manifold episodes filling up all slack between isolated points of scoial decorum or composure. On the contrary, these three artists give us people nothing if not highly conscious they are being

photographed. And this consciousness feeds content directly into our understanding that something has gone wrong. We look at these prints fully aware of a singular disparity between our consciousness and the sitters'.

Obviously, that would apply throughout, to anyone who allows his image to be exposed on film. The individual hopes the photographer will collaborate in presenting a certain fantasy of himself, but wonders realistically whether the physical facts of his appearance, no matter how doctored, actually give shape to that fantasy. Sander's Germans of the interregnum are exceptions, which makes their confidence all the more a victim of his detachment. Arbus's freaks and transvestites, on the other hand, have a built-in vulnerability and have little more to expect from their portraits than a record that they exist—a record she will pitilessly intensify with every means at her disposal. By a curious inversion, she can speak of them as aristocrats, as already having "passed their test in life." But the situation is even more extreme with Samaras, since he is photographing *himself* in a hundred different capering guises, overt fantasies that are not to be taken as substantive masks, while yet raising questions as to why he should want to make such outlandish multiplications of himself at all. It remains for us to see how truly isolated is all this acting out, how wounded are all these subjects because of the absence, not of "self delineated in terms of approved social attributes," but of those who would confirm it. Here again, that special estranging quality of the photograph becomes magnified. The faces that appear to us are left with their "cathected" features separated from their audience as if by a stage.

Actors performing, of course, experience real contact with people, even though everyone pretends to ignore it until curtain. In these photographs, however, there is a species of lapsed theatre and of mute performance, which elicits a muffled threatening response in those viewers not actually present to the cast. In the act of being photographed, one cannot attempt to minimize one's psychological deficits by behaving and interacting with others. Any last-minute shift or mien merely continues to play poker with the lens. One confronts, after all, only a mechanical eye through which is recorded the visual information one circumstantially presents at a given instant, but far less of the totality and mobility of one's personality.

The particular slant of this photography maximizes what amounts to an ongoing betrayal—emphasizing its offerings as all that can be known. Samaras reacts in questioning himself: "Why are you making art? So that

I can forget my separateness from everything else. What are you running away from? From people's evaluations" (*The Samaras Album*, p. 6). Here, then, is a subject of photography who can take unusual means toward protection because he is his own photographer, which possibly accounts for the rabid theatricality of his work. Among other things, his auto-Polaroids are, for him, "a stylized pretension of emotion—acting." Yet it is remarkable how acting, of a kind, with many undiscoverable pretensions, permeates the photos of Arbus and Sander as well. The aggressive mode of address, the bizarre clothing, the exaggerated makeup, the calculated pose: all these expose a form of theatrical consciousness upon which their cameras close in. Arbus makes it momentous; Sander gives it deadpan. But there, at any rate, it is, hanging out yet weirdly aborted.

Thomas Mann's son, Golo, when introducing Sander's typical personage in *Menschen ohne Maske* (a collection of Sander's photos, Lucerne: Verlag C. J. Bucher, 1971), says that the subject becomes more than himself when solemnly confronting the camera. If, then, we are asked to be interested in the lesser individual as interpreted by the larger one, this usually implies a caricatural device. The classic theory of caricature entailed the revealing of

the true man behind the mask of pretense and to show up his "essential" littleness and ugliness. The serious artist, according to academic tenets, creates beauty by liberating the perfect form that Nature sought to express in resistant matter. The caricaturist seeks for the perfect deformity, he shows how the soul of the man would express itself in his body if only matter were sufficiently pliable to nature's intentions (Ernst Kris and E. H. Gombrich, *Psychoanalytic Explorations in Art*, New York: International Universities Press, 1952, p. 191).

How much more subtle a phenomenon must be this mode of caricature (derived from the Italian verb *caricare,* "to overload or overcharge") than in painting or sculpture. The image of the human face is not nearly as malleable on film as it is when materialized by the brush, pen, or modeling tool. And the photographer does not ordinarily desire the license to disturb physiognomy for the purpose of making its more characteristically aberrant features or expressions lord over its nondescript ones.

A wonder of Sander's photography consists in his perhaps unconscious ability to evoke caricature without anyone so much as grimacing, cracking a smile, or rolling an eye. Somewhere, deep in his work, there is a comic affinity with Keaton, an imperturbable, chaste ridiculousness, which might almost have disarmed us were we not so aware that the society of which people were such vivid fixtures came to a bad end. Sander teaches us, without the need for overt editorializing, that George Grosz did not lie in his picture of the Weimar Republic. As for Diane Arbus, her world, though much closer to ours in time than Sander's, is even more exotic. For the stylizing which often possesses her sitters identifies them through and through as pariahs, functioning outcasts whose fetishes impel them to exhibitionistic behavior. Gravitating toward people who have no economic status, she shows them as peacocks of subcultures or minority groups, brandishing their emblems and signaling their kind, no less when naked than clothed. Arbus suggests that American society is not to be analyzed in such outdated terms as class structure, but as a field populated by discards whose protective coloring, whether voluntary or not, is grotesque in her eyes. With Samaras, finally, all the narcissism, sexual neurosis, and "warm embarrassment" that distinguishes the American zoo for Arbus is charaded by the shameless mugging of his face and the contortions of his own body. His cockeyed posturings recall such eighteenth-century students of facial tics and emotional states as Lavater, Franz-Xavier Messerschmidt, and Fuseli. He even invokes some of their thrill at the human being *in extremis*. These programmed auto-Polaroids belong to a species of gag photos so hyped up as to be infused with a Dionysiac frenzy.

If the privilege of rearranging human anatomy is not granted these photographers as flagrantly as in drawing, they yet confront us with real people regardless of the filter through which pathos is felt. The larger individual constantly harks back to the lesser one. Visual art may bring this about by appealing to our memory or conjecture. Photography, though, encourages direct, simultaneous comparison of two aspects of a person captured on film.

The vital ingredient added to this equation is a social schematism. Their representation of definite types is no more haphazard than the pos-

tures of these subjects is casual. It does not surprise that artists concerned with the self-dramatizations of human beings, injecting them with a caricatural element, should view the resulting spectacle as one of fixed, interpersonal relationships. That the parts these people play seem very finite and static owes as much to a framework deliberately imposed by the photographers as to the stillness of their medium. Most every subject comes across as a distinct somebody: a sibling or a parent, lover or spouse, an official, a patriot, an entertainer, say, or a professional or retired person. They are often seen in their work environments and/or at home. Conversely, they can be shown as without evident family, lovers, work, or home. They incarnate the specific kinds of wisdom, prejudices, limitations, and skills of their background—and, for practical purposes, no others. Each sitter is encapsulated by a blatant social mood or destiny, marked by the niche that is given him for life. Sander's farm kids appear to have a future almost identical with their parents'. And even Arbus's children, wailing, crazed, or in some fashion looking like stunted adults, seem to have an utterly foreclosed maturity.

The comic geniuses of our tradition flourish on the hilarities of stereotypes which encourage much greater harshness of treatment than a naturalistic psychology that must explain unique cause and effect in human behavior. These photographs, with their cruel overdeterminisms, have as frequent a mechanistic outlook as comedy's, but do not partake of the comic viewpoint because they don't consider social stereotypes of character and circumstance in any active, surprising, and happy collision. On the contrary, suffused throughout these prints is the method of the anthropologist, the stranger who documents traits, habits, and above all, tribal markings as they are stratified in what is, for him, an alien society. Like the anthropologist, these portraitists want to fill in and classify the gaps of their picture. They would offer as comprehensive a structural description of a culture as possible.

That it is their own culture, or their own psyche understood as culture, becomes the main issue and causes a certain shiver. Their cultural closeness to their themes would make their psychological remoteness look inappropriate were it not that remoteness is such an evident stance in their aesthetic. Something like this must explain the peculiar, almost negative, identification we have with their sitters. To be caught unaware by some

eavesdropping or voyeuristic journalist with a camera is one thing. No one can guard against it. But it is much more serious to have one's privacy invaded when attentive to exposure. In these photos, the futility of human pretense becomes, by transference, our own. Yet, who amongst us would feel this way if the subjects were of North Borneo or Tanzania? Perhaps despite themselves, Sander, Arbus, and Samaras startle us politically because they photograph people of our own heritage or who look very familiar in a mundane way, as if they belonged to such ritualized societies. The "opacity" of a third-world tribe yields to the greater transparency with which we are accustomed to view ours. If we are relentlessly trained to seek out the individual within the type, these photographers uphold types to enable a clearer sighting of the individual. The variable tensions maintained by this dialectic in their work crystallize into an artistic principle. It rapidly distinguishes itself from those potluck poets of human foibles or miseries who have largely monopolized contemporary photography.

How often is the reader struck by head-on stares in *Menschen ohne Maske*, the many frontal poses, and finally, the surfeit of closed mouths with their thin, clamped, and pinched lips! It is as if practically everyone in Germany for twenty-five years had forgotten how to smile or knew only how to imitate pleasure but weakly. Could there have been something about Sander and the professional atmosphere he created that inhibited their spontaneity, or was there, as we suspect, a long-lived starch in the race? Yet on those few occasions when someone wanted to look agreeable or just felt nice, the photographer's magic dissipates. Typically frumpish, they are more natural, then, in their bodily stiffness, and they have about them a heavy and angular formality, a reluctance to use any muscle that does not contribute to an imposing facade. The weightier virtues of looking dignified appeal to them more than the lighter charms of appearing civilized. Of course, Sander is quite conventional in this, having company in the nineteenth century (he was born in 1876), and the early part of this one, with thousands of photographers for whom relaxing their subjects was not part of the trade. Still, we see him even in the 1930s carrying on in this old-fashioned way. A reflex for presenting themselves solemnly passes through the Germans during this long period.

From Sander, however, one would never guess at the mob chaos of the Weimar era as *history* nor of the vast industrial energies mobilized under Hitler.

The absence nags, nevertheless, because we do observe a historical ambition that accumulates in his work. With this album, the largest and most recent of three, is published a changing record of German twentieth-century consciousness seen, through the appearances of hundreds of its citizens rather than in larger event or situation. It is a roll call of stock figures that moves horizontally through the professions or trades, and vertically, up or down, through the progress of generations and the division of classes. Here are peasants and small-town bourgeoisie, almost untouched by the world of larger affairs outside in Wilhelmine Germany. Here, too, one finds artisans, workers, cooks, postmen, bailiffs, students, Hindenburgian druggists, accountants. Then there are soldiers, doctors, judges, municipal councilors, Emil Janning professors, industrialists, actors, musicians, artists—even scruffy revolutionaries and a grand duke. In this book, though with many apparent omissions, the tally is built up, part by part, patiently, face by face, affording a rough cross section of how this highly specialized society is put together, and what kinds of mentality make it function. Using another metaphor, Alfred Döblin wrote: "As there is a comparative anatomy, so this photographer did comparative photography."

To American eyes of the present, it's remarkable how each individual holds his place, high or low, with a mulish aplomb. Yet these slow, graceless, bald, pompous, and morose faces are by no means empty. Stamped firmly on their features is the concentrated ability to give or take orders, and the overall effect they impart is not solely one of circumstantial smugness or servility, but of an implacable, deep-grained social order. It is a Christian world, at least in its older rural roots, but not a humanist one. Sander graphs a will to stability all the more ruthless the more there swirled about it, as we know, the pent-up hungers, pressures, and manias of an epoch being torn to shreds.

In that sense, his sociology would seem to be at war with history, except that no picture of interregnum Germany would be complete without the presence in it of a persistently conservative cast of mind, one that would and did revolt only to establish a tighter hierarchy, and a more holistic,

fixed set of values. Numerous propaganda photos from the 1930s show the youth camps, the jolly mountaineers in *lederhosen*, the strength through joy movements, local choral societies. Sander gives us the propaganda of individuals as against that of nationalized groups, or more properly, the state. Only once do the two come seamlessly together: in the 1940 portrait of a young *Wehrmacht* soldier whose role and identity are exactly the same, and whose face, with the die-cut regularity of its features, is really the sweetest of them all.

Still, he does provide a key for interpreting the others. As with him, though often times more refreshingly distrustful and peevish, they are screwed up for inspection. Most likely the careworn peasants, whom Sander befriended from his youth, knew or desired no other way by which to be remembered. But this antagonist of the ephemeral tended to overlay their hard-bitten, primitive mold upon all social levels, even the cosmopolitan. In 1954, he spoke of his program vaguely as a kind of genealogical chart where ". . . the types discovered were classified under the archetype with all the characteristic common human qualities noted." How much this appears the reverse of the malign, yet similarly farfetched categories by which the Nazis tried to determine anatomical standards for racial purity. One of Sander's books was banned by the party, naturally as it seems, because of its divergences from Aryan norms, and its inclusion of "enemies of the state" (e.g., a liberal politician, Paul Hindemith, etc.).

Heinrich Lützeler spoke of Sander's ability to lure from people their myth. But this myth is precisely what can be misleading about them. When considering this work early on, I could not decide which group, the older bourgeoisie he shows, with their Bismarckian jowls and their hair cut *en brosse*, or the younger men, sensing a newer power to be garnered in the *Jugend* of SS units, was the more antipathetic. Still, it did not follow that those who were mature or middle-aged during the 1920s lent themselves to such typecasting. A caped, moldy owl of a man, who for all the world appears to be an escapee from *The Cabinet of Dr. Caligari*, turns out to be an official of the Democratic party. A glowering gentleman with cutaway collar and gloves, standing in a Cologne street—by the look of him an affluent undertaker or even (memories of Hollywood), a Gestapo member—is identified as an artist. (But then, isn't it true that for

Hollywood, the Nazi agent or officer is always an aesthete?) Those individuals who lived in borrowed clothes, whether involuntarily and in some confusion, or as distinct masquerade, take their positions more subtly than the better established playactors. A bemonocled Dadaist, Raoul Hausmann, does his enemies one better in the guise of gross authority. Certain women assume the appearance of young fathers or husbands. And everywhere, Sander, with his ascetic, meticulous style, never shooting above the eye level of his subjects, transcribes the gothic spectacle with nerveless clarity. His hallmark is an even, natural, limpid light.

Diane Arbus was after a similar though less petrified truth than Sander, whose work she knew very well. It's useful to juggle this fact with those of her background in setting up the ideas and scenarios of fashion photography, and her research for The Museum of Modern Art exhibition "From The Picture Press," its "Losers" section most specifically. Sander started in the nineteenth century as a miner; Arbus came from a rich New York Jewish family whose father owned a department store. As the German compiled a rogue's gallery of the pillars of society, she studied its rejects and dropouts. Always emotive where he was circumspect (compare their portraits of circus artists), she apparently could not "ennoble" her subjects without feeling she was condescending to them. They are worldly people whom she approaches, for the most part, but the goods of their world are reduced to the rock tunes on transistors, the TV in rest homes or squalid hotels, and the stale tastes of the flesh. She is the Nathanael West of photography, equipped, when she wants, with a flashgun. Of flash itself, John Szarkowski writes that it is

> a great simplifier. Its brilliant light falls off rapidly as it leaves the camera, and imposes on the structure of the picture a tight planarity, drawing a brilliantly lighted main subject against a dark background. The character of flash light from the camera is profoundly artificial, intrusive, and minutely descriptive (*From the Picture Press*, New York: The Museum of Modern Art, 1972).

Arbus presents glittering tinsel and social anomie with corrosive exhilaration, and the very sweat and pores of several models are textured as if

they are news. At the same time we realize that fashion can be like news photography, in quest of the novel or sensational, a turn of fortune that separates individuals, if only for an instant, from average experience. That most people might want to emulate the aristocratic artifices of high fashion and would want to avoid being exposed as a news event are feelings jarringly projected by a gamut of anonymous portraits, neither newsworthy nor fashionable—in fact quite the contrary. Sander, no doubt, would have been paid for his commissioned photos; a few of Arbus's sitters give the impression they would have taken pay for being filmed. In the older artist, hierarchical themes that tie people together are work, family, and money; for the American, it is sex. Yet, with what sad, disabused glamour she proposes it, and how pitiable it is in the inspiringly mangled contexts of the art she achieved before her suicide in 1971. "The slightest loss of composure would ruin everything. Her subjects must not seem to feel too much, lest they destroy the delicate superiority we gain from knowing more of their vulnerability than they do. Nor can they be heroic; we must admire ourselves for respecting them." To bring off this composure, well observed here by Amy Goldin, required the most tactful brutality. A new situation was, for Arbus, "a blind date," but at the same time, having her camera, "everyone knows you've got some edge." The result of her contacts shows itself as the accidental pose or expression becoming hyperformalized, the decisive catching of annoyance, wariness, laughter, or curiosity before it might go soft into embarrassment and spoil her aim. A "Seated Man in a Bra and Stockings," just ceasing to be as bemused as his counterpart, the topless dancer in San Francisco, reveals how fine are her photographic tolerances.

So, her characters cooperate in the portrait enterprise, may even look straight out at us, but, once again, are caught off guard and found out. How do they relate to the artist herself, or she to them? Is she a nominal member of the scene? Yes, in the nudist camp. Is she a confidante? Yes, with the queens and transvestites. Could she be an outside observer who is given casual sanction? Yes, in the park episodes. And can we say, finally, that she is a presence of no particular account to the subjects? Yes, once more, on the playgrounds of a madhouse. All this enriches and variegates the expressive moods of her work, induces the nuances of tension and relaxation we feel before it. (Not incidentally because we equate our

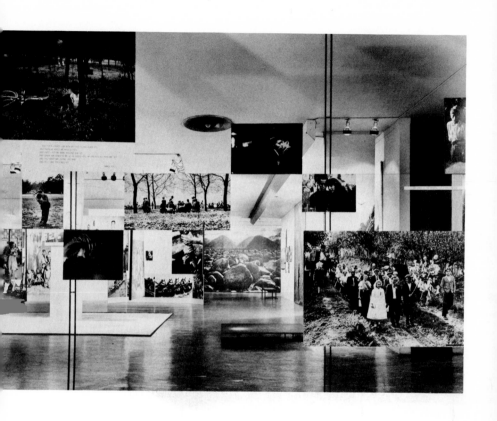

Edward Steichen: Installation shot, ''The Family of Man'' exhibition at The Museum of Modern Art, New York, 1955. Photograph: Copyright © Ezra Stoller.

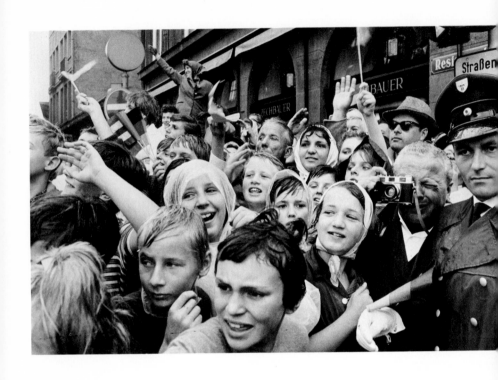

Henri Cartier-Bresson: ''Munich, De Gaulle's Visit,'' 1962. Photograph: Copyright © Magnum Photos, Inc., New York.

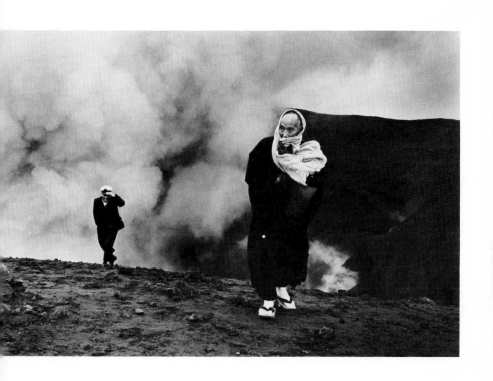

Henri Cartier-Bresson: ''Mount Aso, Japan,'' 1965. Photograph: Copyright © Magnum Photos, Inc., New York.

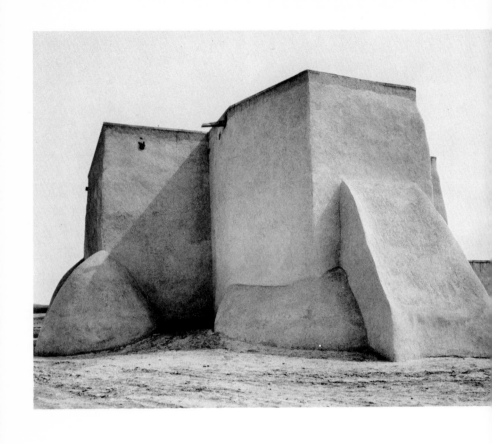

Ansel Adams: ''Saint Francis Church, Ranchos de Taos, New Mexico,''
c.1929. Courtesy Light Gallery, New York.

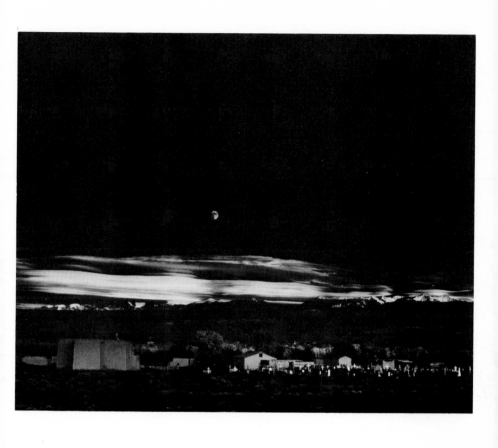

Ansel Adams: ''Moonrise, Hernandez, New Mexico,'' c. 1941. Courtesy
Light Gallery, New York.

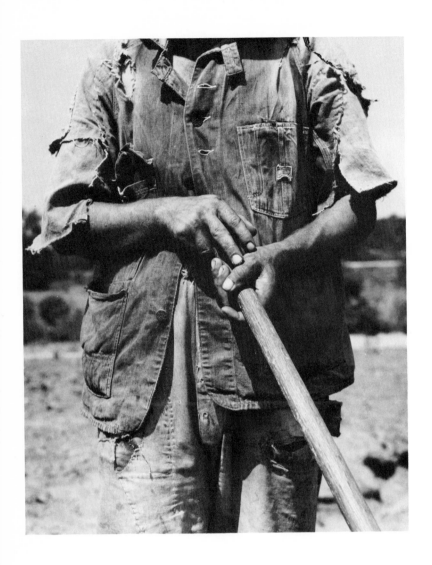

Dorothea Lange: ''Hoe Culture, Alabama,'' c. 1935–1943. Courtesy The Library of Congress.

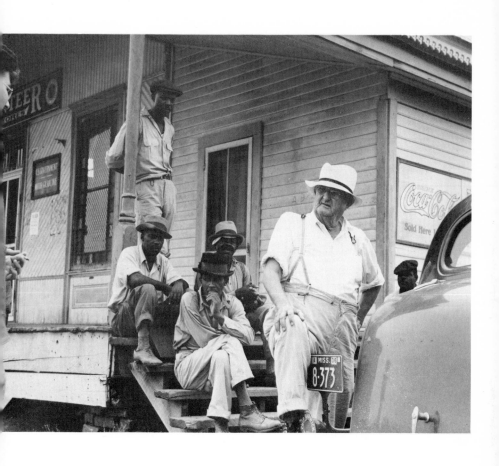

Dorothea Lange: ''Plantation Owner, near Clarksdale, Mississippi,'' 1936.
Courtesy The Library of Congress.

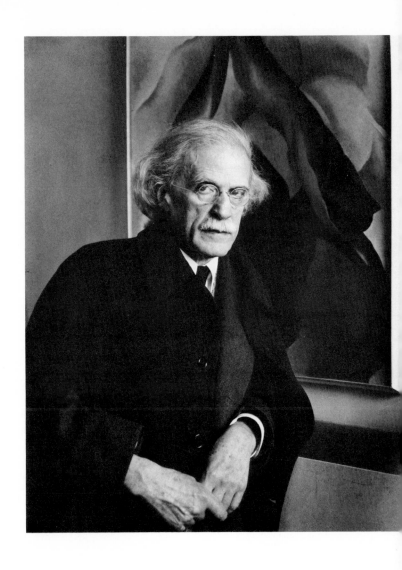

Imogen Cunningham: ''Alfred Stieglitz, Photographer,'' 1934. Courtesy The Imogen Cunningham Trust, San Francisco.

Imogen Cunningham: ''Self-Portrait on Geary Street,'' 1958. Courtesy The Imogen Cunningham Trust, San Francisco.

Minor White: ''Cobblestone House, Avon, New York,'' 1958. Courtesy The Minor White Archive, Princeton University, New Jersey.

InFraRed Film - Red FilteR.

Minor White: ''Wall, Santa Fe, New Mexico,'' 1966. Courtesy The Minor White Archive, Princeton University, New Jersey.

Frederick Sommer: ''Circumnavigation of the Blood,'' 1950. Courtesy Light Gallery, New York.

Frederick Sommer: ''Fighting Centaur,'' 1952. Courtesy Light Gallery, New York.

Jerry Uelsmann: ''Questioning Moments,'' 1971. Courtesy the artist.

Jerry Uelsmann: ''Untitled,'' 1972, from *Silver Meditations*, 1975. Courtesy the artist.

Duane Michals: ''Paradise Regained'' (nos. 1 and 6 in a sequence of six), 1971. Courtesy the artist.

Alice's Mirror

One Two

Three Four

Five Six

Duane Michals: ''Alice's Mirror,'' 1975. Courtesy the artist. Print by Joe Maloney.

Lee Friedlander: ''Self-Portrait, New York City,'' 1968. Courtesy the artist.

Lee Friedlander: ''Route 9W, New York State,'' 1969. Courtesy the artist.

August Sander: "Widower with Sons," 1925. Courtesy Sander Gallery, Inc., Washington, D.C.

Diane Arbus: ''A Flower Girl at a Wedding, Connecticut,'' 1964. The Estate of Diane Arbus, New York. Print by Joe Maloney.

Lucas Samaras: "Auto-Polaroids," 1971. Courtesy The Pace Gallery, New York.

Garry Winogrand: ''Untitled,'' from *The Animals,* 1969. Courtesy the artist.

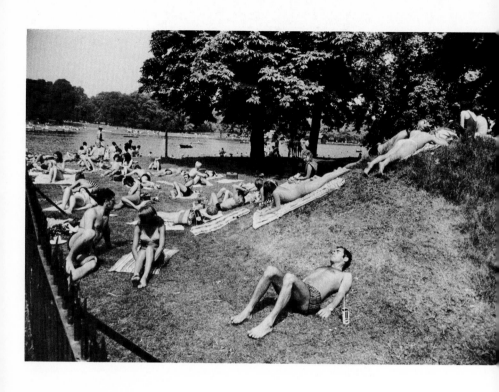

Garry Winogrand: ''Untitled,'' 1974, from *The Snapshot,* 1974. Courtesy the artist.

own eye with that of the camera.) The same, of course, goes for the re-flexes caused by her forbidding subjects in themselves. For some of them get defined by their class or social situation, others by their compulsions, and several by their abnormal physical condition. Thirty-three years after he played in Tod Browning's *Freaks*, a Russian midget poses among friends for Diane Arbus. Yet, despite the spectrum of social contacts in-voked by her work, it seems by and large, a witness of great loneliness.

For if human features as matter are not that pliable to the lens, the space that encloses or opens around them can tell of their plight—and with Arbus that space is frightening and oppressive. Sometimes, then, the face is brought excruciatingly close up, giving us no relief from nose-rub-bing confrontation. At other moments, people are seen in just the reverse, as if through the wrong end of a low-power telescope, so that they look diminished and surrounded by an emptiness of barren room or smoky field. "Four People at a Gallery Opening," an example, is neatly handled as a combined news and fashion item, but with what a difference! In either case, the normal canons of distance in portraiture are violated, and men and women appear to live in a world visited by some glandular dis-turbance. The fascination of twins or look-alikes, the plethora of masks these subjects wear, the tattooed man and the carnival sword-swallower, the mongoloids and the malignant children, what are these if not some weird inflection of that disturbance?

One of the amazements of Lucas Samaras's auto-Polaroids lies in the fact that he rarely if ever peered through the viewfinder when the shutter clicked. How he would look to himself, or how best to compose his visage and gesture, he never saw at the second it mattered. Amazing, because nothing in his uncropped output, shot through with complex and quirky compositions, looks like guesswork. One imagines him racing to assume his pose against the timer and triumphing always with flair and virtuosity in slightly panicky situations. This Greek-born sculptor, in his mid-thir-ties, long practicing a kind of horrific narcissism in his primary media, recently found in Polaroid, the just mirror of his fancy.

Artists' self-portraits always fascinated me. I wanted to see the face that was responsible for the deed. Anyway, I was always inside-out rather than out-side-in . . . My body is one of the materials I work with. I use myself and

> therefore I don't have to go through all the extraneous kinds of relationships
> like finding models and pretending artistic distance (*The Samaras Album*).

Yet, "It isn't only me that I'm looking at, it's a work. It is a positive withdrawal." What a feat to be a peeping tom upon yourself, an erotic object to your own subjectivity. No categories can be distinguished anymore in this program—neither home nor workplace, subject from object, body or spirit, latent nor manifest content, least of all, visual art from photography. I would go further and say that the chasm between the one and the many doesn't exist in this work overall. He would eke out from images of his flesh a hundred different psyches, hew from them the macrocosm of a race. These modest little home photos show a one-man republic. Still, he blinks away all aesthetic distance but wants a "positive withdrawal." Despite his indelible presence, the truth is that there is no historicity in it. The charades of this imposter break open the connection between sign and signified in the portrait, inconclusive as that may already have been. To be sure, we know quite well what he means, but we are handed every weapon with which to disbelieve it. And so, a kind of megalomaniac articulateness recedes back into silence.

Samaras amplifies the bad taste needed by Arbus to carry out her most chilling effects. On the other hand, he outdoes the systematic inventory that made Sander's ambition impressive. Every garish and cheap manipulative trick, forgotten or stigmatized in the lexicon of photography, he puts to work: double or multiple exposure, fade-outs, cellophane colored filters, movie premiere illumination, halo lighting, running, many of them, up and down the f-stops. He will not hesitate to ink or paint on his prints with a Chiclet pointillism. And there is nothing the matter with an orange foot emerging from a green thigh. Meanwhile, he puts his mimic talents through their paces. One discovers Lucas the howler, the ecstatic, the coquettish, the gangster, the saintly, the infantile, the paranoid, or any other emotionalistic mask, you name it, that would besmirch his normally pleasant features. If this weren't enough, he places the camera at the nerviest angles, so that you might feel like an ant under his naked heel, or, more extreme still, a bugger or a crucifier. Under such circumstances, his figure turns into the craziest putty, and the well-known looming distortions of a stretched depth of field are nowhere more promiscuously han-

dled than here. So radical is the leap from the flat painted surface to the tiny, foreshortened rear of head or toe that the space involved seems almost astronomical.

Still, these mock aggressions are put into series analogically juxtaposed with each other. *The Samaras Album* is filled with "runs" in which the subject seems to be rolling languidly over from shot to shot, crawling away, quietly slipping above or beneath the frame in a progressive manner, and otherwise worming, sniffing, or pawing to get out at some invisible crease in the middle, or over into the next photo. Obviously there is a cinematic mind at work here (natural in one who starred in his own movie, called *Self*). He is anxious to give his life, as revealed through his face and body, a narrative dimension. In contrast though he is just as emphatic in his will to make all this—the two feet one of which is a hand, the fusion of male and female—into a satisfying, repeated pattern. In the autointerviews of Lucas Samaras we come upon the first account of how it feels to be a model for one of those uncanny portraits which is treated objectively as a thing by itself. Certainly, too, they contain the only testimony of a portraitist who submitted to the exposure with which others are psychologically undressed. "When people make comments about my body I feel peculiar. They can't see my separation from it." Yet this is a body most characteristically seen in the act of making different kinds of love to itself. Could there be any poetic justice in the fact that a Polaroid, the ideal, illicit medium for recording a naked flounce at home, comes into being with the destruction of its negative? "What is your reflection to you? A disembodied relative."

"To think," wrote Rilke in *The Notebooks of Malte Laurids Brigge*

that I have never been aware before how many faces there are. There are quantities of human beings, but there are many more faces, for each person has several. There are people who wear the same face for years; naturally it wears out, it gets dirty, it splits at the folds, it stretches, like gloves one has worn on a journey. These are thrifty, simple people; they do not change their face, they never even have it cleaned. It is good enough, they say, and who can prove to them the contrary? The question of course arises, since they have several faces, what do they do with the others? They store them up. Their children will wear them. But sometimes, too, it happens that their dogs go out with them on. And why not? A face is a face.[1]

[1] I should like to thank Gert Schiff for his translation.

Transcribed and edited by
Dennis Longwell

Garry Winogrand (1928–) asserts that his photographs are statements about the problems of photography. Winogrand's view validates the integrity of photography that is distinguished for exclusive formal preoccupations. For Winogrand a photograph's descriptive representational content is secondary. His work attempts to broaden established notions of photographic subject matter. His books include The Animals *(1969) and* Women Are Beautiful *(1975).*

In this interview Winogrand wrestles with the continuing artistic controversy about the relationship between form and content in a work of art. In part Winogrand is reacting against the accusation that photography is an uncreative, merely reproductive, medium.

> In an artistic work of true beauty the content ought to be nil, the form everything. . . . The secret of great artists is that they cancel matter through form; the more imposing the matter is in itself, the greater its obstinacy in striving to emphasize its own particular effect, the more the spectator inclines to lose himself immediately in the matter, so much more triumphant is the art which brings it into subjection and enforces its own sovereign power
>
> —JOHANN CHRISTOPH FRIEDRICH VON SCHILLER (1759–1805)
>
> Art is the supreme game which the will plays with itself. . . .
>
> —SUSAN SONTAG (1933–)[1]

* Reprinted from *Image* (July 1972).

[1] Schiller is quoted by Roland Rood in his book, *Color and Light in Painting* (New York: Columbia University Press, 1941), p. 8. Miss Sontag's statement appears in her essay, "On Style," from her book, *Against Interpretation* (New York: Farrar, Straus & Giroux, fourth printing, 1969), p. 33.

Garry Winogrand spent two days in Rochester, New York, in October 1970. On Friday the 9th, he was the guest of the Rochester Institute of Technology. On Saturday the 10th, he visited the Visual Studies Workshop, also in Rochester. The format was identical on both occasions. Winogrand, without comment, showed slides of his latest work and then answered questions from the student audiences. All in all, he talked for over five hours. The following transcript, edited from a tape recording of the proceedings, represents but one idea among the many ideas that were touched on.[2]

Rochester Institute of Technology, October 9, 1970

Q. I saw a photograph that—there's a photograph that had "Kodak" and there's a kid holding a dog—

A: Yeah.

Q: —and the people kind of wandering in and out. Now, it might be due to my own ignorance or something, but could you give me like a straight answer as to what you're trying to say in that photograph?

A: I have nothing to say.

Q: Nothing to say? Then why do you print it?

A: I don't have anything to say in any picture.

Q: Why do you print it if it has no meaning?

A: With that particular picture—ah, I'm interested in the space and I maybe can learn something about photography. That's what I get from photographs; if I'm lucky, I can learn something.

Q: Then you're trying to reveal something about space?

A: I'm not revealing anything.

Q: Then what do you think is the purpose of the photograph if you're not revealing anything.

A: My education.

Q: Then what's the purpose of that? That's what I'm trying to find out.

A: That's the answer. That's really the answer. . . .

[2] It is hoped that the interview will seem to the reader to have happened exactly as it is printed. While the questions and responses occurred in the order in which they appear, large sections—some as long as an hour—have been removed from the text. Ellipses (. . . .) have been used to indicate omissions.

Visual Studies Workshop, October 10, 1970

Q: Yesterday at R.I.T. somebody asked you what are you trying to say in a certain picture and you said you weren't trying to say anything. He jumped to the conclusion that it was meaningless, and if it was meaningless, why did you bother to print it, and they seemed very confused about this. Could you tell me what—I think I know what you're saying and I like it but I—

A: Tell me.

Q: I can't tell you, but if you'd do it again I might get a closer idea.

A: My only interest in photographing is photography. That's really the answer.

Q: In other words it isn't social comment, it isn't ah—

A: When you photograph—there's [*sic*] things in a photograph. Right?

Q: Yeah.

A: So this can't help but be a document or whatever you want to call it. It's automatic. I mean if you photograph a cake of soap, in the package or out of it, it goes without saying—

Q: But that's not what you're concerned about. I mean, your concern is photography.

A: That's it. And I have to photograph where I am.

Q: If you were somewhere else—if for some reason you went to Arizona or Alaska, would you photograph—

A: Then that's what the pictures would look like, whatever those places look like.

Q: Is your choice of subject matter just limited by where you are, by the fact that you live in New York?

A: Yeah, I mean there are pictures in here from California and some other places, too.

Q: Yeah. But you return to certain things, though, which have more to do than just with place. Like you've got a thing about dogs no matter where they are.

A: Dogs are everyplace.

Q: You've got a thing about, say, personal injury.

A: That has to do with photography—I'm not interested in injuries. Believe me I'm not.

Q: What about the reoccurrence of, say, oh, monkeys, which goes back—

A: Listen, it's interesting; but it's interesting for photographic reasons, really.

Q: What are photographic reasons?

A: Basically, I mean, ah—well, let's say that for me anyway when a photograph is interesting, it's interesting because of the kind of photographic problem it states—which has to do with the . . . contest between content and form. And, you know, in terms of content, you can make a problem for yourself, I mean, make the contest difficult, let's say, with certain subject matter that is inherently dramatic. An injury could be, a dwarf can be, a monkey—if you run into a monkey in some idiot context, automatically you've got a very real problem taking place in the photograph. I mean, how do you beat it?

Q: Are you saying then that your primary concern is a kind of formal one?

A: Of course.

Q: In what sense "formal?" Getting things on the page? Filling up the space?

A: You can't help doing that either; I mean, it just automatically happens when you make an exposure.

Q: Well, then I don't understand what the "formal" problem is.

A: It's, ah—

Q: —to make it not look formal.

A: No, sorry. You've got a number of things that take place that are peculiar to still photography. One: how a picture looks—what you photograph is responsible for how a photograph looks. In other words, it's responsible for the form.

Q: It, or are you?

A: What you photograph is responsible for how a photograph looks—the form, the design, whatever word you want to use. Because of that there's no way a photograph has to look . . . in a sense. There are no formal rules of design that can apply. In other words, a photograph can look anyway. It just depends basically on what you photograph.

Q: Well, the choice of the 28mm lens over a 50mm is going to give you a different looking photograph.

A: It makes the problem—it ups the ante in a way, if you want to put

it that way. You have more to contend with. Maybe it makes the problem a little bit more interesting.

Q: I always feel very precarious when I look at your images. I feel like I'm falling over. Is that because you're not—you don't use a viewfinder?

A: I don't know why you feel the way you feel. . . . What are you asking?

Q: Actually, what I'm asking is do you often shoot without using your viewfinder?

A: I never shoot without using the viewfinder—Oh, yes, there'll be a few times—I may have to hold the camera up over my head because for just physical reasons, but very rarely does that ever work.

Q: Are you conscious of that?

A: Of what?

Q: Of sort of an off-kilter thing happening?

A: Oh, yeah, sure. I pretty much know what I'm doing.

Q: Is that an attempt to solve a photographic problem?

A: Generally it's to make one. Another reason can be just because physically I might have trouble to get what I want to include in [the frame], you know, just physically. And that's a good reason.

Q: You were talking about this in terms of it being a problem and you said something before about, you know, like if there were monkeys and they're in a strange context—are you saying that made the problem more difficult?

A: Yeah.

Q: Why do you think that is? You know, if you've already got this strange thing in front of you, why does it make it more difficult for you to make, you know, the—

A: Because that's what I know. It would be a boring photograph, at least to me, if it didn't involve itself in my game—whatever.

Q: Well, like the photograph of the black man and the [white] woman with the two monkeys—

A: Yeah, what about it?

Q: Like, was that difficult to make?

A: I don't know if that photograph is really—this selection is things I'm just thinking about more than anything else. It's all over the place. I don't know if that [picture] is that interesting photographically. I'm

still—I mean, you know, it's a sort of an automatic "yuk," I guess, and that could destroy you. I don't know. . . .

Q: I'm wondering what, like, your concern with this is. Why photography?

A: I told you before. It's, ah—the thing itself is fascinating. The game, let's say, of trying to state photographic problems is, for me, absolutely fascinating.

Q: You keep trying to know more and more about the game?

A: I'm trying to learn more and more about what's possible, you know—really, I am answering your question.

Q: Yeah.

A: I'm not dissembling.

Q: Any change in your work you would attribute to somehow learning—the learning process?

A: Yeah. I think if I did a tight editing, let's say, of this bunch [of photographs], I'd say I'm a different photographer here than from those animals or whatever.[3]

Q: Were the animals done in a concentrated period of time or did they just kind of pop up as you—

A: Basically, they were done in a relatively concentrated period of time. I mean, I wasn't just working on them. But, I'd say I can safely say over a year's—about a year I went on—yeah, when I knew I had a game to play there. . . .

Q: Do you look at a lot of other people's photographs?

A: Sure. I look at photographs.

Q: Whose photographs do you find interesting?

A: Quickly, off the top of my head: Atget, Brassaï, Kertesz, Weston, Walker Evans, Robert Frank, Bresson.

Q: Do you like them for different reasons or do you find a reason?

A: I learn from them. I can learn from them.

Q: On the problem level, do you feel they've solved a problem, and you think, "Thank God, I don't have to do that"?

A: It's not a question of solving. It's a question of stating.

[3] Garry Winogrand, *The Animals*, with an afterword by John Szarkowski (New York: The Museum of Modern Art, 1969).

Q: Stating?

A: Yeah. You don't solve anything ever, really. You simply state a problem which, when you're lucky, gives you some idea of what possible problems you can—it indicates, you know, your future headaches.

Q: But that's all related to the idea of the *game*—it's being a *game?*

A: Whatever word you want to use—you want to use *work?* Use the word *work*.

Q: Work—play—

A: I use the word *play;* but you understand the word *play*—if you ever watch children play—what do you observe when you watch children play? You know, they're dead serious. They're not on vacation.

Q: If the problem you're working on now is the contest between form and content, what was the problem before?

A: It's always—every photograph, every—somehow bang of the shutter—basically, I'm playing the *game* in a way.

Q: When you first started photographing, what was your, like primary interest in picking up the camera? Did you like people?

A: No, the process, really. I really liked—it was a very crazy thing to me, I mean, this business of being uncertain that it would come out. I still enjoy—I still don't understand why when you put a piece of paper in a tray with solution in it, it comes up. It's still, in a sense, magic to me. It's a funny thing, you know. I've got two kids, and when they were very young, they used to come in the darkroom and I thought they'd be astounded by that. Nothing. When they got a little older, *then* they got astounded by it. . . .

Q: Is it relevant to ask what you were doing before you began to take pictures?

A: I don't know. . . . I had a camera but I had no darkroom facilities, nothing like that was available. And so, you know, I shot a roll of film, I sent it in, and stuff like that. And I was painting. I was studying painting, which is not valid because it's ridiculous to talk about it. But I was at Columbia [University] and they had a camera club. I think I registered there for the fall term. And so I found out about this camera club and they told me they had this darkroom available twenty-four hours a day. And I'd never done any darkroom work, so I went down. It must have been two weeks after I started there, and I'd say, give it another

week, and I never went back to class. I'm telling you, it was basically the process. . . .[4]

Q: Well, like let's say [Robert] Frank's book of photographs—[5]

A: What about it?

Q: You talked about learning from—

A: Yeah—

Q:—his stuff—

A: I hope I did. I learned—

Q: I'm interested to learn, like, when you looked in the book, like, do you think there's anything you can say afterward what, you know, "I learned" or what might be different in your work afterward?

A: Well, let's put it—you have to talk, speak about photographs, specific photographs. . . . Let's say, primarily—let's say Walker Evans in a general sense was maybe the first man who, in his book, states that you could—or rather the work states that America was a place to photograph in. Just on that level. Of course, there's much more about those photographs; they're astounding.[6]

Q: You think you can get different things from a specific photograph?

A: Yeah, you can go into your own mumbo jumbo.

Q: Would you go into a mumbo jumbo about [Robert] Frank's photograph of the flag or would you just look at it?

A: That photograph doesn't interest me that much. There are photographs in there far more interesting. The gasoline station photograph would be.[7]

Q: Would you go into a mumbo jumbo or would you just look at it?

A: That [the gasoline station] photograph, in the first place, is an ex-

[4] Winogrand studied painting at City College of New York and Columbia University, 1947–1948. He began to photograph in the U.S. Air Force during World War II when he worked as a weather forecaster. He studied photography with Alexey Brodovitch at the New School for Social Research in 1951. See *Camera*, 51, no. 2 (February 1972) p. 41; *Documentary Photography* (New York: Time-Life Books, 1972), p. 190.

[5] Robert Frank, *Les Américains,* textes réunis et présentés par Alain Bosquet (Paris: Encyclopédie Essentielle, 1958); Robert Frank, *The Americans,* Introduction by Jack Kerouac (New York: Grove Press, 1959); Robert Frank, *The Americans*, Introduction by Jack Kerouac (New York: Grossman, revised edition, 1969).

[6] Walker Evans, *American Photographs*, with an essay by Lincoln Kirstein (New York: The Museum of Modern Art, 1938).

[7] See page 89 in the French edition; the American editions are unpaged.

ercise in, ah—it's a lesson, number one, in just camera operation, in a sense. It's a lesson in how responsible that machine is for how photographs can look. Begin with that. To me that was one of the most important pictures in the book. It's also a photograph of nothing, there's nothing happening there. I mean, the subject matter has no dramatic ability of its own whatsoever and yet somehow it looks, what it is, it's the most mundane—and there's nothing happening, there's no physical action.

Q: You get the feeling that he played the game very well?

A: Extremely well. That he could conceive of that being a photograph in the first place is, ah—I don't know if he, on any conscious level, thinks in terms of this "game" or whatever. And I certainly don't really, in a conscious way, worry about it when I'm working. The contest between form and content is what, is what art is about—it's art history. That's what basically everybody has ever contended with. The problem is uniquely complex in still photography.

Q: How so?

A: Well, in terms of what a camera does. Again, you go back to that original idea that what you photograph is responsible for how it [the photograph] looks. And it's not plastic, in a way. The problem is unique in photographic terms.

Q: Well, if what you photograph is responsible for what it looks like, what if ten people take a photograph of the same thing?

A: The same way? If they're standing in the same place, the same kind of lens on the camera, the same film, the right exposure, and their cameras are in the same position? It would be the same picture—The camera's dumb, it don't [*sic*] care who's pushing the button. It doesn't know—

Q: What is it, say, in a photo that makes it interesting instead of dead; what makes it alive instead of dead?

A: Well, let's say—let's go back to that gasoline picture. . . . Let's say [it's] the photographer's understanding of *possibilities*. Let me say something else. When he [Robert Frank] took that photograph, he couldn't possibly know—he just could not know that it would work, that it would be a photograph. He knew he probably had a chance. In other words, he cannot know what that's going to look like as a *photograph*. I mean, understanding fully that he's going to render what he sees, he still

does not know what it's going to look like as a photograph. Something, the fact of photographing something changes—I mean, when you photograph—if I photograph you I don't have you, I have a photograph of you. It's got its own thing. That's really what photography, still photography, is about in the simplest sentence, I photograph to find out what something will look like photographed. Bascially, that's why I photograph, in the simplest language. That's the beginning of it and then we get to play the games.

Q: But the thing that's intriguing is not really knowing what the result is going to be like.

A: Of course. What I know bores me. You know, you get into the business of commercial photography, and that's all you do is photograph what you know. That's what you're hired for. And it's very easy to make successful photographs—it's very easy. I'm a good craftsman and I can have this particular intention: let's say, I want a photograph that's going to push a certain button in an audience, to make them laugh or love, feel warm or hate, or what—I know how to do this. It's the easiest thing in the world to do that, to make successful photographs. It's a bore. I certainly never wanted to be a photographer to bore myself. It's no fun—life is too short. . . .

Q: Do you shoot pool?

A: What?

Q: Do you shoot pool?

A: I have, yeah. I was good. Ah, yeah, why?

Q: I shoot pool, I don't know—

(*tape unclear*)

A: There was a time in my life when I lived in one [a pool room?], you know, when I was a kid. Once in a while I get a chance—

Q: I feel the same thing, like how you're talking about photography—I don't know—I can't—

A: All right.

Q: You feel you've been hustled in a pool room. . . . Are there any other things that relate photographically that are not necessarily other photographs? By this I mean, do you ever get ideas—not ideas—is your education ever expanded by an interest in something else other than photography?

A: I would think so. A heck of a lot. Reading and music and painting and sculpture and other stuff. Basketball, baseball, hockey, etc. Certainly, you know, you can always learn from some—from somebody else's— from some intelligence. I think. I hope. Nobody exists in a vacuum. Where do you come from? The first time I really got out of New York as a photographer was in 1955 and I wanted to go around the country photographing. And a friend of mine, at that time, I was talking to him about it—a guy named Dan Weiner.[8] I don't know if you know his name. He's dead now. [He] asked me if I had ever seen Walker Evans's book and I said no I had never heard of Walker Evans. He said, if you're going around the country, take a look at the book. And he did me a big fat favor.

And then it's funny, I forget what year when Robert Frank's book came out. He was working pretty much around that time, '55 or whenever it was. And there were photographs in there, particularly that gas station photograph, that I learned an immense amount from. I mean, I hope I learned. At least, I feel very responsible . . . (*tape unclear*)

Q: What you're responding to, is it the quality of the intelligence that states the problem?

A: Yeah, I don't give a rap about gasoline stations. . . .

[8] Dan Weiner (1919–1959). See *Documentary Photography* (New York: Time-Life Books, 1972), p. 112; Cornell Capa, ed., *The Concerned Photographer* (New York: Grossman, 1968), unpaged.

Les Levine

Les Levine (1935-) is an advocate of conceptual art; he values art as an intellectual process. In his activities as an artist and a writer he challenges traditional notions of artworks as objects of aesthetic appreciation. He uses video tape, photography, mass media, and varied materials in his work.

In this essay Levine defines Camera Art as the use of the photographic medium by advanced artists. These artists do not consider themselves photographers. They are uninterested in the technical aspects of image-making in any art form. Levine is enthusiastic about the potential of photography to document ideas, gestures, and experiences.

Levine is president of the Mott Museum of Art in New York City and writes about radical art developments for various publications. This essay was included in the exhibition catalog for "Camerart" at Galeria Optica, Montreal, in 1975 and "Camera Art" at Lund Konsthallen, Sweden, in 1975.

The expression "the camera never lies" is a lie. Anyone who has ever looked through a camera would realize that what the camera sees is by no means the same as what the eye sees. With the eye you can look at all that is before you, whereas the camera only frames a small part of it. It's as though you are looking at the world through your eyes and as soon as you put the camera to your eye, you are defining which part of it you really want to see.

The artist in taking a photograph has framed its contents with the lens of the camera, creating a context by deciding what should be in the frame and what should not. So what is inside the frame is art and what is outside is life. Or it is like taking a lens and putting it over the exact spot of the world you want to examine. It's as though the camera were a new form of magnifying glass.

Paintings or drawings require framing to set them apart from the rest of

* Reprinted from *Studio International* (July/August 1975).

the environment, to make it clear where the context of art begins and ends. The camera is an automatic framing device. Photographs do not require framing, because a mind-set frame is already implied by the picture itself.

Paintings and drawings are extensions of the hand. The camera is the extension of the eye. In Camera Art the mind is the tool, whereas in painting and drawing the hand is the tool. Camera Art is a postcraft discipline. In painting and drawing the physical skills of the artist enhance the visual experience. In camera art such skills don't exist.

The painter and sculptor create images through a variety of physical-making processes, which are all an extension of the industrial world, by brushing, pouring, moulding, shaping, etc. The camera artist creates his images merely by seeing through a number of postindustrial devices, such as still cameras, vidicons, etc. The painter often goes through a series of processes to create an image. The camera artist merely processes images.

The relationship between artist and finished product in painting requires that the artist place his entire body in between the product and his mind. In Camera Art the only thing in between the product and the artist is a lens. Camera Art is an art of ideas. The body has been removed so that the mind may reach the surface more expressly.

All of the previous formal aesthetic problems have been absorbed by new technology. In technologies, later developments are invested with all previous experience, making the previous experience unnecessary and redundant. Those who are born into later technologies develop from that technological point onwards. Therefore, while a fifty-year-old painter may be more mature in terms of actual experience time, he is less mature than a twenty-five-year-old camera artist in terms of technological development time. Put more simply the camera artist is a product of this time and this generation. The painter is a product of a previous time with all its obsolescences. Camera artists are born in a time of computer technology, video tapes, automatic cameras, etc., and accept them as part of the natural environment. The painter calls such things "new technology, a stranger coming into town to upset artistic order."

New technology has changed our method of counting time and space, of seeing and feeling. Time must now be measured in terms of psycho-technical advances or more logically counted in generations of generative

systems as opposed to actual or calendar years. How many years would it take an unassisted individual to reach the same level of perception as it takes another individual aided by a computer? Advances in the artificial intelligence field are more accurate ways to gauge aesthetic development within the perceptive mind.

For the most part camera artists are attempting to use the phenomenology of "perception architecture" (the way the mind works) as the context for their art. The precamera artist will watch a person make a statement on TV and judge the statement on the basis of how clearly the statement is formed in language. The camera artist listens to the statement, collates it to the texture from which it is transmitted to come up with an aggregate mind-set. That is to say, if President Ford says he's appalled by the cost of living, the precamera artist assumes that he's telling them that he is appalled by the cost of living. The camera artist, the vidicon generation, looks at the shirt he is wearing, the colour of his tie, the texture of his face, and comes up with the aggregation: this texture and that image in that form is saying, "I am appalled at the cost of living." What has been said for the camera artist lies somewhere in between the phenomenology of striped silk ties, blue serge suits, and the cost of living.

The context for Camera Art, then, is the brain itself and whatever previous experimental developments the brain has been able to accumulate. The brain is an anti-intellectual organ. It merely intellectualizes as a preamble to perception. Perception allows the brain repose. Intellectualization forces the brain to work. And the brain only does this task of work so that it can obtain the repose of perception. The brain shows no preferences to information sources. The brain couldn't care less where its information is coming from.

The camera artist's context is his metapsychology and his own phenomenal relationship to time and space. Wherever the camera artist finds his brain responding to some kind of feedback from the environment or wherever his perception is activated is where the camera artist makes his work. Camera Art for the most part is a poststudio art. Anywhere the camera artist is becomes his studio.

For most camera artists, perception probably lies in the area of speed-reading, the semiology of any given cybernetic reflex. The camera artist

attempts to read the language of the space he finds himself in and acts upon it accordingly, in other cases to define the difference between information and knowledge. Knowledge is in the realm of understanding, something known, something understood based on previous experience. Information merely implies transmission. To inform is an act of transmission. Information makes no reference to the qualitative value of that which has been transmitted. The best camera artists collate these transmissions with previous experience and attempt to turn them into knowledge.

The question that often comes up in art experiences is "This could not have been done at any time; this could only be done at this period in history." It seems to be important that these works indeed could not have been done before the camera had arrived at the state that it is at this moment in time. Most cameras are completely automatic. They require no skill in operation. It's also interesting that this enormous glut of Camera Art is occurring at a period when photojournalism is seeing its demise because of infringement by electronic media. We have seen magazines such as *Life, Look, Saturday Review,* and various other photo magazines go under. Famous photojournalists no longer have a magazine market for their material, which seems to bear out the old idea that artists always come to a material after it has been totally established within society.

Most works that are concerned with Camera Art or information art are using the media as a form of evidence-creating. The photographs or documents act pretty much in the same way they are used in the courtroom. They are not to be considered for their own particular aesthetic quality, as good or bad photographs. If the question comes up, "Here's an artist who has produced photographs, but they are not as good as Avedon, or some other renowned photographic artist," then I think the distinction needs to be made that the aesthetic quality of the photographs is not an issue. They're merely a form of circumstantial evidence to prove that in fact a specific thing has occurred and this is the way it looked when it did occur.

In the best of Camera Art is a particular aesthetic, perceptual, or conceptual experience that the artist has encountered in some way and finds the camera a useful tool in documenting for the consideration of others.

He is not, in most cases, concerned with the idea that it be a beautiful print or an ugly print or any other kind of print. It doesn't hurt the work if it is a beautiful photograph, but the primary concern is not to produce beautiful photographs.

The viewer, for the most part, becomes at least fifty percent of the diameter of the artistic circle. The viewer is left in the position of creating an intellectual structure that will complete the conception or perception of the artist.

The camera artist experiences a particular perception, conception, idea in normal, real life outside the realm of art history or art writing, in his everyday experiences, and he documents this experience. Camera artworks are open—they tend to have no taste or choice position, and this is valuable. At best, the camera artist is refusing on some level to be the intellectual nigger of a gross materialistic system. The artist is trying to stop saying things like "Yessir, boss, gettin' some colour in it for ya, boss. Yessir, boss, gettin' a nice composition in it for ya, boss. Yes, boss, makin' it beautiful for ya, boss. Makin' 'em apartment size, makin' 'em museum size, makin' 'em abstract, makin' 'em realistic. Yessir, boss, you do what you want with the world and we'll come in and pretty up your mess, boss." If society demands that the artist be no more than a minstrel who has got a few little happy tunes to make them feel comfortable after their hard day in the horror-environment of their daily work, then the artist may as well become a sofa manufacturer, because sofas can take care of that job better than the artist.

What the audience expects from the artist is that he be some heroic figure which they can look up to. They want him to say, "I'm the greatest fucking artist you've ever seen." But as soon as you've said it, they reply, "Look at that artist saying such awful, ugly, pretentious things about himself." And yet they still have to have the satisfaction of watching you present yourself as some kind of hero. They want you to do something they can't do. They want you to appear to be more in tune with life than they are, and if you don't allow yourself to be any better than they are or be any better for them, they're embarrassed and irritated. The audience has this middle-class conception about specialists and they want the artist to be a specialist who will not fall down on his job. So when they're embarrassed by him not being any better than they are, they don't just as-

sume that, indeed, maybe he is no better than they are. They won't accept the artist saying, "I'm no better than you are. I'm just as fucked-up as you are."

What they will say is "He's no good as an artist. That is awful art. What has that got to do with the great traditions of art?" Because being no better than they are is a state of madness as far as they can see. "That camera artist is an absolute psychological case. He needs treatment because they all need treatment." Now you've given them something which is a serious problem: a model of yourself as themselves. They have some understanding of that model and they start to see the nature of the model. So at that point they just automatically assume something has gone wrong. That they are not witnessing what they are supposed to witness. Their minds will not allow them to authenticate the experience they're having at that time. It's being dissatisfied with their situation, and the reason they got themselves into the situation in the first place was being dissatisfied with whatever they were doing before.

So the artist is going to straighten it out for us. The artist will show us how to see. The artist will see for us. But the artist tells you he can't see any better than you can. It is a condition of being alive, the relationship between the artist and whomever. It is a more universal relationship between everybody and their condition. So the state of dissatisfaction is a universal state for both the artist and the audience, only it's the artist who is pointing it out.

The audience wants the artist to create a situation which does not exist in their lives, which takes away the true image of their lives for them and, for a short period of time, puts them within a realm of fantasy life. Puts them in a realm of experience which makes life appear to be more beautiful, more acceptable, more pleasant, more palatable than they know it is really. In that situation the artist creating or attempting to create is like the destruction of creation. By attempting to create something or in creating something, he totally destroys the creative process. Because the creative process is not to create anything, but to allow what is happening to be absorbed by you, the artist, in such a way that you can express it and clarify it and make it clear, so that when you're making it clear, people might say that what you have done is creative. The only thing that *is* creative is to allow whatever is happening to be reabsorbed into itself,

which is what the artist does on his highest level. He mirrors it back, or it is just the making available of that particular experience or piece of information which the artist is sensitized to, however it manifests itself. That is essentially art. Anything other than that is blockage, commerce, exoticism, romanticism, humanism, psychology. But it is not art!

The camera artist has to respond to the underlying cultural anxiety of our society. And somehow he also has to shed light on that anxiety. He has to expose that anxiety in such a way that people can see it as an anxiety and not take it to be part of an equilibrium. But see that it's not part of their equilibrium, that it's a negative force that is trying to upset them and pull the rug out from underneath them. Besides that, the only thing the audience has to do is to feel it. What generally happens with anxiety is that you try to anesthetize it so that you don't feel the pain. You know the anxiety is there because you feel it and you try to get rid of it as quickly as possible, with alcohol, smoking dope, etc. But the whole point is to feel the anxiety because then you begin to understand the nature of the anxiety that is destroying your mind and grabbing you in such a way that it is turning your mind to cancer, making you think that the old ideas are your rightful property, making you feel that because you've seen something before, you like it, and because you're seeing something for the first time, you don't like it.

Art cannot be a way of escaping reality, of covering over what is lousy, of putting a screen between you and real experience. "If I only had art now, I wouldn't have to see what really is there, or how horrible and disgusting my ugly life is." Art is a way of cutting through to your own reality, getting through to that space in which you understand what is making the things around you occur in all their ugliness, in all their beauty. What one should demand of life is that you are authentically having your own experiences. They're not somebody else's version of how you should experience something or what you should think about what you're experiencing, but your way of cutting through to your reality, to feeling what you feel at this given moment.

What a serious artist should be doing with Camera Art is producing a kind of self-induced media psychodrama in which he shows the way he feels and experiences things, although *psychodrama* is too complicated a

word for it. It's like the artist is in a state of sensing and he makes records of that state of sensing. The feeling becomes exaggerated in a way so that it may be transmitted to others.

Advanced art can now be defined as social software, knowledge, and perceptions that understand and refer to realities in the environment that make us behave the way we do. It is the artist's job to show us the shape of what we've got and how it works. The point is to take art out of the realm of special or particular exotic interest and put it within the range of believable experience. Experience that at least gels with the nature and type of culture that we live in, that at least gels with the way we are, think, feel, and see as a people.

Good taste at this time in a technological democracy ends up to be nothing more than taste prejudice. If all that art does is create good or bad taste, then it has failed completely. In the question of taste analysis, it is just as easy to express good or bad taste in the kind of refrigerator, carpet, or armchair that you have in your home. What good camera artists are trying to do now is to raise art beyond the level of mere taste. Camera Art must be completely devoid of logic. The logic vacuum must be there so that the viewer applies his own logic to it, and the work, in fact, makes itself before the viewer's eyes. So that it becomes a direct reflection of the viewer's consciousness, logic, morals, ethics, and taste. The work should act as a feedback mechanism to the viewer's own working model of himself.

Camera artworks that heavily rely on aesthetic presence of one sort or another generally fail because the value of Camera Art does not lie within the area of aesthetics. Its value has something to do with the instantaneous capabilities of the medium. The capability to almost make your mind and your eye work simultaneously and to catch a moment of real experience, of real perception, in such a way that it eliminates the difficulty in having a thought and having to spend a lot of time to create something from that thought. It's a more immediate form of expression. And because of that, any serious concern with the aesthetic nature of the final product would tend to detract from the immediacy of the conceptual experience. That you are not really just presenting the experience as it occurred, as you felt it, but you are arbitrating the experience once again, wanting to add to the experience, to add aesthetics, prettiness, and frills to it. Once again putting it back within the realm of previous art.

So an important distinction has to be made between the kind of art which is primarily concerned with only presenting the photographs as a form of documentation of either a perception or a conception and the kind of art that seems to take the actual photograph seriously. The best Camera Art is not dealing with what painting and sculpture have dealt with before, but with how the particular contemporary mind responds to certain kinds of visual imagery that are around. Experiences that can be related to the medium of photography.

On the whole, the most important Camera Art is completely postconscious. It does not involve itself in perceiving the idea of consciousness. But in actual fact it's not mindless. A lot of Camera Art is just involved in what I assume to be some form of nonintellectual, postconscious roleplaying. That is to say, the point of the art is mainly in expressing how you perceive things. Identifying the way you perceive and feel things. Fortunately or unfortunately, depending on how you look at it, most of the things that camera artists are dealing with are very ordinary, things that you've seen before, that you haven't seen in art, that you don't think are art, that you think are part of your everyday life. And you wonder why they should be art now merely because somebody has taken a photograph of them. Well, in reality they aren't art. They don't become art merely because somebody has photographed them. That hasn't changed their position, but what happens by the artist photographing them is that he relates to you his own particular experience of an object of which you've had an experience. So there's that common ground between the viewer and the artist in that the viewer knows the object or the experience very well. He's seen it or had it a number of times, and so has the artist. Except that in this case, it is the artist who is presenting the way he feels and sees that experience. There is, to a degree, something unique about his particular conceptual construction around that experience. But added to that there is always the possibility that because the artist is an ordinary person like you or I, the conceptual experience he creates around it or the perceptual construction that he creates around the particular ordinary thing that we both know may shed some light on our lives. Because we may have the same kind of ordinary feelings about it that he does. So as an audience we seem to feel that nothing has happened, that we're not witnessing anything, that no experience is occurring before us, that what is happening here already has happened in some way, that it doesn't take

us sufficiently out of our normal life-style or mind-set, in order to create an exaggerated sense of experience. A kind of an exaggerated sense of experience that would say: "This is art; life is not going on right now, but art is going on." That always happens when you use things within the common environment which tend to have no importance within the hierarchy of subject matter.

The audience generally assumes that there is no route to understanding the nature of quality within Camera Art, that it's all the same, all photographs. There's no way of saying that is a well-bent surface, that is nicely shaped, or there are a good pair of colors put together. But there is a way of judging whether Camera Art is good or not. It is important to say that you make a decision about how a person thinks, whether he is thinking well or whether he is thinking badly. It's not as easy to define as a paint surface that has been painted well or painted badly. The point I'm making is that to some degree qualitative judgments don't work. Because the qualitative judgments are based on notions of qualities that we've established from previous object art. If you want to use those values, there are no qualities. Perhaps *quality* is not a good word. I like to use the word *activate* as a better word.

All artworks, whether they be physical or subliminal, have to go through some kind of authentication process. It relies in the long run on the ability of the viewer to authenticate what is happening in front of him as a real, a genuine experience. The way one would authenticate a physical object is that it is well-made according to standards of how things are made. You know that is a beautifully shined piece of metal or well formed, or indeed that is a perfect likeness of something. The difficulty in Camera Art is that the authentication process is different in that we're relying on two conceptual elements meeting in the centre. The conceptual process of the artist and the conceptual process of the viewer have got to overlap in such a way that they "lock in," like a range finder on a camera. But it's always clear when it has happened. Sometimes you can't say why it's happened. But you can tell that "this" is offering you a deeper level of experience than that is. Or that the one over there is merely reinforcing a set of experiences which you've had before from some other medium. Quality in Camera Art comes down to the abstract ability of the art itself

to create genuine authentication. So that the thing in itself is not a question of I like it because it's good or bad. It activates because it is authentic, which is a different way of approaching quality. It relies on throwing out the idea of physical quality. If you're dealing with a conceptual structure, you'll have to find a conceptual mechanism to define the difference.

In Camera Art all the artists are photographers. But the differences one has to see are essentially mind-set differences in the way a person thinks. There are no physical differences. And that becomes a serious thing because the public is not used to making judgments on the quality of a conceptualization. The public does not know the difference between a good idea and a bad idea.

André Bazin

André Bazin (1918-1958) was a leader in the recognition of film as a serious field of study. He was associated with the French Catholic intellectual circle of Emmanuel Mounier. In 1947 Bazin founded and edited La Revue du Cinéma *changing its name to* Cahiers du Cinéma *in 1950 to voice his theory of film objectivity.* Cahiers *was influential in introducing New Wave filmmakers—Jean-Luc Godard, Eric Rohmer, François Truffaut—and the auteur approach to film criticism.*

In this celebrated essay Bazin analyzes the invention of photography and cinema as a radical event in the history of art. For Bazin, photography is superior to painting for revealing objective reality. Bazin is convinced that the photographic image is in fact the thing represented.

Bazin's essays have been translated into English and collected in What Is Cinema? *(2 volumes, 1967, 1971), edited with an introduction by Hugh Gray.*

If the plastic arts were put under psychoanalysis, the practice of embalming the dead might turn out to be a fundamental factor in their creation. The process might reveal that at the origin of painting and sculpture there lies a mummy complex. The religion of ancient Egypt, aimed against death, saw survival as depending on the continued existence of the corporeal body. Thus, by providing a defense against the passage of time it satisfied a basic psychological need in man, for death is but the victory of time. To preserve, artificially, his bodily appearance is to snatch it from the flow of time, to stow it away neatly, so to speak, in the hold of life. It was natural, therefore, to keep up appearances in the face of the reality of death by preserving flesh and bone. The first Egyptian statue, then, was a mummy, tanned and petrified in sodium. But pyramids and labyrinthine corridors offered no certain guarantee against ultimate pillage.

*Reprinted from *What Is Cinema?* vol. I (Berkeley, Calif.: University of California Press, 1967), pp. 9–16.

Other forms of insurance were therefore sought. So, near the sarcophagus, alongside the corn that was to feed the dead, the Egyptians placed terra-cotta statuettes, as substitute mummies which might replace the bodies if these were destroyed. It is this religious use, then, that lays bare the primordial function of statuary, namely, the preservation of life by a representation of life. Another manifestation of the same kind of thing is the arrow-pierced clay bear to be found in prehistoric caves, a magic identity substitute for the living animal, that will ensure a successful hunt. The evolution, side by side, of art and civilization has relieved the plastic arts of their magic role. Louis XIV did not have himself embalmed. He was content to survive in his portrait by Le Brun. Civilization cannot, however, entirely cast out the bogy of time. It can only sublimate our concern with it to the level of rational thinking. No one believes any longer in the ontological identity of model and image, but all are agreed that the image helps us to remember the subject and to preserve him from a second spiritual death. Today the making of images no longer shares an anthropocentric, utilitarian purpose. It is no longer a question of survival after death, but of a larger concept, the creation of an ideal world in the likeness of the real, with its own temporal destiny. "How vain a thing is painting" if underneath our fond admiration for its works we do not discern man's primitive need to have the last word in the argument with death by means of the form that endures. If the history of the plastic arts is less a matter of their aesthetic than of their psychology, then it will be seen to be essentially the story of resemblance, or, if you will, of realism.

Seen in this sociological perspective, photography and cinema would provide a natural explanation for the great spiritual and technical crisis that overtook modern painting around the middle of the last century. André Malraux has described the cinema as the furthermost evolution to date of plastic realism, the beginnings of which were first manifest at the Renaissance and which found its completest expression in baroque painting.

It is true that painting, the world over, has struck a varied balance between the symbolic and realism. However, in the fifteenth century Western painting began to turn from its age-old concern with spiritual realities expressed in the form proper to it, toward an effort to combine this spir-

itual expression with as complete an imitation as possible of the outside world.

The decisive moment undoubtedly came with the discovery of the first scientific and already, in a sense, mechanical system of reproduction, namely, perspective: the camera obscura of Da Vinci foreshadowed the camera of Niépce. The artist was now in a position to create the illusion of three-dimensional space within which things appeared to exist as our eyes in reality see them.

Thenceforth painting was torn between two ambitions: one, primarily aesthetic, namely the expression of spiritual reality wherein the symbol transcended its model; the other, purely psychological, namely the duplication of the world outside. The satisfaction of this appetite for illusion merely served to increase it till, bit by bit, it consumed the plastic arts. However, since perspective had only solved the problem of form and not of movement, realism was forced to continue the search for some way of giving dramatic expression to the moment, a kind of psychic fourth dimension that could suggest life in the tortured immobility of baroque art.[1]

The great artists, of course, have always been able to combine the two tendencies. They have allotted to each its proper place in the hierarchy of things, holding reality at their command and molding it at will into the fabric of their art. Nevertheless, the fact remains that we are faced with two essentially different phenomena, and these any objective critic must view separately if he is to understand the evolution of the pictorial. The need for illusion has not ceased to trouble the heart of painting since the sixteenth century. It is a purely mental need, of itself nonaesthetic, the origins of which must be sought in the proclivity of the mind toward magic. However, it is a need the pull of which has been strong enough to have seriously upset the equilibrium of the plastic arts.

The quarrel over realism in art stems from a misunderstanding, from a confusion between the aesthetic and the psychological; between true realism, the need that is to give significant expression to the world both concretely and in its essence, and the pseudorealism of a deception aimed at

[1] It would be interesting from this point of view to study, in the illustrated magazines of 1890–1910, the rivalry between photographic reporting and the use of drawings. The latter, in particular, satisfied the baroque need for the dramatic. A feeling for the photographic document developed only gradually.

fooling the eye (or for that matter the mind); a pseudorealism content in other words with illusory appearances.[2] That is why medieval art never passed through this crisis; simultaneously vividly realistic and highly spiritual, it knew nothing of the drama that came to light as a consequence of technical developments. Perspective was the original sin of Western painting.

It was redeemed from sin by Niépce and Lumière. In achieving the aims of baroque art, photography has freed the plastic arts from their obsession with likeness. Painting was forced, as it turned out, to offer us illusion and this illusion was reckoned sufficient unto art. Photography and the cinema on the other hand are discoveries that satisfy, once and for all and in its very essence, our obsession with realism.

No matter how skillful the painter, his work was always in fee to an inescapable subjectivity. The fact that a human hand intervened cast a shadow of doubt over the image. Again, the essential factor in the transition from the baroque to photography is not the perfecting of a physical process (photography will long remain the inferior of painting in the reproduction of color); rather does it lie in a psychological fact, to wit: in completely satisfying our appetite for illusion by a mechanical reproduction in the making of which man plays no part. The solution is not to be found in the result achieved but in the way of achieving it.[3]

This is why the conflict between style and likeness is a relatively modern phenomenon of which there is no trace before the invention of the sensitized plate. Clearly the fascinating objectivity of Chardin is in no sense that of the photographer. The nineteenth century saw the real beginnings of the crisis of realism of which Picasso is now the mythical central figure and which put to the test at one and the same time the conditions determining the formal existence of the plastic arts and their

[2] Perhaps the Communists, before they attach too much importance to expressionist realism, should stop talking about it in a way more suitable to the eighteenth century, before there were such things as photography or cinema. Maybe it does not really matter if Russian painting is second rate provided Russia gives us first-rate cinema. Eisenstein is her Tintoretto.

[3] There is room, nevertheless, for a study of the psychology of the lesser plastic arts, the molding of death masks for example, which likewise involves a certain automatic process. One might consider photography in this sense as a molding, the taking of an impression, by the manipulation of light.

sociological roots. Freed from the "resemblance complex," the modern painter abandons it to the masses who, henceforth, identify resemblance on the one hand with photography and on the other with the kind of painting which is related to photography.

Originality in photography as distinct from originality in painting lies in the essentially objective character of photography. [Bazin here makes a point of the fact that the lens, the basis of photography, is in French called the *objectif*, a nuance that is lost in English—Tr.] For the first time, between the originating object and its reproduction there intervenes only the instrumentality of a nonliving agent. For the first time an image of the world is formed automatically, without the creative intervention of man. The personality of the photographer enters into the proceedings only in his selection of the object to be photographed and by way of the purpose he has in mind. Although the final result may reflect something of his personality, this does not play the same role as is played by that of the painter. All the arts are based on the presence of man, only photography derives an advantage from his absence. Photography affects us like a phenomenon in nature, like a flower or a snowflake whose vegetable or earthly origins are an inseparable part of their beauty.

This production by automatic means has radically affected our psychology of the image. The objective nature of photography confers on it a quality of credibility absent from all other picture-making. In spite of any objections our critical spirit may offer, we are forced to accept as real the existence of the object reproduced, actually *re*-presented, set before us, that is to say, in time and space. Photography enjoys a certain advantage in virtue of this transference of reality from the thing to its reproduction.[4]

A very faithful drawing may actually tell us more about the model but despite the promptings of our critical intelligence it will never have the irrational power of the photograph to bear away our faith.

Besides, painting is, after all, an inferior way of making likenesses, an *ersatz* of the processes of reproduction. Only a photographic lens can give us the kind of image of the object that is capable of satisfying the deep

[4] Here one should really examine the psychology of relics and souvenirs which likewise enjoy the advantages of a transfer of reality stemming from the "mummy-complex." Let us merely note in passing that the Holy Shroud of Turin combines the features alike of relic and photograph.

need man has to substitute for it something more than a mere approximation, a kind of decal or transfer. The photographic image is the object itself, the object freed from the conditions of time and space that govern it. No matter how fuzzy, distorted, or discolored, no matter how lacking in documentary value the image may be, it shares, by virtue of the very process of its becoming, the being of the model of which it is the reproduction; it *is* the model.

Hence the charm of family albums. Those gray or sepia shadows, phantomlike and almost undecipherable, are no longer traditional family portraits but rather the disturbing presence of lives halted at a set moment in their duration, freed from their destiny; not, however, by the prestige of art but by the power of an impassive mechanical process: for photography does not create eternity, as art does, it embalms time, rescuing it simply from its proper corruption.

Viewed in this perspective, the cinema is objectivity in time. The film is no longer content to preserve the object, enshrouded as it were in an instant, as the bodies of insects are preserved intact, out of the distant past, in amber. The film delivers baroque art from its convulsive catalepsy. Now, for the first time, the image of things is likewise the image of their duration, change mummified as it were. Those categories of *resemblance* which determine the species *photographic* image likewise, then, determine the character of its aesthetic as distinct from that of painting.[5]

The aesthetic qualities of photography are to be sought in its power to lay bare the realities. It is not for me to separate off, in the complex fabric of the objective world, here a reflection on a damp sidewalk, there the gesture of a child. Only the impassive lens, stripping its object of all those ways of seeing it, those piled-up preconceptions, that spiritual dust and grime with which my eyes have covered it, is able to present it in all its virginal purity to my attention and consequently to my love. By the power of photography, the natural image of a world that we neither know

[5] I use the term *category* here in the sense attached to it by M. Gouhier in his book on the theatre in which he distinguishes between the dramatic and the aesthetic categories. Just as dramatic tension has no artistic value, the perfection of a reproduction is not to be identified with beauty. It constitutes rather the prime matter, so to speak, on which the artistic fact is recorded.

nor can know, nature at last does more than imitate art: she imitates the artist.

Photography can even surpass art in creative power. The aesthetic world of the painter is of a different kind from that of the world about him. Its boundaries enclose a substantially and essentially different microcosm. The photograph as such and the object in itself share a common being, after the fashion of a fingerprint. Wherefore, photography actually contributes something to the order of natural creation instead of providing a substitute for it. The Surrealists had an inkling of this when they looked to the photographic plate to provide them with their monstrosities and for this reason: the Surrealist does not consider his aesthetic purpose and the mechanical effect of the image on our imaginations as things apart. For him, the logical distinction between what is imaginary and what is real tends to disappear. Every image is to be seen as an object and every object as an image. Hence photography ranks high in the order of Surrealist creativity because it produces an image that is a reality of nature, namely, a hallucination that is also a fact. The fact that Surrealist painting combines tricks of visual deception with meticulous attention to detail substantiates this.

So, photography is clearly the most important event in the history of plastic arts. Simultaneously a liberation and an accomplishment, it has freed Western painting, once and for all, from its obsession with realism and allowed it to recover its aesthetic autonomy. Impressionist realism, offering science as an alibi, is at the opposite extreme from eye-deceiving trickery. Only when form ceases to have any imitative value can it be swallowed up in color. So, when form, in the person of Cézanne, once more regains possession of the canvas there is no longer any question of the illusions of the geometry of perspective. The painting, being confronted in the mechanically produced image with a competitor able to reach out beyond baroque resemblance to the very identity of the model, was compelled into the category of object. Henceforth Pascal's condemnation of painting is itself rendered vain since the photograph allows us on the one hand to admire in reproduction something that our eyes alone could not have taught us to love, and on the other, to admire the painting as a thing in itself whose relation to something in nature has ceased to be the justification for its existence.

On the other hand, of course, cinema is also a language.

Rudolf Arnheim

Rudolf Arnheim (1904-) is noted for his studies in the psychology of visual perception. His approach derives from Gestalt theory. For Arnheim, vision is not an exact duplication of reality but a complex interaction between viewer and reality.

In this essay Arnheim defends photography by analyzing its unique characteristics and limitations. He advises photographers to exploit the camera's mechanical nature. Influenced by André Bazin (see essay by Bazin, pp. 140-146), he defines photography as an instrument for recording human perceptions of reality.

Arnheim's enthusiasm for photography's mechanical nature represents a departure from his influential book Film as Art. *His defense of photography there focused on its similarities to other interpretative media, painting, and sculpture. Arnheim's reevaluation of the exclusive properties of the camera machine in determining an aesthetic for photography reflects his belief that mimetic representation is a creative form of communication.*

Arnheim has taught at Sarah Lawrence College, University of Michigan at Ann Arbor, and Harvard University. His books include Film as Art *(1957),* Art and Visual Perception *(1974), and* Toward a Psychology of Art *(1966).*

When a theorist of my persuasion looks at photography he is more concerned with the character traits of the medium as such than with the particular work of particular artists. He wishes to know what human needs are fulfilled by this kind of imagery, and what properties enable the medium to fulfill them. For his purpose, the theorist takes the medium at its best behavior. The promise of its potentialities captures him more thoroughly than the record of its actual achievements, and this makes him optimistic and tolerant, as one is with a child, who has a right to demand credit for his future. Analyzing media in this way requires a very different temperament than analyzing the use people make of them. Stud-

* Reprinted from *Critical Inquiry* (September 1974).

ies of this latter kind, given the deplorable state of our civilization, often make depressing reading.

The social critic, by his resentment and disapproval, is tied to the happenings and productions of the day, whereas the media analyst of my kind can display detachment. He, the media analyst, scrutinizes the passing crowd of the daily productions in the hope of an occasional catch, some hint at the true nature of the medium in an otherwise perhaps insignificant example, or even one of those rare and glorious fulfillments of the medium's finest capacity. Not being a critic, he views photographs more as specimens than as individual creations, and he may not be up-to-date on the names of the latest promising newcomers. Perhaps the photographer can afford to have some sympathy for this remoteness, since, it seems to me, he too, although in a different sense, must practice his trade in an attitude of detachment.

This may seem a strange thing to say about a medium whose inextricable involvement with the settings and acts of practical behavior is one of its principal characteristics. Epitomized by the news photographers, the men and women of the camera invade the haunts of intimacy and privacy, and even the most visionary of photographers has no substitute for going in person to the place that will give shape to his dream. But precisely this intimate involvement with the subject matter necessitates the detachment of which I am speaking.

In the olden days, when a painter set up his easel at some corner to do a picture of the market square, he was an outsider, looked at with curiosity and awe, perhaps with amusement. It is the prerogative of the stranger to contemplate things instead of dealing with them. Apart from sometimes being bodily in the way, the painter did not interfere with the public private life around him. Nobody felt spied upon or even observed unless he or she was sitting quietly on a bench, for it was evident that the painter was looking at and putting down something other than the facts of the moment. Only the moment is private, and the painter looked right through the coming and going at something that was not there at all because it was always there. The painting denounced nobody in particular.

In the portrait studio again, a different social code protected both participants. The sitter, his spontaneity suspended and his best appearance

displayed, invited scrutiny. The amenities of intercourse were abrogated, there was no need for conversation, and the I was fully authorized to stare at the Thou as though it were an It. This was true for the early phase of photography as well. The equipment was too bulky to catch anybody unawares, and the exposure time was long enough to wipe the accidents of the moment from face and gesture. Hence the enviable timelessness of the early photographs. A sort of otherworldly wisdom was symbolized by the fact that any momentary motion vanished automatically from those metallic plates.

Later, when photography drew the stylistic consequences from the technique of instantaneous exposure, it began to define its objective in a way that was totally new in the history of the visual arts. Whatever the style and purpose of art, its goal had always been the representation of the lasting character of things and actions. Even when depicting motion, it was the abiding nature of that motion which the artist portrayed. This remained true also for the paintings of the nineteenth century, although we are accustomed to saying that the Impressionists cultivated the fleeting moment. If one looks carefully, one realizes that those contemporaries of the first generations of photographers were not intent primarily on replacing scenes of some permanence with quickly passing ones. It was not a matter of duration. Rather, one might say that they supplemented the fundamental attitudes of the human mind and body—the expression of thought and sorrow, of care and love and repose and attack—with the more extrinsic gestures of daily behavior and that they found a new significance in them. They often replaced the root stance of the classical poses with a more casual slouch or stretch or yawn, or the steady illumination of a scene with a twinkling one. But if one compares those washerwomen, *midinettes*, or *boulevardiers*, those smoke-filled railroad yards or milling street crowds with photographic snapshots, one realizes that, for the most part, even those "momentary" poses had none of the incompleteness of the fraction of a second lifted from the context of time. In terms of time, a Degas ballerina fastening her shoulder strap is just as collected and reposes as firmly as the winged goddess of victory untying her sandal on a marble relief of ancient Athens.

The same is true for many photographs. But it is not true for the typical snapshot, and the snapshot quality of photographs manifests a unique

character trait of the medium. Photography does something unheard-of when it catches motion in the act. The accidental shape of its appearance reveals the snapshot as a fragment, a sample extirpated from an action whose integrity resides beyond the realm of the picture. If one compares Degas's dancers with a photograph of a similar subject, it is evident that the attitudes of the painted figures, although brought about by a trifling occupation, have an almost classical finality, whereas in the photograph the tensely open mouth and the placement of the fingers applying the makeup rely for their visual validity on the action of which they are a phase.

Photography reaches into the world as an intruder, and therefore it also creates a disturbance, just as in the physics of light the single photon at the atomic level upsets the facts on which it reports. The photographer takes a hunter's pride in capturing the spontaneity of life without leaving traces of his presence. News reporters enjoy recording the uncontrolled fatigue or embarrassment of a public figure, and the photographic manuals never tire of warning the amateur against the frozen poses of the family lined up for their picture in front of some famous landmark. Animals and infants, the prototypes of unselfconsciousness, are the darlings of the trade. But the need for such precaution and trickery highlights the congenital problem of photography: inevitably the photographer is a part of the situation he depicts. A court order may be necessary to keep him away, and the more skillfully he hides and surprises, the more acute is the social problem he creates. It is in this connection that we should think of the irresistible fascination which photography, film, and video have for young people today.

Only a malicious observer would unduly emphasize the fact that the opportunity to produce acceptable pictures without much training, toil, or talent is tempting in itself. More relevantly, it can be noted that if someone opts for the camera, he may be demonstrating against form. Form is the characteristic distinction of all traditional art. Form is suspected of serving the establishment, of detracting from the raw impact of passions and dreams psychologically, and from injustice, brutality, and deprivation politically and socially. In reply to such accusations, one can only say that good form, far from emasculating the message, is, on the

contrary, the only way of making it accessible to the mind. We need only glance at the work of a great social photographer such as Dorothea Lange to realize the forceful eloquence of form. On the other side, the kind of current video work which records interviews, debates, and other events without sufficient control of perspective, light, and camera movement proves negatively that the gray evasiveness of the noncommittal image sabotages communication.

Form is unavoidable. However, the way in which photographs are taken reminds us furthermore that there is not only form of observation but also form of action. In the other arts, the problem of how to reconcile these two arises only indirectly. Should the poet write revolutionary hymns at home or mount the barricade in person? In photography, there is no geographic escape from the conflict. The photographer must be present where the action is. It is true that limiting oneself to observing and recording in the midst of battle, destruction, and tragedy may require as much courage as does participation; however, when one takes pictures one also transforms life and death into a spectacle to be watched with detachment. This is what I meant to suggest in the beginning: the detachment of the artist becomes more of a problem in the photographic media precisely because they immerse him bodily in situations that call for human solidarity. In a broader sense, photography serves as an effective instrument of activist revelation, but at the same time it enables a person to be busy in the midst of things without having to take part, and to overcome alienation bodily without having to give up detachment. Self-deception comes easy in the twilight of such ambiguous conditions (Sontag, 1973).

So far I have mentioned two phases in the development of photography: the early period during which the image, as it were, transcended the momentary presence of the portrayed objects because of the length of exposure and the bulkiness of the equipment; and the second phase, which exploited the technical possibility of capturing motion in a fraction of time. The ambition of instantaneous photography, I noted, was that of preserving the spontaneity of action and avoiding any indication that the presence of the picture taker had a modifying influence on what was going on. Characteristically enough, however, our own century has discovered a new attraction in the very artificiality of picture taking and en-

deavored to use it deliberately for the symbolic representation of an age that has fallen from innocence. This stylistic trend has two main aspects: the introduction of surrealist apparitions, and the frank acknowledgment of photography as an exposure.

By its very nature, Surrealism depended on the trompe-l'oeil illusion of the settings it presented. Here the painter has a powerful competitor in the photographer, for, although the incisive presence of realistically painted images is not easily matched by the camera, a photograph has an authenticity from which painting is barred by birth. Fashion photography may have started the trend by showing in the midst of an authentic setting, on a hotel terrace at the Riviera or on the Spanish Steps in Rome, a grotesquely stylized model, the body reduced to a scaffold and the face to a mask, in a deliberately angular pose. Startling though such apparitions in the public domain were for a while, they looked too obviously like artifacts truly to stir the sense of the superreal. They were more like pranks than like creations of the bona fide world; and only as an outgrowth of reality can apparitions work their spell. A surrealist shiver was more effectively produced by the more recent practice of photographing nude figures in a forest or living room or abandoned cottage. Here was indubitably real human flesh, but since such appearances of nude figures were known only from the visions of painters, the reality of the scene was transfigured into a dream—pleasant perhaps but also frightening because it invaded the mind as a hallucination.

I referred to still another way in which photographers of our time have exploited the artificiality of their medium. Not by accident perhaps, it is often in documentary reportage that we see persons acknowledging the presence of the photographer, either by displaying themselves for him cheerfully or ceremoniously, or by watching him with suspicious attention. What we seem to be shown here is man and woman after they have eaten from the tree of knowledge. "And the eyes of them both were opened," says the Book of Genesis, "and they knew that they were naked." This is man under observation, in need of persona, concerned with his image, exposed to danger or to the prospect of great fortune by simply being looked at.

All I have said derives ultimately from the fundamental peculiarity of the photographic medium: the physical objects themselves print their

image by means of the optical and chemical action of light. This fact has always been acknowledged but treated in a variety of different ways by the writers on the subject. I am thinking back to my own way of dealing with the psychology and aesthetics of the film in *Film als Kunst* (Arnheim, 1932). In that early book I attempted to refute the accusation that photography was nothing but a mechanical copy of nature. Such an approach was suggested as a reaction to the narrow notion that had prevailed every since Baudelaire in his famous statement of 1859 predicted the value of photography for the faithful documentation of sights and scientific facts, but also denounced it as an act of a revengeful god who, by sending Daguerre as his messiah, granted the prayer of a vulgar multitude that wanted art to be an exact imitation of nature (Baudelaire, 1859). In those early days, the mechanical procedure of photography was doubly suspect as an attempt by industry to replace the manual work of the artist with a mass production of cheap pictures. Such critical voices, although less eloquent, were still influential when I decided upon my own apologia for the cinema. The strategy was therefore to describe the differences between the images we obtain when we look at the physical world and the images perceived on the motion-picture screen. These differences could then be shown to be a source of artistic expression.

In a sense it was a negative approach because it defended the new medium by measuring it according to the standards of the traditional ones, that is, by pointing to the range of interpretation it offered to the artist, very much like painting and sculpture, in spite of its mechanical nature. Only secondarily was I concerned with the positive virtues that photography derives precisely from the mechanical quality of its images. Even so, the demonstration was necessary then, and perhaps it is worth being remembered now—at least, to judge from one of the best known and also one of the more confusing statements of recent years, Roland Barthes's paper on "Le message photographique" (1961). Barthes calls the photograph a perfect and absolute analogue, derived from the physical object by reduction but not by transformation. If this statement means anything at all, the meaning must be that the primary photographic image is nothing but a faithful copy of the object and that any elaboration or interpretation is secondary. To me, it seems necessary to keep insisting that an image cannot transmit its message unless it acquires form at its primary level.

Pictures produced by a camera can resemble paintings or drawings in presenting recognizable images of physical objects. But they have also characteristics of their own, of which the following two are relevant here: first, the photograph acquires some of its unique visual properties through the technique of mechanical recording; and second, it supplies the viewer with a specific kind of experience, which depends on his being aware of the picture's mechanical origin. To put it more simply: (1) the picture is coproduced by nature and man and in some ways looks strikingly like nature, and (2) the picture is viewed as something made by nature. The distinction between these two characteristics matters whenever the viewer is sophisticated enough to realize the difference between an image and the objects it represents. A primitive tribesman or peasant knows that the effigy he worships is not materially identical with the god or saint, but he treats it as though it actually were that superior power, and he does not acknowledge the qualities introduced by the judgment and skill of the image-maker. For the purposes of modern man these differences count. Regardless of whether he is actually aware of any particular qualities that distinguish a photograph from a handmade painting, his conviction that the picture was generated by a camera profoundly influences the way he views and uses it. This point has been stressed by the film critic André Bazin (1945).

In addition, however, a sensitive observer may appreciate certain significant visual differences between shapes produced by a lens in a photographic emulsion and others created by a painter's brush, although in principle he may know nothing about the technical conditions of origin to which these differences are due. These properties of the photographic image are brought to our attention if we apply the principle on which Siegfried Kracauer based his treatment of the subject. I want to say a little more about both characteristics of our medium.

Photography, observed Bazin in 1945, profits from the absence of man while all other arts are based on his presence. "Photography affects us like a phenomenon in nature, like a flower or a snowflake whose vegetable or earthly origins are an inseparable part of their beauty" (p. 13). Looking in a museum at a Flemish tavern scene, we are interested in what objects the painter introduced and which occupations he gave his

characters. Only indirectly do we use his picture as a documentary testimony on what life was like in the seventeenth century. How different is the attitude in which we approach a photograph showing, say, a lunch counter! "Where was this taken?," we want to know. The word *caliente* that we discover on the list of foods in the background of the picture points to a Spanish element, but the paunchy policeman at the door, the hot dogs and the orange drinks assure us that we are in the United States. With the delighted curiosity of the tourist we explore the scene. The glove near the wastepaper basket must have been dropped by a customer; it was not placed there by an artist as a compositional touch. We are on vacation from artifice. Also the different attitude toward time is characteristic. "When was this painted?" means mostly that we want to know to which stage of the artist's life the work belongs. "When was this taken?" means typically that we are concerned with the historical locus of the subject. Is it a view of Chicago from before the great fire? Or did Chicago look that way after 1871?

In evaluating the documentary qualities of a photograph we ask three questions: Is it authentic? Is it correct? Is it true? Authenticity, vouched for by certain features and uses of the picture, requires that the scene has not been tampered with. The masked burglar leaving the bank is not posed, the clouds are not printed from another negative, the lion is not taken in front of a painted oasis. Correctness is another matter; it calls for the assurance that the picture corresponds to what the camera took: the colors are not off, the lens does not distort the proportions. Truth, finally, does not deal with the picture as a statement about what was present in front of the camera but refers to the depicted scene as a statement about facts the picture is supposed to convey. We ask whether the picture is characteristic of what it purports to show. A photograph may be authentic but untrue, or true though inauthentic. When in Jean Genet's play *The Balcony* a photographer of the queen sends one of the arrested revolutionaries to get him a pack of cigarettes and pays a police officer to shoot the man, the picture of the rebel killed while trying to escape is inauthentic but probably correctly taken and not necessarily untrue. "Monstreux!," says the queen. "C'est dans les habitudes, Majesté," says the photographer. To be sure, when it comes to truth the problem is no longer photographic.

One can understand why Bazin suggested that the essential factor of photography "is not to be found in the result achieved but in the way of achieving it" (p. 12). It is equally important, however, to consider what the mechanical recording process does to the visual qualities of the photographic image. Here we are helped by Siegfried Kracauer, who based his book, *Theory of Film*, on the observation that the photographic image is a kind of compromise product between physical reality as it impresses its own optical image on the film and the picture-maker's ability to select, shape, and organize the raw material (1960). The optically projected image, Kracauer suggested, is characterized by the visual accidents of a world that has not been created for the convenience of the photographer, and it would be a mistake to force these unwieldy data of reality into the straitjacket of pictorial composition. Indefiniteness, endlessness, random arrangement should be considered legitimate and indeed necessary qualities of film as a photographic product. If, with Kracauer's observation in mind, we look attentively at the texture of a typical photographic image, we find, perhaps to our surprise, that the subject matter is represented mostly by visual hints and approximations. In a successful painting or drawing every stroke of the pen, every touch of color, is an intentional statement of the artist about shape, space, volume, unity, separation, lighting, etc. The texture of the pictorial image amounts to a pattern of explicit information. If we approach photographs with an expectation trained by the perusal of handmade images, we find that the work of the camera lets us down. Shapes peter out in muddy darkness, volumes are elusive, streaks of light arrive from nowhere, neighboring items are not clearly connected or separate, details do not add up. The fault is ours, of course, because we are looking at the photograph as though it were made and controlled by man and not as a mechanical deposit of light. As soon as we take the picture for what it is, it hangs together and may even be beautiful.

But surely there is a problem here. If what I affirmed earlier is true, it takes definite form to make a picture readable. How, then, can an agglomerate of vague approximations deliver its message? To speak of "reading" a picture is appropriate but dangerous at the same time because it suggests a comparison with verbal language, and linguistic analogies, although fashionable, have greatly complicated our understanding

of perceptual experiences everywhere. I will refer here once more to the article of Roland Barthes (1961), in which the photographic image is described as coded and uncoded at the same time. The underlying assumption is that a message can be understood only when its content has been processed into the discontinuous, standardized units of a language, of which verbal writing, signal codes, or musical notation are examples. Pictorial surfaces, being continuous and unstandardized in their elements, are therefore uncoded, and this is said to mean unreadable. (This observation, of course, holds for paintings as well as for photographs.) How, then, do we gain access to pictures? By making the subject matter conform, says Barthes, to another kind of code, not inherent in the picture itself but imposed by society as a set of standardized meanings upon certain objects and actions. Barthes gives the example of a photograph depicting a writer's study: an open window with a view of tiled roofs, a landscape of vineyards; in front of the window a table with an album of photographs, a magnifying lens, a vase of flowers. Such an arrangement of objects, asserts Barthes, is nothing more or less than a lexicon of concepts whose standardized meanings can be read off like a description in words.

It will be evident that such an interpretation denies the very substance of visual imagery, namely, its capacity to convey meaning by full perceptual experience. The standardized designations of things are nothing but the husks of information. By reducing the message to meager conceptual fare, one accepts the impoverished practical responses of modern man in the street as the prototype of human vision. In opposition to this approach we must maintain that imagery can fulfill its unique function—whether photographic or pictorial, artistic or informational—only if it goes beyond a set of standardized symbols and exerts the full and ultimately inexhaustible individuality of its appearance.[1]

If, however, we are correct in asserting that the messages conveyed by pictures cannot be reduced to a sign language, then our problem of how

[1] Ironically, not even a verbal message is coded, only the means of conveying it. Words are discontinuous signs, reasonably well standardized, but the message they transmit consists in the image that induced the sender to verbalize and is resurrected by the words in the mind of the recipient. This image, whatever precisely its nature, is as "continuous" as any photograph or painting. What comes across when a person is told "There has been a fire!" neither consists of five verbal units nor is it standardized.

to read them is still with us. Here we need to realize, first of all, that a picture is "continuous" only when we scan it mechanically with a photometer. Human perception is no such recording instrument. Visual perception is pattern perception; it organizes and structures the shapes offered by the optical projections in the eye. These organized shapes, not sets of conventional ideographs, yield the visual concepts that make pictures readable. They are the keys that give us access to the rich complexity of the image.

When the viewer looks at the world around him, these shapes are delivered to him entirely by the physical objects out there. In a photograph, the shapes are selected, partially transformed, and treated by the picture taker and his optical and chemical equipment. Thus, in order to make sense of photographs one must look at them as encounters between physical reality and the creative mind of man—not simply as a reflection of that reality in the mind but as a middle ground on which the two formative powers, man and world, meet as equal antagonists and partners, each contributing its particular resources. What I described earlier in negative terms as a lack of formal precision must be valued positively from the point of view of the photographic medium as the manifest presence of authentic physical reality, whose irrational, incompletely defined aspects challenge the image-maker's desire for visually articulate form. This unshaped quality of the optical raw material exerts its influence not only when the viewer recognizes the objects that have been projected on the sensitive coating of the film but is actually more manifest in highly abstract photographs in which objects have been reduced to pure shapes.

Even so, a medium that limits the creations of the mind by powerful material constraints must have corresponding limitations. In fact, when the artistic development of photography from the days of David Octavius Hill to the great photographers of our own time is compared with the range of painting from Manet to, say, Jackson Pollock, or of music from Wagner's *Tristan and Isolde* to, say, Arnold Schönberg, we may come to the conclusion that there has been photographic work of high quality but consistently limited in its range of expression as well as in the depth of its insights. The photographic medium seems to operate under a definite ceiling. To be sure, every artistic medium limits the range of successful expression and needs to do so. But there is a difference between the pro-

ductive limitations that intensify the statement by confining it to a few formal dimensions and a narrowing of expressive freedom within the range of a particular medium.

If this diagnosis is correct, I think the difference is not due to the relative youth of the photographic art but to its intimate physical connection with the activities of human life. I would also suggest that this is a liability when looked at from the point of view of the painter, the composer, or the poet, but it is an enviable privilege when we consider its function in human society. Let us consult another medium of artistic expression, one of the most ancient but equally bound to physical conditions, namely, the dance. Here too we seem to find that, when we compare the dances of remote times and places to our own, the resemblance outweighs the difference, and the visions conveyed, though beautiful and impressive, remain at a relatively simple level. This is so, I believe, because the dance is essentially a ritualized extension of the expressive and rhythmical movement of the human body in its daily activities, its mental manifestations and communications. As such it lacks the almost unconditional freedom of imagination granted to the other media, but it is also spared the remoteness that separates the great private visions of the poets, composers, or painters from the commerce of social existence.

Perhaps the same is true for photography. Wedded to the physical nature of landscape and human settlement, animal and man, to our exploits, sufferings, and joys, photography is privileged to help man view himself, expand and preserve his experiences, and exchange vital communications—a faithful instrument whose reach need not extend farther than that of the way of life it reflects.

Works Cited

Rudolf Arnheim, *Film als Kunst.* Berlin, 1932. (American ed.: *Film as Art.* Los Angeles and Berkeley, Calif., 1957.)

Roland Barthes, "Le message photographique," *Communications*, no. 1 (1961), Paris.

Charles Baudelaire, *Salon de 1859.* 1859. II. *Le public moderne et la photographie.* In *Oeuvres completes* (Paris, 1968).

André Bazin, "The Ontology of the Photographic Image" (1945). In

What Is Cinema? Edited and translated by Hugh Gray (Los Angeles and Berkeley, Calif., 1967).

Susan Sontag, "Photography," *New York Review of Books* (October 18, 1973).

Siegfried Kracauer

Siegfried Kracauer (1889–1966) is respected for his pioneering work in the field of cultural history and criticism. Kracauer examined cultural phenomena as reflections of the society in which they were produced. He developed a sociological-psychological type of analysis aimed toward serious appreciation of mass media. His writing was first noted while he was a feuilletoniste, or cultural essayist, for the prestigious Weimar Republic paper Frankfurter Zeitung, *and later for his study of German films* From Caligari to Hitler: A Psychological History of the German Film (*1947*).

This essay is the first chapter of Kracauer's Theory of Film: The Redemption of Physical Reality (*1960*). *The culmination of his lifelong fascination with film, the book argues that film's essential function is the re-creation of real events. Like Bazin (see essay by Bazin), Kracauer was tenacious about the necessity for film to be faithful to visible reality. Kracauer discusses photography to validate his film aesthetic. For Kracauer film is an extension of photography; he thinks that the photograph, never absolutely mimetic, is a means to encounter real life.*

Kracauer was a senior member of the Bureau of Applied Social Research at Columbia University and special assistant to the film department at The Museum of Modern Art. His other books include Propaganda and the Nazi War Film (*1942*), *and* History: The Last Things Before the Last (*1969*).

This study rests upon the assumption that each medium has a specific nature which invites certain kinds of communications while obstructing others. Even philosophers of art concentrating on what is common to all the arts cannot help referring to the existence and possible impact of such differences. In her *Philosophy in a New Key* Susanne Langer hesitantly admits that "the medium in which we naturally conceive our ideas may restrict them not only to certain forms but to certain fields."[1]

* Reprinted from *Theory of Film: The Redemption of Physical Reality* (New York: Oxford University Press, 1960).

[1] Langer, *Philosophy in a New Key* (New York: A Mentor Book, 1953), p. 210.

But how can we trace the nature of the photographic medium? A phenomenological description based on intuitive insight will hardly get at the core of the matter. Historical movements cannot be grasped with the aid of concepts formed, so to speak, in a vacuum. Rather, analysis must build from the views held of photography in the course of its evolution—views which in some way or other must reflect actually existing trends and practices. It would therefore seem advisable first to study the historically given ideas and concepts. Now this book is not intended as a history of photography—nor of film, for that matter. So it will suffice for our purposes to scrutinize only two sets of ideas about photography: those entertained in the early stages of development and relevant present-day notions. Should the thoughts of the pioneers and of modern photographers and critics happen to center on approximately the same problems, the same essentials, this would bear out the proposition that photography has specific properties and thus lend vigor to the assumption about the peculiar nature of media in general. Such similarities between views and trends of different eras should even be expected. For the principles and ideas instrumental in the rise of a new historical entity do not just fade away once the period of inception is over; on the contrary, it is as if, in the process of growing and spreading, that entity were destined to bring out all their implications. Aristotle's theory of tragedy is still being used as a valid starting point for interpretation. A great idea, says Whitehead, "is like a phantom ocean beating upon the shores of human life in successive waves of specialization."[2]

The following historical survey, then, is to provide the substantive conceptions on which the subsequent systematic considerations proper will depend.

HISTORICAL SURVEY

Early Views and Trends

With the arrival of the daguerreotype, discerning people were highly aware of what they felt to be the new medium's specific properties, which they unanimously identified as the camera's unique ability to record as well as reveal visible, or potentially visible, physical reality. There was

[2] Alfred North Whitehead, *Adventures of Ideas* (New York: A Mentor Book, 1955), p. 27.

general agreement that photography reproduces nature with a fidelity "equal to nature itself."[3] In supporting the bill for the purchase of Daguerre's invention by the French government, Arago and Gay-Lussac reveled in the "mathematical exactness"[4] and "unimaginable precision"[5] of every detail rendered by the camera; and they predicted that the medium would benefit both science and art. Paris correspondents of New York newspapers and periodicals chimed in, full of praise for the unheard-of accuracy with which daguerreotypes copied "stones under the water at the edge of the stream,"[6] or a "withered leaf lying on a projecting cornice."[7] And no less a voice than Ruskin's was added to the chorus of enthusiasm over the "sensational realism" of small plates with views of Venice; it is, said he, "as if a magician had reduced the reality to be carried away into an enchanted land."[8] In their ardor these nineteenth-century realists were emphasizing an essential point—that the photographer must indeed reproduce, somehow, the objects before his lens; that he definitely lacks the artist's freedom to dispose of existing shapes and spatial interrelationships for the sake of his inner vision.

Recognition of the camera's recording faculty went together with an acute awareness of its revealing power. Gay-Lussac insisted that no detail, "even if imperceptible," can escape "the eye and the brush of this new painter."[9] And as early as 1839 a New York *Star* reporter admiringly remarked that, when viewed under a magnifying glass, photographs show minutiae which the naked eye would never have discovered.[10] The American writer and physician Oliver Wendell Holmes was among the

[3] Quoted from Joseph Louis Gay-Lussac's speech in the French House of Peers, July 30, 1839, by Josef Maria Eder, *History of Photography*, trans. Edward Epstean (New York: Columbia University Press, 1945), p. 242.

[4] Quoted from same speech, *ibid.*, p. 242.

[5] Quoted from François Arago's speech in the French Chamber of Deputies, July 3, 1839, *ibid.*, p. 235.

[6] Beaumont Newhall, *The History of Photography: From 1839 to the Present Day* (New York: The Museum of Modern Art, 1949), pp. 17–18.

[7] Beaumont Newhall, "Photography and the Development of Kinetic Visualization," *Journal of the Warburg and Courtauld Institutes*, 7 (1944), p. 40. This paper is an important contribution to the history of instantaneous photography, which, says Mr. Newhall (p. 40), has not yet been written.

[8] John Ruskin, *Praeterita: Outlines of Scenes and Thoughts Perhaps Worthy of Memory in My Past Life*, 1885–1889 (London, 1949), p. 341.

[9] Quoted by Eder, *op. cit.*, p. 341.

[10] Newhall, *The History of Photography*, p. 21.

first to capitalize on the camera's scientific potentialities. In the early 1860s he found that the movements of walking people, as disclosed by instantaneous photographs, differed greatly from what the artists imagined they were, and on the grounds of his observations he criticized an artificial leg then popular with amputated Civil War veterans. Other scientists followed suit. For his *The Expression of the Emotions in Man and Animals* (1872) Darwin preferred photographs to engravings and snapshots to time exposures, arguing that he was concerned with truth rather than beauty; and snapshots could be relied upon to convey the "most evanescent and fleeting facial expressions."[11]

Many an invention of consequence has come into being well-nigh unnoticed. Photography was born under a lucky star inasmuch as it appeared at a time when the ground was well prepared for it. The insight into the recording and revealing functions of this "mirror with a memory"[12]—its inherent realistic tendency, that is—owed much to the vigor with which the forces of realism bore down on the romantic movement of the period. In nineteenth-century France the rise of photography coincided with the spread of positivism—an intellectual attitude rather than a philosophical school which, shared by many thinkers, discouraged metaphysical speculation in favor of a scientific approach, and thus was in perfect keeping with the ongoing processes of industrialization.[13]

Within this context, only the aesthetic implications of this attitude are of interest. Positivist mentality aspired to a faithful, completely impersonal rendering of reality, in the sense of Taine's radical dictum: "I want to reproduce the objects as they are, or as they would be even if I did not exist." What counted was not so much the artist's subject matter or easily deceptive imagination as his unbiased objectivity in representing the visible world; hence the simultaneous breakthrough of *plein-air* painting devoid of romantic overtones.[14] (Yet of course, despite their emphatic

[11] For the references to Oliver Wendell Holmes and Darwin, see Newhall, "Photography and the Development of Kinetic Visualization," pp. 41–42.

[12] Newhall, *The History of Photography*, p. 27.

[13] Cf., for instance, Überweg/Heinze, *Grundriss der Geschichte der Philosophie*, vol. 5, (Basel, 1953), p. 27.

[14] Gisèle Freund, *La Photographie en France au dix-neuvième siècle* (Paris, 1936), pp. 102–107. For the Hippolyte Taine quote, see *ibid.*, p. 103. In her excellent study Freund traces the social and ideological trends that had a bearing on the development of photography. Her book is not free from lapses into commonplace materialism, but this minor shortcoming is compensated for by a wealth of source material.

insistence on truth to reality, the intellectual *bohème*[15] would expect such truth to serve the cause of the revolution temporarily defeated in 1848; a few years later, Courbet called himself both a "partisan of revolution" and a "sincere friend of real truth."[16]) It was inevitable that this turn to realism in art—which gained momentum with Courbet's *Burial at Ornans* (1850) and had its short heyday after the scandal roused by *Madame Bovary* (1857)—should bring photography into focus.[17] Was the camera not an ideal means of reproducing and penetrating nature without any distortions? Leading scientists, artists and critics were predisposed to grasp and acknowledge the peculiar virtues of the emergent medium.

However, the views of the realists met with strong opposition, not only in the camp of the artists but among the photographers themselves. Art, the opponents held, did not exhaust itself in painterly or photographic records of reality; it was more than that; it actually involved the artist's creativity in shaping the given material. In 1853, Sir William Newton suggested that the photographic image could, and should, be altered so as to make the result conform to the "acknowledged principles of Fine Art."[18] His suggestion was heeded. Not content with what they believed to be a mere copying of nature, numerous photographers aimed at pictures which, as an English critic claimed, would delineate Beauty instead of merely representing Truth.[19] Incidentally, it was not primarily the many painters in the ranks of the photographers who voiced and implemented such aspirations.

With notable exceptions the "artist-photographers" of those days followed a tendency which may be called "formative," since it sprang from their urge freely to compose beautiful pictures rather than to capture nature in the raw. But their creativity invariably manifested itself in photographs that reflected valued painterly styles and preferences; consciously or not, they imitated traditional art, not fresh reality.[20] Thus the sculptor Adam-Salomon, a top-ranking artist-photographer, excelled in portraits

[15] *Ibid.*, pp. 49, 53–57.
[16] Arnold Hauser, *The Social History of Art*, trans. Stanley Godman, (London, 1951), vol. 2, p. 775.
[17] *Ibid.*, pp. 775, 779; Freund, *La Photographie en France*, pp. 106–107.
[18] Newhall, *The History of Photography*, p. 71.
[19] *Ibid.*, p. 71.
[20] Edward Weston, "Seeing Photographically," *The Complete Photographer*, 9, issue 49 (1943): 3200.

which, because of their "Rembrandt lighting" and velvet drapery, caused the poet Lamartine to recant his initial opinion that photographs were nothing but a "plagiarism of nature."[21] Upon seeing these pictures, Lamartine felt sure that photography was equally capable of attaining the peaks of art. What happened on a relatively high level became firmly established in the lower depths of commercial photography: a host of would-be artist-photographers catered to the tastes of the *juste-milieu*, which, hostile to realism, still went for romantic painting and the academic idealism of Ingres and his school.[22] There was no end of prints capitalizing on the appeal of staged genre scenes, historical or not.[23] Photography developed into a lucrative industry, especially in the field of portraiture in which Disdéri set a widely adopted pattern.[24] From 1852, his *portrait-carte de visite* ingratiated itself with the petit bourgeois, who felt elated at the possibility of acquiring, at low cost, his likeness—a privilege hitherto reserved for the aristocracy and the well-to-do upper middle class.[25] As might be expected, Disdéri too preached the gospel of beauty.[26] It met the needs of the market. Under the Second Empire professional photographers, no less than popular painters, sacrificed truth to conventional pictorialness by embellishing the features of their less attractive clients.[27]

All this means that such concern with art led the artist-photographers to neglect, if not deliberately to defy, the properties of their medium, as perceived by the realists. As far back as 1843, daguerreotypists renounced camera explorations of reality for the sake of soft-focus pictures.[28] Adam-Salomon relied on retouching for artistic effect,[29] and Julia Margaret Cameron availed herself of badly made lenses in order to get at the "spirit" of the person portrayed without the disturbing interference of "accidental" detail.[30] Similarly, Henry Peach Robinson encouraged the

[21] Newhall, *The History of Photography,* pp. 75–76; Freund, p. 113.
[22] Hauser, *The Social History of Art,* vol. 2, p. 778.
[23] Freund, *La Photographie en France,* p. 96.
[24] *Ibid.,* p. 12; Newhall, *The History of Photography,* p. 43.
[25] Freund, *La Photographie en France,* pp. 78–79.
[26] *Ibid.,* p. 92.
[27] *Ibid.,* pp. 83, 85, 90.
[28] Newhall, *The History of Photography,* pp. 71–72.
[29] *Ibid.,* p. 76.
[30] *Ibid.,* p. 81.

use of any kind of "dodge, trick, and conjuration" so that pictorial beauty might arise out of a "mixture of the real and the artificial."[31] *2 Schools*

Small wonder that the champions of realism and their adversaries engaged in a lively debate.[32] This famous controversy, which raged in the second half of the nineteenth century with no clear-cut solution ever being reached, rested upon a belief common to both schools of thought—that photographs were copies of nature. Yet there the agreement ended. Opinions clashed when it came to appraising the aesthetic significance of reproductions which light itself seemed to have produced.

The realists, it is true, refrained from identifying photography as an art in its own right—in fact, the extremists among them were inclined to discredit artistic endeavors altogether—but strongly insisted that the camera's incorruptible objectivity was a precious aid to the artist. Photography, as a realistic-minded critic put it, reminds the artist of nature and thus serves him as an inexhaustible source of inspiration.[33] Taine and even Delacroix expressed themselves in similar terms; the latter compared daguerreotype to a "dictionary" of nature and advised painters diligently to consult it.[34]

Those in the opposite camp naturally rejected the idea that a medium confining itself to mechanical imitation could provide artistic sensations or help achieve them. Their contempt of this inferior medium was mingled with bitter complaints about its growing influence, which, they contended, lent support to the cult of realism, thereby proving detrimental to elevated art.[35] Baudelaire scorned the worshipers of Daguerre among the artists. He claimed they just pictured what they saw instead of projecting their dreams.[36] The artist-photographers shared these views with a difference: they were confident that photography need not be limited to reproduction pure and simple. Photography, they reasoned, is a medium which offers the creative artist as many opportunities as does painting or literature—provided he does not let himself be inhibited by the camera's pe-

[31] *Ibid.*, p. 75.
[32] *Ibid.*, pp. 71–72; Freund, *La Photographie en France*, pp. 69, 101.
[33] Freund, *La Photographie en France*, pp. 107–108, 110–112.
[34] *Ibid.*, pp. 117–119.
[35] *Ibid.*, pp. 108–109.
[36] *Ibid.*, pp. 116–117.

culiar affinities but uses every "dodge, trick, and conjuration" to elicit beauty from the photographic raw material.

All these nineteenth-century arguments and counterarguments now sound oblique. Misled by the naïve realism underlying them, both sides failed to appreciate the kind and degree of creativeness that may go into a photographic record. Their common outlook prevented them from penetrating the essence of a medium which is neither imitation nor art in the traditional sense. Yet stale as those old notions have become, the two divergent tendencies from which they drew strength continue to assert themselves.

Current Views and Trends

Of the two camps into which modern photography is split, one follows the realistic tradition. True, Taine's intention to reproduce the objects as they are definitely belongs to the past; the present-day realists have learned, or relearned, that reality is as we see it. But much as they are aware of this, they resemble the nineteenth-century realists in that they enhance the camera's recording and revealing abilities and, accordingly, consider it their task as photographers to make the "best statement of facts."[37] The late Edward Weston, for instance, highly valued the unique precision with which instantaneous photography mechanically registers fine detail and the "unbroken sequence of infinitely subtle gradations from black to white"[38]—a testimony which carries all the more weight since he often indulges in wresting abstract compositions from nature. It is evident that Weston refers to camera revelations rather than representations of familiar sights. What thrills us today then is the power of the medium, so greatly increased by technical innovations and scientific discoveries, to open up new, hitherto unsuspected dimensions of reality. Even though the late László Moholy-Nagy was anything but a realist, he extolled records capturing objects from unusual angles or combinations of phenomena never before seen together; the fabulous disclosures of high-speed, micro- and macro-photography; the penetrations obtained by

[37] So the painter and photographer Charles Scheeler in 1914; quoted in Newhall, *The History of Photography*, p. 152.

[38] Weston, "Seeing Photographically," 3202. See also Moholy-Nagy, *Malerei, Photographie, Film* (Munich, 1925), p. 22.

means of infrared emulsions, etc. Photography, he declares, is the "golden key opening the doors to the wonders of the external universe."[39] Is this a poetic exaggeration? In his book, *Schöpfung aus dem Wasser-tropfen* (*Creation out of a Waterdrop*), the German photographer Gustav Schenk uncovers the Lilliputian world contained in a square millimeter of moving plain water—an endless succession of shapes so fantastic that they seem to have been dreamed rather than found.

In thus showing the "wonders of the external universe," realistic photography has taken on two important functions unforeseeable in its earlier stages of development. (This may explain why, for instance, Moholy-Nagy's account of contemporary camera work breathes a warmth and a sense of participation absent in pertinent nineteenth-century statements.)

First, modern photography has not only considerably enlarged our vision but, in doing so, adjusted it to man's situation in a technological age. A conspicuous feature of this situation is that the viewpoints and perspectives that framed our images of nature for long stretches of the past have become relative. In a crudely physical sense we are moving about with the greatest of ease and incomparable speed so that stable impressions yield to ever-changing ones: bird's-eye views of terrestrial landscapes have become quite common; not one single object has retained a fixed, definitely recognizable appearance.

The same applies to phenomena on the ideological plane. Given to analysis, we pass in review, and break down into comparable elements, all the complex value systems that have come to us in the form of beliefs, ideas, or cultures, thereby of course weakening their claim to absoluteness. So we find ourselves increasingly surrounded by mental configurations which we are free to interpret at will. Each is iridescent with meanings, while the great beliefs or ideas from which they issue grow paler. Similarly, photography has effectively impressed upon us the dissolution of traditional perspectives. Think of the many prints picturing unwonted aspects of reality—spatial depth and flatness are strangely intertwined, and objects apparently well known turn into inscrutable patterns. All in all, the realists among the modern photographers have done

[39] Moholy-Nagy, *Vision in Motion* (Chicago: Theobald & Co., 1947), pp. 206–207, 210.

much to synchronize our vision with topical experiences in other dimensions. That is, they have made us perceive the world we actually live in—no mean achievement considering the power of resistance inherent in habits of seeing. In fact, some such habits stubbornly survive. For instance, the predilection which many people show today for wide vistas and panoramic views may well go back to an era less dynamic than ours.

Second, precisely by exploding perceptual traditions, modern photography has assumed another function—that of influencing art. Marcel Duchamp relates that in 1912, when he was painting his *Nude Descending the Staircase*, Paris art circles were stimulated by stroboscopic and multiple-exposure high-speed photographs.[40] What a change in the relationships between photography and painting! Unlike nineteenth-century photography, which at best served as an aid to artists eager to be true to nature—nature still conceived in terms of time-honored visual conventions—scientific camera explorations of the first decades of the twentieth century were a source of inspiration to artists, who then began to defy these conventions.[41] It sounds paradoxical that, of all media, realistic photography should thus have contributed to the rise of abstract art. But the same technological advance that made possible photographs bringing our vision, so to speak, up to date has left its imprint upon painters and prompted them to break away from visual schemata felt to be obsolete. Nor is it in the final analysis surprising that the achievements in the two media do coincide up to a point. Contemporary photographic records and painterly abstractions have this in common: they are both remote from the images we have been able to form of reality in a technically more primitive age. Hence the "abstract" character of those records and the surface similarity to them of certain modern paintings.

Yet, as in the old days, formative urges still vie with realistic intentions. Although Moholy-Nagy delights in the visual conquests of realistically handled photography and readily acknowledges their impact on art, he is nevertheless much more concerned with emancipating the medium from the "narrow rendering of nature." His guiding idea is that we should learn to consider photography, no less than painting, an "ideal instru-

[40] *Newhall, The History of Photography,* p. 218. Moholy-Nagy, *Malerei, Photographie, Film,* p. 27.

[41] Moholy-Nagy, *Vision in Motion,* p. 178.

ment of visual expression."[42] "We want to create," he exclaims.[43] Consequently, he capitalized, as did Man Ray, on the sensitivity to light of the photographic plate to produce black-and-white compositions from purposefully controlled material. All modern experimental photographers proceed in essentially the same way. It is as if they suffered from their obligations toward nature in the raw; as if they felt that, to be artists, they would have to work the given raw material into creations of an expressive rather than reproductive order. So they use, and often combine, various artifices and techniques—among them negatives, photograms, multiple exposure, solarization, reticulation, etc.—in order to mount pictures which are palpably designed to externalize what Leo Katz, an experimental photographer, calls "our subjective experiences, our personal visions, and the dynamics of our imagination."[44]

No doubt these artistic-minded experimenters aspire to photographic values; significantly, they refrain from retouching as an interference with the alleged purity of their laboratory procedures.[45] And yet they are clearly the descendants of the nineteenth-century artist-photographers. Much as they may be reluctant to imitate painterly styles and motifs after the manner of their predecessors, they still aim at achieving art in the traditional sense; their products could also be patterned on abstract or surrealist paintings. Moreover, exactly like the early champions of pictorialism, they tend to neglect the specific properties of the medium. In 1925, it is true, Moholy-Nagy still referred to astronomical and X-ray photographs as prefigurations of his photograms,[46] but meanwhile the umbilical cord, tenuous anyway, between realistic and experimental photography seems to have been completely severed. Andreas Feininger suggests that "superfluous and disturbing details" should be suppressed for the sake of "artistic simplification"; the goal of photography as an art medium, he stipulates, is "not the achievement of highest possible 'likeness' of the depicted subject, but the creation of an abstract work of art,

[42] *Ibid.*, p. 178.

[43] Moholy-Nagy, *Malerei, Photographie, Film,* p. 22.

[44] Katz, "Dimensions in Photography," *The Complete Photographer,* 4, issue 21 (1942): 1354.

[45] Newhall, *The History of Photography,* p. 131.

[46] Moholy-Nagy, *Malerei, Photographie, Film,* p. 24.

featuring composition instead of documentation."[47] He is not the only one to discount the "wonders of the external universe" in the interest of self-expression; in a publication on the German experimental photographer Otto Steinert, the latter's so-called subjective photography is characterized as a deliberate departure from the realistic point of view.[48]

All of this implies that the meaning of photography is still controversial. The great nineteenth-century issue of whether or not photography is an art medium, or at least can be developed into one, fully retains its topical flavor. When tackling this perennial issue, the modern realists are wavering. In their desire to highlight the artistic potentialities of their medium they usually draw attention to the photographer's selectivity, which, indeed, may account for prints suggestive of his personal vision and rich in aesthetic gratifications. But is he for that reason on a par with the painter or poet? And is his product a work of art in the strict sense of the word? Regarding these crucial questions, there is a great deal of soul-searching in the realist camp, affirmative testimony alternating with resignation over the limitations which the medium imposes upon its adepts. No such ambivalence is found among the experimental photographers. They cut the Gordian knot by insisting that renderings of chance reality, however beautiful, cannot possibly be considered art. Art begins, they argue, where dependence upon uncontrollable conditions ends. And in intentionally ignoring the camera's recording tasks, Feininger and the others try to transform photography into the art medium which they claim it to be.

Toward the end of 1951, *The New York Times* published an article by Lisette Model in which she turned against experimental photography, pronouncing herself in favor of a "straight approach to life." The reactions to her statement, published in the same newspaper, strikingly demonstrate that the slightest provocation suffices to revive hostilities between the defenders of realism and of unfettered creativity. One letter writer, who described himself as a "frankly experimental photographer," blamed Miss Model for arbitrarily curtailing the artist's freedom to use

[47] Feininger, "Photographic Control Processes," *The Complete Photographer*, 8, issue 43 (1942): 2802.

[48] J. A. Schmoll, "Vom Sinn der Fotografie," in Otto Steinert, *Subjective Fotografie 2: ein Bildband moderner Fotografie* (Munich, 1955), p. 38.

the medium as he pleases. A second reader endorsed her article on the strength of the argument that "photographers work best within the limitations of the medium." And a third preferred not to advance an opinion at all because "any attempt . . . to formalize and sharply define the function of our art can only lead to stagnation."[49] Skirmishes such as these prove that the belligerents are as far apart as ever before.

In sum, the views and trends that marked the beginnings of photography have not changed much in the course of its evolution. (To be sure, its techniques and contents have, but that is beside the point here.) Throughout the history of photography there is on the one side a tendency toward realism culminating in records of nature, and on the other a formative tendency aiming at artistic creations. Often enough, formative aspirations clash with the desire to render reality, overwhelming it in the process. Photography, then, is the arena of two tendencies which may well conflict with each other. This state of things raises the aesthetic problems to which we now must turn.

SYSTEMATIC CONSIDERATIONS

The Basic Aesthetic Principle

It may be assumed that the achievements within a particular medium are all the more satisfying aesthetically if they build from the specific properties of that medium. To express the same in negative terms, a product which, somehow, goes against the grain of its medium—say, by imitating effects more "natural" to another medium—will hardly prove acceptable; the old iron structures with their borrowings from Gothic stone architecture are as irritating as they are venerable. The pull of the properties of photography is, perhaps, responsible for the inconsistent attitudes and performances of some photographers with strong painterly inclinations. Robinson, the early artist-photographer who recommended that truth should be sacrificed to beauty, at the same time eulogized, as if under a compulsion, the medium's unrivaled truth to reality.[50] Here also

[49] "Reaction to 'Creative Photography,' " *The New York Times*, December 16, 1951.
[50] Quoted by Newhall, *The History of Photography*, p. 78, from Henry Peach Robinson, *Pictorial Effect in Photography* (1869), p. 109.

belongs the duality in Edward Weston's work; devoted to both abstraction and realism, he paid tribute to the latter's superiority only after having become aware of their incompatibility and of his split allegiance.[51]

Yet this emphasis on a medium's peculiarities gives rise to serious objections, one of which may be formulated as follows: The properties of a medium elude concise definition. It is therefore inadmissible to postulate such properties and use them as a starting point for aesthetic analysis. What is adequate to a medium cannot be determined dogmatically in advance. Any revolutionary artist may upset all previous speculations about the "nature" of the medium to which his works belong.

On the other hand, however, experience shows that not all media obstruct a definition of their nature with equal vigor. In consequence, one may arrange the different media along a continuum according to the degree of the elusiveness of their properties. One pole of the continuum can be assigned, for instance, to painting, whose varying modes of approach seem to be least dependent upon the fixed material and technical factors. (Lessing's great attempt, in his *Laocoön,* to delineate the boundaries between painting and poetry suffered from his inability to gauge the potentialities of either art. But this does not invalidate his attempt. Notwithstanding their near-intangibility, these boundaries make themselves felt whenever a painter or poet tries to transfer to his own medium statements advanced in the other.) "There are many things beautiful enough in words," remarks Benvenuto Cellini, roughly anticipating Lessing, "which do not match . . . well when executed by an artist."[52] That the theatre is more restrictive than painting is strikingly demonstrated by an experience of Eisenstein. At a time when he still directed theatrical plays he found out by trial and error that stage conditions could not be stretched infinitely—that in effect their inexorable nature prevented him from implementing his artistic intentions, which then called for film as the only fitting means of expression. So he left the theatre for the cinema.[53] Nor does, at least in our era, the novel readily lend itself to

[51] Newhall, *ibid.*, pp. 157–158.

[52] Benvenuto Cellini, *The Autobiography of Benvenuto Cellini* (New York: The Modern Library, 1927), p. 285.

[53] Sergei Eisenstein, *Film Form: Essays in Film Theory*, ed. and trans. Jay Leyda (New York: Harcourt, Brace, 1949), p. 16.

all kinds of uses; hence the recurrent quest for its essential features. Ortega y Gasset compares it to a "vast but finite quarry."[54]

But if any medium has its legitimate place at the pole opposite that of painting, it is photography. The properties of photography, as defined by Gay-Lussac and Arago at the outset, are fairly specific; and they have lost nothing of their impact in the course of history. Thus, it seems all the more justifiable to apply the basic aesthetic principle to this particular medium. (Since hybrid genres drawing on photography are practically nonexistent, the problem of their possible aesthetic validity does not pose itself.)

Compliance with the basic aesthetic principle carries implications for (1) the photographer's approach to his medium, (2) the affinities of photography, and (3) the peculiar appeals of photographs.

The Photographic Approach

The photographer's approach may be called "photographic" if it conforms to the basic aesthetic principle. In an aesthetic interest, that is, he must follow the realistic tendency under all circumstances. This is of course a minimum requirement. Yet in meeting it, he will at least have produced prints in keeping with the photographic approach. Which means that an impersonal, completely artless camera record is aesthetically irreproachable, whereas an otherwise beautiful and perhaps significant composition may lack photographic quality. Artless compliance with the basic principle has its rewards, especially in case of pictures adjusting our vision to our actual situation. Pictures of this kind need not result from deliberate efforts on the part of the photographer to give the impression of artistic creations. In fact, Beaumont Newhall refers to the intrinsic "beauty" of aerial serial photographs taken with automatic cameras during the last war for strictly military purposes.[55] It is understood that this particular brand of beauty is an unintended by-product which adds nothing to the aesthetic legitimacy of such mechanical explorations of nature.

[54] Ortega y Gasset, *The Dehumanization of Art* (Garden City, N.Y.: Doubleday Anchor, 1956), p. 54. (Translator not named.)

[55] Newhall, *The History of Photography*, p. 218. Cf. Moholy-Nagy, *Vision in Motion*, p. 177.

But if candid shots are true to the medium, it would seem natural to imagine the photographer as a "camera-eye"—a man devoid of formative impulses who is all in all the exact counterpart of the type of artist proclaimed in the realist manifesto of 1856. According to the manifesto, the artist's attitude toward reality should be so impersonal that he might reproduce the same subject ten times without any of his copies showing the slightest difference.[56] This is how Proust conceives of the photographer in that passage of *The Guermantes Way*, where, after a long absence, the narrator enters, unannounced, the living room of his grandmother:

> I was in the room, or rather I was not yet in the room since she was not aware of my presence. . . . Of myself . . . there was present only the witness, the observer with a hat and traveling coat, the stranger who does not belong to the house, the photographer who has called to take a photograph of places which one will never see again. The process that mechanically occurred in my eyes when I caught sight of my grandmother was indeed a photograph. We never see the people who are dear to us save in the animated system, the perpetual motion of our incessant love for them, which before allowing the images that their faces present to reach us catches them in its vortex, flings them back upon the idea that we have always had of them, makes them adhere to it, coincide with it. How, since into the forehead, the cheeks of my grandmother I had been accustomed to read all the most delicate, the most permanent qualities of her mind; how, since every casual glance is an act of necromancy, each face that we love a mirror of the past, how could I have failed to overlook what in her had become dulled and changed, seeing that in the most trivial spectacles of our daily life our eye, charged with thought, neglects, as would a classical tragedy, every image that does not assist the action of the play and retains only those that may help to make its purpose intelligible. . . . I, for whom my grandmother was still myself, I who had never seen her save in my own soul, always at the same place in the past, through the transparent sheets of contiguous, overlapping memories, suddenly in our drawing room which formed part of a new world, that of time, saw, sitting on the sofa, beneath the lamp, red-faced, heavy and common, sick, lost in thought, following the lines of a book with eyes that seemed hardly sane, a dejected old woman whom I did not know.[57]

Proust starts from the premise that love blinds us to the changes which the beloved object is undergoing in the course of time. It is therefore logi-

[56] Freund, *La Photographie en France*, pp. 105–106.
[57] Marcel Proust, *Remembrance of Things Past* (New York: Random House, 1932, 1934), vol. 1, pp. 814–815. Trans. C. K. Scott Moncrieff.

cal that he should emphasize emotional detachment as the photographer's foremost virtue. He drives home this point by comparing the photographer with the witness, the observer, the stranger—three types supposed not to be entangled in the events they happen to watch. They may perceive anything because nothing they see is pregnant with memories that would captivate them and thus limit their vision. The ideal photographer is the opposite of the unseeing lover. He resembles the indiscriminating mirror; he is identical with the camera lens. Photography, Proust has it, is the product of complete alienation.

The one-sidedness of this definition is obvious. Yet the whole context suggests that Proust was primarily concerned with the depiction of a state of mind in which the impact of involuntary memories blurs the external phenomena touching them off. And the desire to contrast, in the interest of clarity, this state of mind with the photographer's may have led him to adopt the credo of the extreme nineteenth-century realists, according to which the photographer—any artist, for that matter—holds a mirror up to nature.

Actually there is no mirror at all. Photographs do not just copy nature but metamorphose it by transferring three-dimensional phenomena to the plane, severing their ties with the surroundings, and substituting black, gray, and white for the given color schemes. Yet if anything defies the idea of a mirror, it is not so much these unavoidable transformations—which may be discounted because in spite of them photographs still preserve the character of compulsory reproductions—as the way in which we take cognizance of visible reality. Even Proust's alienated photographer spontaneously structures the inflowing impressions; the simultaneous perceptions of his other senses, certain perceptual form categories inherent in his nervous system, and not least his general dispositions prompt him to organize the visual raw material in the act of seeing.[58] And the activities in which he thus unconsciously engages are bound to condition the pictures he is taking.

But what about the candid photographs mentioned above—prints obtained almost automatically? In their case it falls to the spectator to do the structuring. (The aerial reconnaissance photos referred to by Newhall in-

[58] Muzafer Sherif and Hadley Cantril, *The Psychology of Ego-Involvements* (New York: John Wiley & Sons, 1947), *passim*; e.g. pp. 30, 33, 34. Arnheim, "Perceptual Abstraction and Art," *Psychological Review*, 54, no. 2 (March 1947).

terfere with the conventional structuring processes because of their unidentifiable shapes, which cause the spectator to withdraw into the aesthetic dimension.) Objectivity in the sense of the realist manifesto is unattainable. This being so, there is no earthly reason why the photographer should suppress his formative faculties in the interest of the necessarily futile attempt to achieve that objectivity. Provided his choices are governed by his determination to record and reveal nature, he is entirely justified in selecting motif, frame, lens, filter, emulsion, and grain according to his sensibilities. Or rather, he must be selective in order to transcend the minimum requirement. For nature is unlikely to give itself up to him if he does not absorb it with all his senses strained and his whole being participating in the process. The formative tendency, then, does not have to conflict with the realistic tendency. Quite the contrary, it may help substantiate and fulfill it—an interaction of which the nineteenth-century realists could not possibly be aware. Contrary to what Proust says, the photographer sees things in his "own soul."

And yet Proust is right in relating the photographic approach to a state of alienation. Even though the photographer who acknowledges the properties of his medium rarely, if ever, shows the emotional detachment which Proust ascribes to him, he cannot freely externalize his inner vision either. What counts is the "right" mixture of his realist loyalties and formative endeavors—a mixture, that is, in which the latter, however strongly developed, surrender their independence to the former. As Lewis Mumford puts it: the photographer's "inner impulse, instead of spreading itself in subjective fantasy, must always be in key with outer circumstances."[59] Some early artist-photographers, such as Nadar, David Octavius Hill, and Robert Adamson, knew how to establish this precarious balance. Much as they were influenced by painting, they primarily aimed at bringing out the essential features of any person presented;[60] the photographic quality of their portraits, says Newhall, must be traced to the "dignity and depth of their perception."[61]

This means that the photographer's selectivity is of a kind which is closer to empathy than to disengaged spontaneity. He resembles perhaps

[59] Mumford, *Technics and Civilization* (New York: Harcourt, Brace, 1934), p. 339.
[60] Freund, *La Photographie en France*, p. 59.
[61] Newhall, *The History of Photography*, p. 47.

most of all the imaginative reader intent on studying and deciphering an elusive text. Like a reader, the photographer is steeped in the book of nature. His "intensity of vision," claims Paul Strand, should be rooted in a "real respect for the thing in front of him."[62] Or in Weston's words, the camera "provides the photographer with a means of looking deeply into the nature of things, and presenting his subjects in terms of their basic reality."[63] Due to the revealing power of the camera, there is also something of an explorer about him; insatiable curiosity stirs him to roam yet-unconquered expanses and capture the strange patterns in them. The photographer summons up his being, not to discharge it in autonomous creations but to dissolve it into the substances of the objects that close in on him. Once again, Proust is right: selectivity within this medium is inseparable from processes of alienation.

Let me insert here an observation on the possible role of melancholy in photographic vision. It is certainly not by accident that Newhall in his *History of Photography* mentions, on two different occasions, melancholy in connection with pictorial work in a photographic spirit. He remarks that Marville's pictures of the Paris streets and houses doomed under Napoleon III have the "melancholy beauty of a vanished past";[64] and he says of Atget's Paris street scenes that they are impregnated with the "melancholy that a good photograph can so powerfully evoke."[65] Now melancholy as an inner disposition not only makes elegiac objects seem attractive but carries still another, more important implication: it favors self-estrangement, which on its part entails identification with all kinds of objects. The dejected individual is likely to lose himself in the incidental configurations of his environment, absorbing them with a disinterested intensity no longer determined by his previous preferences. His is a kind of receptivity which resembles that of Proust's photographer cast in the role of a stranger. Filmmakers often exploited this intimate relationship between melancholy and the photographic approach in an attempt to render visible such a state of mind. A recurrent film sequence runs as follows: the melancholy character is seen strolling about aimlessly: as he

[62] *Ibid.*, p. 150.
[63] Weston, "Seeing Photographically," 3205.
[64] Newhall, *The History of Photography*, p. 91.
[65] *Ibid.*, p. 139.

proceeds, his changing surroundings take shape in the form of numerous juxtaposed shots of house facades, neon lights, stray passersby, and the like. It is inevitable that the audience should trace their seemingly unmotivated emergence to his dejection and the alienation in its wake.

The formative tendency may not only become so weak that the resultant prints just barely fulfill the minimum requirement, but it may also take on proportions which threaten to overwhelm the realistic tendency. During the last few decades many a noted photographer has indulged in pictures which are either meant to explore the given raw material or serve to project inner images of their authors, or both. Characterizing a photograph of tree trunks with eyelike hollows in their bark, Moholy-Nagy observed: "The surrealist often *finds* images in nature which express his feelings."[66] Or think of Moholy-Nagy's own picture, "From Berlin Wireless Tower," and certain abstract or near-abstract compositions which on closer inspection reveal themselves to be rock and soil formations, unconventional combinations of objects, faces in big close-up, and what not.

In pictures of this type the balance between empathy and spontaneity is rather fragile. The photographer producing them does not subordinate his formative impulses to his realistic intentions but seems eager to manifest both of them with equal vigor. He is animated, perhaps without being aware of it, by two conflicting desires—the desire to externalize his inner images and the desire to render outer shapes. However, in order to reconcile them, he relies on occasional coincidences between those shapes and images. Hence the ambiguity of such photographs, which are a veritable tour de force. A good case in point is Mary Ann Dorr's photograph, "Chairs in the Sunlight".[67] On the one hand, it does justice to the properties of the medium: the perforated chairs and the shadows they cast do exist. On the other hand, it is palpably intended as an artistic creation: the shadows and the chairs affect one as elements of a free composition rather than natural objects.

Unsettled borderline cases like these certainly retain a photographic quality if they suggest that their creators are devoted to the text of nature.

[66] Moholy-Nagy, "Surrealism and the Photographer," *The Complete Photographer,* 9, issue 52 (1943): 3,338.

[67] I am greatly indebted to Mr. Edward Steichen for having this photograph brought to my attention.

And they are on the verge of losing that quality if the impression prevails that the photographer's "finds" merely reflect what he has already virtually found before training his camera on the external world; then he does not so much explore nature as utilize it for a pseudorealistic statement of his own vision. He might even manufacture the coveted coincidence between his spontaneous imagery and actuality by slightly tampering with the latter.

The experimental photographer tends to trespass the border region marked by these blends of divergent intentions. Are his products still in the nature of photographs? Photograms or rayographs dispense with the camera; and those "creative" achievements which do not radically consume—by molding it—the recorded raw material possibly going into them. The same holds true of photomontage.[68] It might be best to classify all compositions of this type as a special genre of the graphic arts rather than as photography proper. Despite their obvious affiliations with photography, they are actually remote from it. Indeed, as we have seen, the experimental photographers themselves assert that their prints belong to a peculiar medium and, being artistic creations, should not be confused with such quasi-abstract records of reality as are, perhaps, no less attractive aesthetically.[69] But if these creations are no records, they do not fall into the dimension of paintings or drawings either. James Thrall Soby once remarked of them that they do not "wear well when hung as pictures."[70] It is as if the use of photography for strictly artistic purposes led into a sort of no man's land somewhere between reproduction and expression.

Affinities

Photographs in keeping with the photographic approach—where no misunderstanding is possible, they may just be called photographs—show certain affinities which can be assumed to be as constant as the properties of the medium to which they belong. Four of them call for special attention.

[68] Cf. Mumford, *Technics and Civilization*, p. 339.
[69] Cf. H. Hajek-Halke, *Experimentelle Fotografie* (Bonn, 1955), preface; p. 14. See also the above-quoted articles by Katz, Feininger, and Schmoll.
[70] Quoted by Newhall, *The History of Photography*, p. 213.

First, photography has an outspoken affinity for unstaged reality. Pictures which strike us as intrinsically photographic seem intended to render nature in the raw, nature as it exists independently of us. Now nature is particularly unstageable if it manifests itself in ephemeral configurations which only the camera is able to capture.[71] This explains the delight of early photographers in such subjects as "an accumulation of dust in a hollow moulding,"[72] or a "casual gleam of sunshine."[73] (It is worth mentioning that Fox Talbot—it was he who exclaimed over the sunbeam— was still so little sure of the legitimacy of his preferences that he tried to authenticate them by invoking the precedent of the "Dutch school of art.") In the field of portraiture, it is true, photographers frequently interfere with the given conditions. But the boundaries between staged and unstaged reality are very fluid in this field; and a portraitist who provides a special setting or asks his model to lower the head a bit may well be trying to bring out the typical features of the client before his lens. What counts is his desire to picture nature at its most characteristic so that his portraits look like casual self-revelations, "instinct with the illusion of life."[74] If, on the other hand, the expressive artist in him gets the better of the imaginative reader or curious explorer, his portraits inevitably turn into those ambiguous borderline cases dealt with above. They give you the impression of being overcomposed in terms of lighting and/or subject matter; they no longer catch reality in its flux, you feel, but arrange its elements into a pattern reminiscent of painting.

Second, through this concern with unstaged reality, photography tends to stress the fortuitous. Random events are the very meat of snapshots. "We want to seize, in passing, upon all that may present itself unexpectedly to our view and interest us in some respect," said a Frenchman about instantaneous photography nearly ten years before the first films appeared.[75] Hence the attractiveness of street crowds. By 1859, New York

[71] Mumford, *Technics and Civilization*, p. 340.

[72] Newhall, "Photography and the Development of Kinetic Visualization," p. 40.

[73] Newhall, *The History of Photography*, p. 40; quoted from H. Fox Talbot, *The Pencil of Nature* (London, 1844), p. 40.

[74] Quoted by Newhall, *ibid.*, p. 144, from John A. Tennant's 1921 review of a New York Stieglitz exhibition.

[75] Albert Londe, *La Photographie instantanée* (Paris, 1886), p. 139. I owe this reference to Mr. Beaumont Newhall who kindly let me have some of his notes on instantaneous photography.

stereographs took a fancy to the kaleidoscopic mingling of vehicles and pedestrians,[76] and somewhat later Victorian snapshots reveled in the same inchoate agglomerates. Marville, Stieglitz, Atget—all of them, as has been remarked, acknowledged city life as a contemporary and photogenic major theme.[77] Dreams nurtured by the big cities thus materialized as pictorial records of chance meetings, strange overlappings, and fabulous coincidences. In portraiture, by the same token, even the most typical portraits must retain an accidental character—as if they were plucked en route and still quivered with crude existence. This affinity for the adventitious again implies that the medium does not favor pictures which seem to be forced into an "obvious compositional pattern."[78] (Of course, photographs of the compositional inventions of nature or man-made reality are quite another thing.)

Third, photography tends to suggest endlessness. This follows from its emphasis on fortuitous complexes which represent fragments rather than wholes. A photograph, whether portrait or action picture, is in character only if it precludes the notion of completeness. Its frame marks a provisional limit; its content refers to other contents outside that frame; and its structure denotes something that cannot be encompassed—physical existence. Nineteenth-century writers called this something nature, or life; and they were convinced that photography would have to impress upon us its infinity. Leaves, which they counted among the favorite motifs of the camera, cannot be "staged" but occur in endless quantities. In this respect there is an analogy between the photographic approach and scientific investigation: both probe into an inexhaustible universe whose entirety forever eludes them.

Fourth and finally, the medium has an affinity for the indeterminate of which Proust was keenly aware. Within the passage partially quoted, Proust also imagines the photograph of an Academician leaving the Institute. What the photograph shows us, he observes, "will be, instead of the dignified emergence of an Academician who is going to hail a cab, his staggering gait, his precautions to avoid tumbling upon his back, the pa-

[76] Newhall, "Photography and the Development of Kinetic Visualization," p. 41.
[77] Elizabeth McCausland, "Alfred Stieglitz," *The Complete Photographer*, 9, issue 51 (1943): 3,321.
[78] Newhall, *The History of Photography*, p. 126.

rabola of his fall, as though he were drunk, or the ground frozen over.''[79] The photograph Proust has in mind does not intimate that the Academician must be thought of as being undignified; it simply fails to tell us anything about his behavior in general or his typical attitudes. It so radically isolates a momentary pose of the Academician that the function of this pose within the total structure of his personality remains everybody's guess. The pose relates to a context which, itself, is not given. Photographs, implies Proust, transmit raw material without defining it.

No doubt Proust exaggerates the indeterminacy of photographs just as grossly as he does their depersonalizing quality. Actually the photographer endows his pictures with structure and meaning to the extent to which he makes deliberate choices. His pictures record nature and at the same time reflect his attempt to assimilate and decipher it. Yet, as in pointing up the photographer's alienation, Proust is again essentially right, for however selective photographs are, they cannot deny the tendency toward the unorganized and diffuse which marks them as records. It is therefore inevitable that they should be surrounded with a fringe of indistinct multiple meanings. (To be sure, the traditional work of art carries many meanings also. But due to its rise from interpretable human intentions and circumstances, the meanings inherent in it can virtually be ascertained, whereas those of the photograph are necessarily indeterminate because the latter is bound to convey unshaped nature itself, nature in its inscrutability. As compared with a photograph, any painting has a relatively definite significance. Accordingly, it makes sense to speak of multiple meanings, vague meaningfulness, and the like only in connection with camera work.)

Appeals

Products of a medium with so [*sic*] outspoken affinities may well exert specific appeals differing from those of the art media proper. Three such appeals are discernible.

We know, says Newhall, that subjects "can be misrepresented, distorted, faked . . . and even delight in it occasionally, but the knowledge still cannot shake our implicit faith in the truth of a photographic record.''[80] This explains a common reaction to photographs: since the

[79] Proust, *Remembrance of Things Past*, vol. I, p. 815.
[80] Newhall, *The History of Photography*, p. 91.

days of Daguerre they have been valued as documents of unquestionable authenticity. Baudelaire, who scorned both art's decline into photography and photography's pretense to art, at least admitted that photographs have the merit of rendering, and thus preserving, all those transient things which are entitled to a place in the "archives of our memory."[81] It would be difficult indeed to overestimate their early popularity as souvenirs. There is practically no family which does not boast an album crowded with generations of dear ones before varying backgrounds. With the passing of time, these souvenirs undergo a significant change of meaning. As the recollections they embody fade away, they increasingly assume documentary functions; their impact as photographic records definitely overshadows their original appeal as memory aids. Leafing through the family album, the grandmother will reexperience her honeymoon, while the children will curiously study bizarre gondolas, obsolete fashions, and old young faces they never saw.

And most certainly they will rejoice in discoveries, pointing to odd bagatelles which the grandmother failed to notice in her day. Or think of the satisfaction people are deriving from the scrutiny of an enlargement in which, one by one, things emerge they would not have suspected in the original print—nor in reality itself, for that matter. This too is a typical reaction to photographs. In fact, we tend to look at them in the hope of detecting something new and unexpected—a confidence which pays tribute to the camera's revealing faculty.

Finally, photography has always been recognized as a source of beauty. Yet beauty may be experienced in different ways. All those who do not expect a photograph to impress them as would a painting are agreed that the beauty of, say, Nadar's portraits, Brady's Civil War scenes, or Atget's Paris Streets is inseparable from their being sensitive and technically impeccable readings rather than autonomous creations.[82] Generally speaking, photographs stand a chance of being beautiful to the extent that they comply with the photographic approach. This would account for the frequent observation that pictures extending our vision are not only gratifying as camera revelations but appeal to us aesthetically also—no matter, for the rest, whether they result from high selectivity or

[81] Walter Benjamin, "Über einige Motive bei Baudelaire," *Zeitschrift für Sozialforschung*, 8, nos. 1–2 (1939): 82.

[82] Cf. Newhall, *The History of Photography*, pp. 140, 143.

amount to purely mechanical products like the aerial reconnaissance photographs.

Fox Talbot called it one of the "charms" of photographs that they include things unknown to their maker, things which he himself must discover in them.[83] Similarly, Louis Delluc, one of the key figures of the French cinema after World War I, took delight—aesthetic delight—in the surprising revelations of Kodak pictures: "This is what enchants me: you will admit that it is unusual suddenly to notice, on a film or a plate, that some passer-by, inadvertently picked up by the camera lens, has a singular expression; that Mme X . . . preserves the unconscious secret of classic postures in scattered fragments; and that the trees, the water, the fabrics, the beasts achieve the familiar rhythm which we know is peculiar to them only by means of decomposed movements whose disclosure proves upsetting to us."[84] The aesthetic value of photographs would in a measure seem to be a function of their explorative powers.[85]

In our response to photographs, then, the desire for knowledge and the sense of beauty interpenetrate one another. Often photographs radiate beauty because they satisfy that desire. Moreover, in satisfying it by penetrating unknown celestial spaces and the recesses of matter, they may afford glimpses of designs beautiful in their own right.

The Issue of Art

At this point the controversial issue of whether or not photography is an art comes into view again. The controversy in its present form is strongly determined by the unwillingness of the champions of creativity to put up with the limitations which the photographic process imposes upon their formative urges. They consider any photographer who is following the photographic approach something less than an artist and, on their part, revolt against the recording duties he readily assumes. The issue, as they see it, could not be more poignantly characterized than by

[83] Quoted by Newhall, *ibid.*, p. 182, from H. Fox Talbot, *The Pencil of Nature*, p. 52.

[84] Louis Delluc, "Photographie," in Marcel Lapierre, ed., *Anthologie du cinéma* (Paris, 1946), p. 135.

[85] Paul Valéry, *Degas, danse, dessin* (Paris, 1938), p. 73, remarks that, in the case of flying birds, instantaneous photographs corroborate the prints of Japanese artists. For the resemblances between instantaneous photography and Japanese art, see K. W. Wolf-Czapek, *Die Kinematographie: Wesen, Enstehung und Ziele des lebenden Bildes* (Berlin, 1911), pp. 112–113.

Moholy-Nagy's definition of the experimental photographer as an artist who "will not only select what he finds but . . . produce situations, introduce devices so far unused and neglected, which for him contain the necessary qualities of photographic expression."[86] The emphasis is on the elimination of accidental reality for the sake of art. Barbara Morgan, who builds a universe of her own with the aid of synchroflash and speedlamps, declares that she is "grateful for man-made light and the creative freedom it gives."[87]

Yet much as the concept of art or creativity behind these statements applies to the traditional arts, it fails to do justice to the high degree of selectivity of which photographic records are susceptible. To be more precise, it overshadows the photographer's peculiar and truly formative effort to represent significant aspects of physical reality without trying to overwhelm that reality—so that the raw material focused upon is both left intact and made transparent. No doubt this effort carries aesthetic implications. Stieglitz's group of huddled trees is a memorable image of autumnal sadness. Cartier-Bresson's snapshots capture facial expressions and interrelationships between human figures and architecture which are strangely moving. And Brassai knows how to make walls and wet cobblestones eloquent.

Why, then, reserve the term "art" for the free compositions of the experimental photographers which, in a sense, lie outside the province of photography proper? This threatens to divert the attention from what is really characteristic of the medium. Perhaps it would be more fruitful to use the term "art" in a looser way so that it covers, however inadequately, achievements in a truly photographic spirit—pictures, that is, which are neither works of art in the traditional sense nor aesthetically indifferent products. Because of the sensibility that goes into them and the beauty they may breathe, there is something to be said in favor of such an extended usage.

Unless otherwise specified, the translations in the text have been made by the author.

[86] Moholy-Nagy, *Vision in Motion*, p. 209.
[87] Newhall, *The History of Photography*, p. 198; quoted from Morgan and Lester, ed., *Graphic Graflex Photography* (1948), p. 218.

Roland Barthes
Translated by Stephen Heath

Roland Barthes (1915–) is one of the French formulators of semiology: the science of signs and symbols and their role in culture and society. He applies his method of structural analysis to interpret popular and other cultural phenomena. For Barthes, meaning is a function of structure and use.

In this essay he examines the paradoxical denotative and connotative structures that constitute the photograph's, specifically the press photograph's, meanings. He argues against a naïve reading of the photograph as a mimetic record of reality.

Barthes teaches at the École Practique des Hautes Études, Paris, and is a member of the Collège de France. This essay is taken from his anthology, Image—Music—Text. *His other books include* Elements of Semiology *(1977),* The Pleasure of the Text *(1975), and* Roland Barthes *(1976).*

The press photograph is a message. Considered overall, this message is formed by a source of emission, a channel of transmission and a point of reception. The source of emission is the staff of the newspaper, the group of technicians certain of whom take the photo, some of whom choose, compose, and treat it, while others, finally, give it a title, a caption, and a commentary. The point of reception is the public which reads the paper. As for the channel of transmission, this is the newspaper itself, or, more precisely, a complex of concurrent messages with the photograph as centre and surrounds constituted by the text, the title, the caption, the layout and, in a more abstract but no less "informative" way, by the very name of the paper (this name represents a knowledge that can heavily orientate the reading of the message strictly speaking: a photograph can change its meaning as it passes from the very conservative *L'Aurore* to the Communist *L'Humanité*). These observations are not without their importance, for it can readily be seen that in the case of the press photograph the three traditional parts of the message do not call for the same

* Reprinted from *Image—Music—Text* (New York: Farrar, Straus & Giroux, 1977).

method of investigation. The emission and the reception of the message both lie within the field of a sociology: it is a matter of studying human groups, of defining motives and attitudes, and of trying to link the behaviour of these groups to the social totality of which they are a part. For the message itself, however, the method is inevitably different: whatever the origin and the destination of the message, the photograph is not simply a product or a channel but also an object endowed with a structural autonomy. Without in any way intending to divorce this object from its use, it is necessary to provide for a specific method prior to sociological analysis and which can only be the immanent analysis of the unique structure that a photograph constitutes.

Naturally, even from the perspective of a purely immanent analysis, the structure of the photograph is not an isolated structure; it is in communication with at least one other structure, namely the text—title, caption, or article—accompanying every press photograph. The totality of the information is thus carried by two different structures (one of which is linguistic). These two structures are cooperative but, since their units are heterogeneous, necessarily remain separate from one another: here (in the text) the substance of the message is made up of words; there (in the photograph) of lines, surfaces, shades. Moreover, the two structures of the message each occupy their own defined spaces, these being contiguous but not "homogenized," as they are, for example, in the rebus, which fuses words and images in a single line of reading. Hence, although a press photograph is never without a written commentary, the analysis must first of all bear on each separate structure; it is only when the study of each structure has been exhausted that it will be possible to understand the manner in which they complement one another. Of the two structures, one is already familiar, that of language (but not, it is true, that of the "literature" formed by the language-use of the newspaper; an enormous amount of work is still to be done in this connection), while almost nothing is known about the other, that of the photograph. What follows will be limited to the definition of the initial difficulties in providing a structural analysis of the photographic message.

THE PHOTOGRAPHIC PARADOX

What is the content of the photographic message? What does the photograph transmit? By definition, the scene itself, the literal reality. From

the object to its image there is of course a reduction—in proportion, perspective, colour—but at no time is this reduction a *transformation* (in the mathematical sense of the term). In order to move from the reality to its photograph, it is in no way necessary to divide up this reality into units and to constitute these units as signs substantially different from the object they communicate; there is no necessity to set up a relay, that is to say a code, between the object and its image. Certainly the image is not the reality but at least it is its perfect *analogon* and it is exactly this analogical perfection which, to common sense, defines the photograph. Thus can be seen the special status of the photographic image: *it is a message without a code;* from which proposition an important corollary must immediately be drawn: the photographic message is a continuous message.

Are there other messages without a code? At first sight, yes: precisely the whole range of analogical reproductions of reality—drawings, paintings, cinema, theatre. In fact, however, each of those messages develops in an immediate and obvious way a supplementary message, in addition to the analogical content itself (scene, object, landscape), which is what is commonly called the *style* of the reproduction; second meaning, whose signifier is a certain "treatment" of the image (result of the action of the creator) and whose signified, whether aesthetic or ideological, refers to a certain "culture" of the society receiving the message. In short, all these "imitative" arts comprise two messages: a *denoted* message, which is the *analogon* itself, and a *connoted* message, which is the manner in which the society to a certain extent communicates what it thinks of it. This duality of messages is evident in all reproductions other than photographic ones: there is no drawing, no matter how exact, whose very exactitude is not turned into a style (the style of "verism"); no filmed scene whose objectivity is not finally read as the very sign of objectivity. Here again, the study of these connoted messages has still to be carried out (in particular it has to be decided whether what is called a work of art can be reduced to a system of significations); one can only anticipate that for all these imitative arts—when common—the code of the connoted system is very likely constituted either by a universal symbolic order or by a period rhetoric, in short by a stock of stereotypes (schemes, colours, graphisms, gestures, expressions, arrangements of elements).

When we come to the photograph, however, we find in principle noth-

ing of the kind, at any rate as regards the press photograph (which is never an "artistic" photograph). The photograph professing to be a mechanical analogue of reality, its first-order message in some sort completely fills its substance and leaves no place for the development of a second-order message. Of all the structures of information,[1] the photograph appears as the only one that is exclusively constituted and occupied by a "denoted" message, a message which totally exhausts its mode of existence. In front of a photograph, the feeling of "denotation," or, if one prefers, of analogical plenitude, is so great that the description of a photograph is literally impossible; *to describe* consists precisely in joining to the denoted message a relay or second-order message derived from a code which is that of language and constituting in relation to the photographic analogue, however much care one takes to be exact, a connotation: to describe is thus not simply to be imprecise or incomplete, it is to change structures, to signify something different to what is shown.[2]

This purely "denotative" status of the photograph, the perfection and plenitude of its analogy, in short its "objectivity," has every chance of being mythical (these are the characteristics that common sense attributes to the photograph). In actual fact, there is a strong probability (and this will be a working hypothesis) that the photographic message too—at least in the press—is connoted. Connotation is not necessarily immediately graspable at the level of the message itself (it is, one could say, at once invisible and active, clear and implicit) but it can already be inferred from certain phenomena which occur at the levels of the production and reception of the message: on the one hand, the press photograph is an object that has been worked on, chosen, composed, constructed, treated according to professional, aesthetic, or ideological norms, which are so many factors of connotation; while on the other, this same photograph is

[1] It is a question, of course, of "cultural" or culturalized structures, not of operational structures. Mathematics, for example, constitutes a denoted structure without any connotation at all; should mass society seize on it, however, setting out for instance an algebraic formula in an article on Einstein, this originally purely mathematical message now takes on a very heavy connotation, since it *signifies* science.

[2] The description of a drawing is easier, involving, finally, the description of a structure that is already connoted, fashioned with a *coded* signification in view. It is for this reason perhaps that psychological texts use a great many drawings and very few photographs.

not only perceived, received, it is *read,* connected more or less consciously by the public that consumes it to a traditional stock of signs. Since every sign supposes a code, it is this code (of connotation) that one should try to establish. The photographic paradox can then be seen as the coexistence of two messages, the one without a code (the photographic analogue), the other with a code (the "art," or the treatment, or the "writing," or the rhetoric, of the photograph); structurally, the paradox is clearly not the collusion of a denoted message and a connoted message (which is the—probably inevitable—status of all the forms of mass communication), it is that here the connoted (or coded) message develops on the basis of a message *without a code.* This structural paradox coincides with an ethical paradox: when one wants to be "neutral," "objective," one strives to copy reality meticulously, as though the analogical were a factor of resistance against the investment of values (such at least is the definition of aesthetic "realism"); how then can the photograph be at once "objective" and "invested," natural and cultural? It is through an understanding of the mode of imbrication of denoted and connoted messages that it may one day be possible to reply to that question. In order to undertake this work, however, it must be remembered that since the denoted message in the photograph is absolutely analogical, which is to say *continuous,* outside of any recourse to a code, there is no need to look for the signifying units of the first-order message; the connoted message on the contrary does comprise a plane of expression and a plane of content,thus necessitating a veritable decipherment. Such a decipherment would as yet be premature, for in order to isolate the signifying units and the signified themes (or values), one would have to carry out (perhaps using tests) directed readings, artificially varying certain elements of a photograph to see if the variations of forms led to variations in meaning. What can at least be done now is to forecast the main planes of analysis of photographic connotation.

CONNOTATION PROCEDURES

Connotation, the imposition of second meaning on the photographic message proper, is realized at the different levels of the production of the photograph (choice, technical treatment, framing, layout) and represents, finally, a coding of the photographic analogue. It is thus possible to sepa-

rate out various connotation procedures, bearing in mind however that these procedures are in no way units of signification such as a subsequent analysis of a semantic kind may one day manage to define; they are not strictly speaking part of the photographic structure. The procedures in question are familiar and no more will be attempted here than to translate them into structural terms. To be fully exact, the first three (trick effects, pose, objects) should be distinguished from the last three (photogenia, aestheticism, syntax), since in the former the connotation is produced by a modification of the reality itself, of, that is, the denoted message (such preparation is obviously not peculiar to the photograph). If they are nevertheless included among the connotation procedures, it is because they too benefit from the prestige of the denotation: the photograph allows the photographer to *conceal elusively* the preparation to which he subjects the scene to be recorded. Yet the fact still remains that there is no certainty from the point of view of a subsequent structural analysis that it will be possible to take into account the material they provide.

1. **Trick effects.** A photograph given wide circulation in the American press in 1951 is reputed to have cost Senator Millard Tydings his seat; it showed the senator in conversation with the Communist leader Earl Browder. In fact, the photograph had been faked, created by the artificial bringing together of the two faces. The methodological interest of trick effects is that they intervene without warning in the plane of denotation; they utilize the special credibility of the photograph—this, as was seen, being simply its exceptional power of denotation—in order to pass off as merely denoted a message which is in reality heavily connoted; in no other treatment does connotation assume so completely the "objective" mask of denotation. Naturally, signification is only possible to the extent that there is a stock of signs, the beginnings of a code. The signifier here is the conversational attitude of the two figures and it will be noted that this attitude becomes a sign only for a certain society, only given certain values. What makes the speakers' attitude the sign of a reprehensible familiarity is the tetchy anti-Communism of the American electorate; which is to say that the code of connotation is neither artificial (as in a true language) nor natural, but historical.

2. **Pose.** Consider a press photograph of President Kennedy widely

distributed at the time of the 1960 election: a half-length profile shot, eyes looking upwards, hands joined together. Here it is the very pose of the subject which prepares the reading of the signifieds of connotation: youthfulness, spirituality, purity. The photograph clearly only signifies because of the existence of a store of stereotyped attitudes which form ready-made elements of signification (eyes raised heavenwards, hands clasped). A "historical grammar" of iconographic connotation ought thus to look for its material in painting, theatre, associations of ideas, stock metaphors, etc., that is to say, precisely in "culture." As has been said, pose is not a specifically photographic procedure but it is difficult not to mention it insofar as it derives its effect from the analogical principle at the basis of the photograph. The message in the present instance is not "the pose" but "Kennedy praying": the reader receives as a simple denotation what is in actual fact a double structure—denoted-connoted.

3. **Objects.** Special importance must be accorded to what could be called the posing of objects, where the meaning comes from the objects photographed (either because these objects have, if the photographer had the time, been artificially arranged in front of the camera or because the person responsible for layout chooses a photograph of this or that object). The interest lies in the fact that the objects are accepted inducers of associations of ideas (bookcase = intellectual) or, in a more obscure way, are veritable symbols (the door of the gas chamber for Chessman's execution with its reference to the funeral gates of ancient mythologies). Such objects constitute excellent elements of signification: on the one hand they are discontinuous and complete in themselves, a physical qualification for a sign, while on the other they refer to clear, familiar signifieds. They are thus the elements of a veritable lexicon, stable to a degree which allows them to be readily constituted into syntax. Here, for example, is a "composition" of objects: a window opening on to vineyards and tiled roofs; in front of the window a photograph album, a magnifying glass, a vase of flowers. Consequently, we are in the country, south of the Loire (vines and tiles), in a bourgeois house (flowers on the table) whose owner, advanced in years (the magnifying glass), is reliving his memories (the photograph album)—François Mauriac in Malagar (photo in *Paris-Match*). The connotation somehow "emerges" from all these signifying units, which are nevertheless "captured" as though the scene were imme-

diate and spontaneous, that is to say, without signification. The text renders the connotation explicit, developing the theme of Mauriac's ties with the land. Objects no longer perhaps possess a *power*, but they certainly possess meanings.

4. **Photogenia.** The theory of photogenia has already been developed (by Edgar Morin in *Le Cinéma ou l'homme imaginaire*[3]) and this is not the place to take up again the subject of the general signification of that procedure; it will suffice to define photogenia in terms of informational structure. In photogenia the connoted message is the image itself, "embellished" (which is to say in general sublimated) by techniques of lighting, exposure, and printing. An inventory needs to be made of these techniques, but only insofar as each of them has a corresponding signified of connotation sufficiently constant to allow its incorporation in a cultural lexicon of technical "effects" (as for instance the "blurring of movement" or "flowingness" launched by Dr. Steinert and his team to signify spacetime). Such an inventory would be an excellent opportunity for distinguishing aesthetic effects from signifying effects—unless perhaps it be recognized that in photography, contrary to the intentions of exhibition photographers, there is never *art* but always *meaning;* which precisely would at last provide an exact criterion for the opposition between good painting, even if strongly representational, and photography.

5. **Aestheticism.** For if one can talk of aestheticism in photography, it is seemingly in an ambiguous fashion: when photography turns painting, composition, or visual substance treated with deliberation in its very material "texture," it is either so as to signify itself as "art" (which was the case with the "pictorialism" of the beginning of the century) or to impose a generally more subtle and complex signified than would be possible with other connotation procedures. Thus Cartier-Bresson constructed Cardinal Pacelli's reception by the faithful of Lisieux like a painting by an early master. The resulting photograph, however, is in no way a painting: on the one hand, its display of aestheticism refers (damagingly) to the very idea of a painting (which is contrary to any true painting); while on the other, the composition signifies in a declared manner a certain ecstatic spirituality translated precisely in terms of an objective spec-

[3] Edgar Morin, *Le Cinéma ou l'homme imaginaire* (Paris, 1956).

tacle. One can see here the difference between photograph and painting: in a picture by a Primitive, "spirituality" is not a signified but, as it were, the very being of the image. Certainly there may be coded elements in some paintings, rhetorical figures, period symbols, but no signifying unit refers to spirituality, which is a mode of being and not the object of a structured message.

6. **Syntax.** We have already considered a discursive reading of object-signs within a single photograph. Naturally, several photographs can come together to form a sequence (this is commonly the case in illustrated magazines); the signifier of connotation is then no longer to be found at the level of any one of the fragments of the sequence but at that—what the linguists would call the suprasegmental level—of the concatenation. Consider for example four snaps of a presidential shoot at Rambouillet: in each, the illustrious sportsman (Vincent Auriol) is pointing his rifle in some unlikely direction, to the great peril of the keepers who run away or fling themselves to the ground. The sequence (and the sequence alone) offers an effect of comedy which emerges, according to a familiar procedure, from the repetition and variation of the attitudes. It can be noted in this connection that the single photograph, contrary to the drawing, is very rarely (that is, only with much difficulty) comic; the comic requires movement, which is to say repetition (easy in film) or typification (possible in drawing), both these "connotations" being prohibited to the photograph.

TEXT AND IMAGE

Such are the main connotation procedures of the photographic image (once again, it is a question of techniques, not of units). To these may invariably be added the text which accompanies the press photograph. Three remarks should be made in this context.

Firstly, the text constitutes a parasitic message designed to connote the image, to "quicken" it with one or more second-order signifieds. In other words, and this is an important historical reversal, the image no longer *illustrates* the words; it is now the words which, structurally, are parasitic on the image. The reversal is at cost: in the traditional modes of illustration the image functioned as an episodic return to denotation from a principal message (the text) which was experienced as connoted since,

precisely, it needed an illustration; in the relationship that now holds, it is not the image which comes to elucidate or "realize" the text, but the latter which comes to sublimate, patheticize, or rationalize the image. As however this operation is carried out accessorily, the new informational totality appears to be chiefly founded on an objective (denoted) message in relation to which the text is only a kind of secondary vibration, almost without consequence. Formerly, the image illustrated the text (made it clearer); today, the text loads the image, burdening it with a culture, a moral, an imagination. Formerly, there was reduction from text to image; today, there is amplication from the one to the other. The connotation is now experienced only as the natural resonance of the fundamental denotation constituted by the photographic analogy an we are thus confronted with a typical process of naturalization of the cultural.

Secondly, the effect of connotation probably differs according to the way in which the text is presented. The closer the text to the image, the less it seems to connote it; caught as it were in the iconographic message, the verbal message seems to share in its objectivity, the connotation of language is "innocented" through the photograph's denotation. It is true that there is never a real incorporation since the substances of the two structures (graphic and iconic) are irreducible, but there are most likely degrees of amalgamation. The caption probably has a less obvious effect of connotation than the headline or accompanying article: headline and article are palpably separate from the image, the former by its emphasis, the latter by its distance; the first because it breaks, the other because it distances the content of the image. The caption, on the contrary, by its very disposition, by its average measure of reading, appears to duplicate the image, that is, to be included in its denotation.

It is impossible however (and this will be the final remark here concerning the text) that the words "duplicate" the image; in the movement from one structure to the other second signifieds are inevitably developed. What is the relationship of these signifieds of connotation to the image? To all appearances, it is one of making explicit, of providing a stress; the text most often simply amplifying a set of connotations already given in the photograph. Sometimes, however, the text produces (invents) an entirely new signified which is retroactively projected into the image, so much so as to appear denoted there. *"They were near to death, their*

faces prove it," reads the headline to a photograph showing Elizabeth and Philip leaving a plane—but at the moment of the photograph the two still knew nothing of the accident they had just escaped. Sometimes too, the text can even contradict the image so as to produce a compensatory connotation. An analysis by Gerbner (*The Social Anatomy of the Romance Confession Cover-Girl)* demonstrated that in certain romance magazines the verbal message of the headlines, gloomy and anguished, on the cover always accompanied the image of a radiant covergirl; here the two messages enter into a compromise, the connotation having a regulating function, preserving the irrational movement of projection-identification.

PHOTOGRAPHIC INSIGNIFICANCE

We saw that the code of connotation was in all likelihood neither "natural" nor "artificial" but historical, or, if it be preferred, "cultural." Its signs are gestures, attitudes, expressions, colours or effects, endowed with certain meanings by virtue of the practice of a certain society: the link between signifier and signified remains if not unmotivated, at least entirely historical. Hence it is wrong to say that modern man projects into reading photographs feelings and values which are characterial or "eternal" (infra- or transhistorical), unless it be firmly specified that *signification* is always developed by a given society and history. Signification, in short, is the dialectical movement which resolves the contradiction between cultural and natural man.

Thanks to its code of connotation the reading of the photograph is thus always historical; it depends on the reader's "knowledge" just as though it were a matter of a real language [*langue*], intelligible only if one has learned the signs. All things considered, the photographic "language" [*"langage"*] is not unlike certain ideographic languages which mix analogical and specifying units, the difference being that the ideogram is experienced as a sign whereas the photographic "copy" is taken as the pure and simple denotation of reality. To find this code of connotation would thus be to isolate, inventoriate, and structure all the "historical" elements of the photograph, all the parts of the photographic surface which derive their very discontinuity from a certain knowledge on the reader's part, or, if one prefers, from the reader's cultural situation.

This task will perhaps take us a very long way indeed. Nothing tells us

that the photograph contains "neutral" parts, or at least it may be that complete insignificance in the photograph is quite exceptional. To resolve the problem, we would first of all need to elucidate fully the mechanisms of reading (in the physical, and no longer the semantic, sense of the term), of the perception of the photograph. But on this point we know very little. How do we read a photograph? What do we perceive? In what order, according to what progression? If, as is suggested by certain hypotheses of Bruner and Piaget, there is no perception without immediate categorization, then the photograph is verbalized in the very moment it is perceived; better, it is only perceived verbalized (if there is a delay in verbalization, there is disorder in perception, questioning, anguish for the subject, traumatism, following G. Cohen-Séat's hypothesis with regard to filmic perception). From this point of view, the image—grasped immediately by an inner metalanguage, language itself—in actual fact has no denoted state, is immersed for its very social existence in at least an initial layer of connotation, that of the categories of language. We know that every language takes up a position with regard to things, that it connotes reality, if only in dividing it up; the connotations of the photograph would thus coincide, *grosso modo*, with the overall connotative planes of language.

In addition to "perceptive" connotation, hypothetical but possible, one then encounters other, more particular, modes of connotation, and firstly a "cognitive" connotation whose signifiers are picked out, localized, in certain parts of the analogon. Faced with such and such a townscape, I *know* that this is a North African country because on the left I can see a sign in Arabic script, in the centre a man wearing a gandoura, and so on. Here the reading closely depends on my culture, on my knowledge of the world, and it is probable that a good press photograph (and they are all good, being selected) makes ready play with the supposed knowledge of its readers, those prints being chosen which comprise the greatest possible quantity of information of this kind in such a way as to render the reading fully satisfying. If one photographs Agadir in ruins, it is better to have a few signs of "Arabness" at one's disposal, even though "Arabness" has nothing to do with the disaster itself; connotation drawn from knowledge is always a reassuring force—man likes signs and likes them clear.

Perceptive connotation, cognitive connotation; there remains the problem of ideological (in the very wide sense of the term) or ethical connota-

tion, that which introduces reasons or values into the reading of the image. This is a strong connotation requiring a highly elaborated signifier of a readily syntactical order: conjunction of people (as was seen in the discussion of trick effects), development of attitudes, constellation of objects. A son has just been born to the Shah of Iran and in a photograph we have: royalty (cot worshiped by a crowd of servants gathering round), wealth (several nursemaids), hygiene (white coats, cot covered in Plexiglas), the nevertheless human condition of kings (the baby is crying)—all the elements, that is, of the myth of princely birth as it is consumed today. In this instance the values are apolitical and their lexicon is abundant and clear. It is possible (but this is only a hypothesis) that political connotation is generally entrusted to the text, insofar as political choices are always, as it were, in bad faith: for a particular photograph I can give a right-wing reading or a left-wing reading (see in this connection an IFOP [Institut Français D'Opinion Publique] survey published by *Les Temps modernes* in 1955). Denotation, or the appearance of denotation, is powerless to alter political opinions: no photograph has ever convinced or refuted anyone (but the photograph can "confirm") insofar as political consciousness is perhaps nonexistent outside the *logos*: politics is what allows *all* languages.

These few remarks sketch a kind of differential table of photographic connotations, showing, if nothing else, that connotation extends a long way. Is this to say that a pure denotation, a *this-side of language*, is impossible? If such a denotation exists, it is perhaps not at the level of what ordinary language calls the insignificant, the neutral, the objective, but, on the contrary, at the level of absolutely traumatic images. The trauma is a suspension of language, a blocking of meaning. Certainly situations which are normally traumatic can be seized in a process of photographic signification but then precisely they are indicated via a rhetorical code which distances, sublimates, and pacifies them. Truly traumatic photographs are rare, for in photography the trauma is wholly dependent on the certainty that the scene "really" happened: *the photographer had to be there* (the mythical definition of denotation). Assuming this (which, in fact, is already a connotation), the traumatic photograph (fires, shipwrecks, catastrophes, violent deaths, all captured "from life as lived") is the photograph about which there is nothing to say; the shock photo is by

structure insignificant: no value, no knowledge, at the limit no verbal categorization can have a hold on the process instituting the signification. One could imagine a kind of law: the more direct the trauma, the more difficult is connotation; or again, the "mythological" effect of a photograph is inversely proportional to its traumatic effect.

Why? Doubtless because photographic connotation, like every well-structured signification, is an institutional activity; in relation to society overall, its function is to integrate man, to reassure him. Every code is at once arbitrary and rational; recourse to a code is thus always an opportunity for man to prove himself, to test himself through a reason and a liberty. In this sense, the analysis of codes perhaps allows an easier and surer historical definition of a society than the analysis of its signifieds, for the latter can often appear as transhistorical, belonging more to an anthropological base than to a proper history. Hegel gave a better definition of the ancient Greeks by outlining the manner in which they made nature signify than by describing the totality of their "feelings and beliefs" on the subject. Similarly, we can perhaps do better than to take stock directly of the ideological contents of our age; by trying to reconstitute in its specific structure the code of connotation of a mode of communication as important as the press photograph, we may hope to find, in their very subtlety, the forms our society uses to ensure its peace of mind and to grasp thereby the magnitude, the detours, and the underlying function of that activity. The prospect is the more appealing in that, as was said at the beginning, it develops with regard to the photograph in the form of a paradox—that which makes of an inert object a language and which transforms the unculture of a "mechanical" art into the most social of institutions.

John Szarkowski

John Szarkowski (1925-) proposes a critical vocabulary for the study of photographic form in this introduction to The Photographer's Eye. *As director of the photography department of The Museum of Modern Art his intention is to establish criteria inherent in the medium. And for Szarkowski a vocabulary for photography must take into consideration photographs made by artists, amateurs, and commercial photographers.*

Szarkowski's approach negates the traditional distinction between fine art and vernacular photography. He is more interested in the image—its formal properties—than in the intent of the image-maker. In the tradition of Steichen he finds that photographic excellence is not determined by the function of the picture. That photography is or is not a fine art is no longer the primary issue. Szarkowski's commitment is to investigating "what photographs look like and . . . why they look that way."

This essay was part of the catalogue for an exhibition of the same title at The Museum of Modern Art in 1966. The exhibition generated varied critical responses. Szarkowski's reconciliation of fine and vernacular photography provoked Janet Malcolm ("Photography: Diana and Nikon," The New Yorker, *April 26, 1976) to question whether artists or artisans are the creative leaders of the medium. S. Varnedoe ("Easy Pictures, Uneasy Art,"* Arts Magazine, *November 1976) asserts that despite shared formal properties fine and vernacular photography are distinguishable. And Susan Sontag (see essay by Sontag) relates the equal appreciation of fine and vernacular photography to the medium's limits as a creative expression.*

Szarkowski has been director of the photography department of The Museum of Modern Art since 1962. He has organized numerous and varied exhibitions on nineteenth- and twentieth-century photography. His books, often written on the occasion of an exhibition, include New Japanese Photography *(1974), with Shoji Yamagishi,* From the Picture Press *(1973), and*

* Reprinted from *The Photographer's Eye* (New York: The Museum of Modern Art, 1966).

Harry Callahan (*1976*). *Also a photographer, books of his own photographs include* The Idea of Louis Sullivan (*1956*) *and* The Face of Minnesota (*1958*).

This book is an investigation of what photographs look like and of why they look that way. It is concerned with photographic style and with photographic tradition: with the sense of possibilities that a photographer today takes to his work.

The invention of photography provided a radically new picture-making process—a process based not on synthesis but on selection. The difference was a basic one. Paintings were *made*—constructed from a storehouse of traditional schemes and skills and attitudes—but photographs, as the man on the street put it, were *taken*.

The difference raised a creative issue of a new order: how could this mechanical and mindless process be made to produce pictures meaningful in human terms—pictures with clarity and coherence and a point of view? It was soon demonstrated that an answer would not be found by those who loved too much the old forms, for in large part the photographer was bereft of the old artistic traditions. Speaking of photography, Baudelaire said: "This industry, by invading the territories of art, has become art's most mortal enemy."[1] And in his own terms of reference Baudelaire was half right; certainly the new medium could not satisfy old standards. The photographer must find new ways to make his meaning clear.

These new ways might be found by men who could abandon their allegiance to traditional pictorial standards—or by the artistically ignorant, who had no old allegiances to break. There have been many of the latter sort. Since its earliest days, photography has been practiced by thousands who shared no common tradition or training, who were disciplined and united by no academy or guild, who considered their medium variously as a science, an art, a trade, or an entertainment and who were often unaware of each other's work. Those who invented photography were scien-

[1] Charles Baudelaire, "Salon de 1859," translated by Jonathan Mayne for *The Mirror of Art, Critical Studies by Charles Baudelaire* (London: Phaidon Press, 1955); quoted from *On Photography, A Source Book of Photo History in Facsimile*, Beaumont Newhall, ed. (Watkins Glen, N.Y.: Century House, 1956), p. 106.

tists and painters, but its professional practitioners were a very different lot. Hawthorne's daguerreotypist hero Holgrave in *The House of the Seven Gables* was perhaps not far from typical:

> Though now but twenty-two years old, he had already been a country schoolmaster; salesman in a country store; and the political editor of a country newspaper. He had subsequently travelled as a peddler of cologne water and other essences. He had studied and practiced dentistry. Still more recently he had been a public lecturer on mesmerism, for which science he had very remarkable endowments. His present phase as a daguerreotypist was of no more importance in his own view, nor likely to be more permanent, than any of the preceding ones.[2]

The enormous popularity of the new medium produced professionals by the thousands—converted silversmiths, tinkers, druggists, blacksmiths, and printers. If photography was a new artistic problem, such men had the advantage of having nothing to unlearn. Among them they produced a flood of images. In 1853 the *New-York Daily Tribune* estimated that three million daguerreotypes were being produced that year.[3] Some of these pictures were the product of knowledge and skill and sensibility and invention; many were the product of accident, improvisation, misunderstanding, and empirical experiment. But whether produced by art or by luck, each picture was part of a massive assault on our traditional habits of seeing.

By the later decades of the nineteenth century the professionals and the serious amateurs were joined by an even larger host of casual snapshooters. By the early 1880s the dry plate, which could be purchased ready-to-use, had replaced the refractory and messy wet-plate process, which demanded that the plate be prepared just before exposure and processed before its emulsion had dried. The dry plate spawned the hand camera and the snapshot. Photography had become easy. In 1893 an English writer complained that the new situation had

> created an army of photographers who run rampant over the globe, photographing objects of all sorts, sizes and shapes, under almost every condition,

[2] Nathaniel Hawthorne, *The House of the Seven Gables* (New York: Signet Classics edition, 1961), pp. 156–157.

[3] A. C. Willers, "Poet and Photography," in *Picturescope*, 11, no. 4 (New York: Picture Division, Special Libraries Association, 1963), p. 46.

without ever pausing to ask themselves, is this or that artistic? . . . They spy a view, it seems to please, the camera is focused, the shot taken! There is no pause, why should there be? For art may err but nature cannot miss, says the poet, and they listen to the dictum. To them, composition, light, shade, form and texture are so many catch phrases. . . .[4]

These pictures, taken by the thousands by journeyman worker and Sunday hobbyist, were unlike any pictures before them. The variety of their imagery was prodigious. Each subtle variation in viewpoint or light, each passing moment, each change in the tonality of the print created a new picture. The trained artist could draw a head or a hand from a dozen perspectives. The photographer discovered that the gestures of a hand were infinitely various, and that the wall of a building in the sun was never twice the same.

Most of this deluge of pictures seemed formless and accidental, but some achieved coherence, even in their strangeness. Some of the new images were memorable, and seemed significant beyond their limited intention. These remembered pictures enlarged one's sense of possibilities as he looked again at the real world. While they were remembered they survived, like organisms, to reproduce and evolve.

But it was not only the way that photography described things that was new; it was also the things it chose to describe. Photographers shot ". . . objects of all sorts, sizes and shapes . . . without ever pausing to ask themselves, is this or that artistic?" Painting was difficult, expensive, and precious, and it recorded what was known to be important. Photography was easy, cheap, and ubiquitous, and it recorded anything: shopwindows and sod houses and family pets and steam engines and unimportant people. And once made objective and permanent, immortalized in a picture, these trivial things took on importance. By the end of the century, for the first time in history, even the poor man knew what his ancestors had looked like.

The photographer learned in two ways: first, from a worker's intimate understanding of his tools and materials (if his plate would not record the clouds, he could point his camera down and eliminate the sky); and second, he learned from other photographs, which presented themselves in

[4] E. E. Cohen, "Bad Form in Photography," in *The International Annual of Anthony's Photographic Bulletin* (New York and London: E. and H. T. Anthony, 1893), p. 18.

an unending stream. Whether his concern was commercial or artistic, his tradition was formed by all the photographs that had impressed themselves upon his consciousness.

The pictures reproduced in this book were made over almost a century and a quarter. They were made for various reasons, by men of different concerns and varying talent. They have in fact little in common except their success, and a shared vocabulary: these pictures are unmistakably photographs. The vision they share belongs to no school or aesthetic theory, but to photography itself. The character of this vision was discovered by photographers at work, as their awareness of photography's potentials grew.

If this is true, it should be possible to consider the history of the medium in terms of photographers' progressive awareness of characteristics and problems that have seemed inherent in the medium. Five such issues are considered below. These issues *do not* define discrete categories of work; on the contrary they should be regarded as interdependent aspects of a single problem—as section views through the body of photographic tradition. As such, it is hoped that they may contribute to the formulation of a vocabulary and a critical perspective more fully responsive to the unique phenomena of photography.

THE THING ITSELF

The first thing that the photographer learned was that photography dealt with the actual; he had not only to accept this fact, but to treasure it; unless he did, photography would defeat him. He learned that the world itself is an artist of incomparable inventiveness, and that to recognize its best works and moments, to anticipate them, to clarify them and make them permanent requires intelligence both acute and supple.

But he learned also that the factuality of his pictures, no matter how convincing and unarguable, was a different thing from the reality itself. Much of the reality was filtered out in the static little black-and-white image, and some of it was exhibited with an unnatural clarity, an exaggerated importance. The subject and the picture were not the same thing, although they would afterward seem so. It was the photographer's problem to see not simply the reality before him but the still-invisible picture and to make his choices in terms of the latter.

This was an artistic problem, not a scientific one, but the public believed that the photograph could not lie, and it was easier for the photographer if he believed it too, or pretended to. Thus he was likely to claim that what our eyes saw was an illusion and what the camera saw was the truth. Hawthorne's Holgrave, speaking of a difficult portrait subject said

> We give [heaven's broad and simple sunshine] credit only for depicting the merest surface, but it actually brings out the secret character with a truth that no painter would ever venture upon, even could he detect it. . . . the remarkable point is that the original wears, to the world's eye . . . an exceedingly pleasant countenance, indicative of benevolence, openness of heart, sunny good humor, and other praiseworthy qualities of that cast. The sun, as you see, tells quite another story, and will not be coaxed out of it, after half a dozen patient attempts on my part. Here we have a man, sly, subtle, hard, imperious, and withal, cold as ice.[5]

In a sense Holgrave was right in giving more credence to the camera image than to his own eyes, for the image would survive the subject, and become the remembered reality. William M. Ivins, Jr., said "at any given moment the accepted report of an event is of greater importance than the event, for what we think about and act upon is the symbolic report and not the concrete event itself."[6] He also said: "The nineteenth century began by believing that what was reasonable was true and it would end up by believing that what it saw a photograph of was true."[7]

THE DETAIL

The photographer was tied to the facts of things, and it was his problem to force the facts to tell the truth. He could not, outside the studio, pose the truth; he could only record it as he found it, and it was found in nature in a fragmented and unexplained form—not as a story, but as scattered and suggestive clues. The photographer could not assemble these clues into a coherent narrative, he could only isolate the fragment, document it, and by so doing claim for it some special significance, a meaning which went beyond simple description. The compelling clarity with

[5] Hawthorne, *The House of the Seven Gables*, p. 85.
[6] William M. Ivins, Jr., *Prints and Visual Communication* (Cambridge, Mass.: Harvard University Press, 1953), p. 180.
[7] *Ibid.*, p. 94.

which a photograph recorded the trivial suggested that the subject had never before been properly seen, that it was in fact perhaps *not* trivial, but filled with undiscovered meaning. If photographs could not be read as stories, they could be read as symbols.

The decline of narrative painting in the past century has been ascribed in large part to the rise of photography, which "relieved" the painter of the necessity of storytelling. This is curious, since photography has never been successful at narrative. It has in fact seldom attempted it. The elaborate nineteenth-century montages of Robinson and Rejlander, laboriously pieced together from several posed negatives, attempted to tell stories, but these works were recognized in their own time as pretentious failures. In the early days of the picture magazines the attempt was made to achieve narrative through photographic sequences, but the superficial coherence of these stories was generally achieved at the expense of photographic discovery. The heroic documentation of the American Civil War by the Brady group, and the incomparably larger photographic record of World War II, have this in common: neither explained, without extensive captioning, what was happening. The function of these pictures was not to make the story clear, it was to make it *real*. The great war photographer Robert Capa expressed both the narrative poverty and the symbolic power of photography when he said, "If your pictures aren't good, you're not close enough."

THE FRAME

Since the photographer's picture was not conceived but selected, his subject was never truly discrete, never wholly self-contained. The edges of his film demarcated what he thought most important, but the subject he had shot was something else; it had extended in four directions. If the photographer's frame surrounded two figures, isolating them from the crowd in which they stood, it created a relationship between those two figures that had not existed before.

The central act of photography, the act of choosing and eliminating, forces a concentration on the picture edge—the line that separates in from out—and on the shapes that are created by it.

During the first half-century of photography's lifetime, photographs were printed the same size as the exposed plate. Since enlarging was gen-

erally impractical, the photographer could not change his mind in the darkroom, and decide to use only a fragment of his picture, without reducing its size accordingly. If he had purchased an eight-by-ten-inch plate (or worse, prepared it), had carried it as part of his back-bending load, and had processed it, he was not likely to settle for a picture half that size. A sense of simple economy was enough to make the photographer try to fill the picture to its edges.

The edges of the picture were seldom neat. Parts of figures or buildings or features of landscape were truncated, leaving a shape belonging not to the subject, but (if the picture was a good one) to the balance, the propriety, of the image. The photographer looked at the world as though it was a scroll painting, unrolled from hand to hand, exhibiting an infinite number of croppings—of compositions—as the frame moved onward.

The sense of the picture's edge as a cropping device is one of the qualities of form that most interested the inventive painters of the later nineteenth century. To what degree this awareness came from photography, and to what degree from Oriental art, is still open to study. However, it is possible that the prevalence of the photographic image helped prepare the ground for an appreciation of the Japanese print, and also that the compositional attitudes of these prints owed much to habits of seeing which stemmed from the scroll tradition.

TIME

There is in fact no such thing as an instantaneous photograph. All photographs are time exposures, of shorter or longer duration, and each describes a discrete parcel of time. This time is always the present. Uniquely in the history of pictures, a photograph describes only that period of time in which it was made. Photography alludes to the past and the future only insofar as they exist in the present, the past through its surviving relics, the future through prophecy visible in the present.

In the days of slow films and slow lenses, photographs described a time segment of several seconds or more. If the subject moved, images resulted that had never been seen before: dogs with two heads and a sheaf of tails, faces without features, transparent men spreading their diluted substance half across the plate. The fact that these pictures were considered (at best) as partial failures is less interesting than the fact that they were produced

in quantity; they were familiar to all photographers, and to all customers who had posed with squirming babies for family portraits.

It is surprising that the prevalence of these radical images has not been of interest to art historians. The time-lapse painting of Duchamp and Balla, done before World War I, has been compared to work done by photographers such as Edgerton and Mili, who worked consciously with similar ideas a quarter-century later, but the accidental time-lapse photographs of the nineteenth century have been ignored—presumably *because* they were accidental.

As photographic materials were made more sensitive, and lenses and shutters faster, photography turned to the exploration of rapidly moving subjects. Just as the eye is incapable of registering the single frames of a motion picture projected on the screen at the rate of twenty-four per second, so is it incapable of following the positions of a rapidly moving subject in life. The galloping horse is the classic example. As lovingly drawn countless thousands of times by Greeks and Egyptians and Persians and Chinese, and down through all the battle scenes and sporting prints of Christendom, the horse ran with four feet extended, like a fugitive from a carousel. Not till Muybridge successfully photographed a galloping horse in 1878 was the convention broken. It was this way also with the flight of birds, the play of muscles on an athlete's back, the drape of a pedestrian's clothing, and the fugitive expressions of a human face.

Immobilizing these thin slices of time has been a source of continuing fascination for the photographer. And while pursuing this experiment he discovered something else: he discovered that there was a pleasure and a beauty in this fragmenting of time that had little to do with what was happening. It had to do rather with seeing the momentary patterning of lines and shapes that had been previously concealed within the flux of movement. Cartier-Bresson defined his commitment to this new beauty with the phrase *the decisive moment*, but the phrase has been misunderstood; the thing that happens at the decisive moment is not a dramatic climax but a visual one. The result is not a story but a picture.

VANTAGE POINT

Much has been said about the clarity of photography, but little has been said about its obscurity. And yet it is photography that has taught us

to see from the unexpected vantage point, and has shown us pictures that give the sense of the scene, while withholding its narrative meaning. Photographers from necessity choose from the options available to them, and often this means pictures from the other side of the proscenium, showing the actors' backs, pictures from the bird's view, or the worm's, or pictures in which the subject is distorted by extreme foreshortening, or by none, or by an unfamiliar pattern of light, or by a seeming ambiguity of action or gesture.

Ivins wrote with rare perception of the effect that such pictures had on nineteenth-century eyes: "At first the public had talked a great deal about what it called photographer distortion. . . . [But] it was not long before men began to think photographically, and thus to see for themselves things that it had previously taken the photograph to reveal to their astonished and protesting eyes. Just as nature had once imitated art, so now it began to imitate the picture made by the camera."[8]

After a century and a quarter, photography's ability to challenge and reject our schematized notions of reality is still fresh. In his monograph on Francis Bacon, Lawrence Alloway speaks of the effect of photography on that painter: "The evasive nature of his imagery, which is shocking but obscure, like accident or atrocity photographs, is arrived at by using photography's huge repertory of visual images. . . . Uncaptioned news photographs, for instance, often appear as momentous and extraordinary. . . . Bacon used this property of photography to subvert the clarity of pose of figures in traditional painting."[9]

The influence of photography on modern painters (and on modern writers) has been great and inestimable. It is, strangely, easier to forget that photography has also influenced photographers. Not only great pictures by great photographers, but *photography*—the great undifferentiated, homogeneous whole of it—has been teacher, library, and laboratory for those who have consciously used the camera as artists. An artist is a man who seeks new structures in which to order and simplify his sense of the reality of life. For the artist photographer, much of his sense of reality (where his picture starts) and much of his sense of craft or

[8] *Ibid.,* p. 138.
[9] Lawrence Alloway, *Francis Bacon* (New York: Solomon R. Guggenheim Foundation, 1963), p. 22.

structure (where his picture is completed) are anonymous and untraceable gifts from photography itself.

The history of photography has been less a journey than a growth. Its movement has not been linear and consecutive, but centrifugal. Photography, and our understanding of it, has spread from a center; it has, by infusion, penetrated our consciousness. Like an organism, photography was born whole. It is in our progressive discovery of it that its history lies.

Susan Sontag

Susan Sontag (1933–) is noted for her controversial discussions on social and political morality and art. For Sontag photography is an aggressive act. The photographer makes images that affect our ability to understand and change our environment. Sontag believes that the camera is a potent instrument that makes permanent an evaluation that can be conceived as an actual experience.

In this essay Sontag explores the polemics of photography's defense as an art form in relation to its current acceptability in museums and galleries. Sontag suggests that the wide range of current photographic styles may signal the medium's senility.

This essay, written as a review of John Szarkowski's Looking at Photographs *(1973) for* The New York Review of Books, *is included in* On Photography. Sontag is the author of other essays collected in Against Interpretation and Other Essays *(1966) and* Styles of Radical Will *(1969), and of two novels,* The Benefactor *(1963) and* Death Kit *(1967), and she also makes films.*

I

Like other steadily aggrandizing enterprises, photography has inspired its leading practitioners with a need to explain, again and again, what they are doing and why it is valuable. The era in which photography was widely attacked (as parricidal with respect to painting, predatory with respect to people) was a brief one. Painting of course did not expire with the advent of the camera in 1839, as one French painter hastily predicted; the finicky soon ceased to dismiss photography as menial copying; and by 1854 Delacroix graciously declared how much he regretted that "such an admirable discovery should have come so late."

Nothing is more acceptable today than the photographic recycling of reality, acceptable as an everyday activity and as a branch of high art. Yet

* Reprinted from *On Photography* (New York: Farrar, Straus & Giroux, 1977).

something about photography still keeps the first-rate professionals defensive and hortatory. And although virtually every important photographer, right up to the present, has written manifestoes and credos which expound photography's moral and aesthetic mission, photographers give the most contradictory accounts of what kind of knowledge they possess and what kind of art they practice.

The disconcerting ease with which photographs can be taken, the inevitable even when inadvertent authority of the camera's results, suggest a very tenuous relation to knowing. No one would dispute that photography gave a tremendous boost to the cognitive claims of sight, because—through close-up and remote sensing—it so greatly enlarged the realm of the visible. But about the ways in which any subject within the range of unaided vision is further known through a photograph or the extent to which, in order to get a "good" photograph, people need to know anything about what they are photographing, there is no agreement.

Picture-taking has been interpreted by its more reflective professionals in two entirely different ways: either as a lucid and precise act of knowing, of conscious intelligence, or as a preintellectual, intuitive encounter. Thus Nadar, speaking of his respectful, expressive pictures of Baudelaire, Doré, Michelet, Hugo, Berlioz, Sand, Delacroix, and other famous friends, said "the portrait I do best is of the person I know best," while Avedon has observed that most of his good portraits are of people he met for the first time when photographing them.

In this century, the older generation of photographers described photography as a heroic effort of attention, an ascetic discipline, a mystic receptivity to the world which requires that the photographer pass through a cloud of unknowing. According to Minor White, "the state of mind of the photographer while creating is a blank. . . . When looking for pictures . . . the photographer projects himself into everything he sees, identifying himself with everything in order to know it and to feel it better." Cartier-Bresson has likened himself to a Zen archer, who must *become* the target so as to be able to hit it. "Thinking should be done beforehand and afterwards," he says, "never while actually taking a photograph." Thought is regarded as clouding the transparency of the photographer's consciousness, and as infringing on the autonomy of what is

being photographed. Determined to prove that photographs could—and when they are "good," always do—transcend literalness, many serious photographers have made of photography a noetic paradox. Photography is advanced as a form of knowing without knowing: a way of outwitting the world, instead of making a frontal attack on it.

But even when ambitious professionals disparage thinking—suspicion of the intellect being a recurrent theme in photographic apologetics—they usually want to assert how rigorous this permissive visualizing needs to be. "A photograph is not an accident—it is a concept," Ansel Adams insists. "The 'machine-gun' approach to photography—by which many negatives are made with the hope that one will be good—is fatal to serious results." To take a good photograph, runs the common claim, one must already see it. That is, the image must exist in the photographer's mind at or before the moment when the negative is exposed. Justifying photography has for the most part precluded admitting that the scatter-shot method, especially as used by someone experienced, may yield a thoroughly satisfactory result. But despite their reluctance to say so, most photographers have always had—with good reason—an almost superstitious confidence in the lucky accident.

Lately, the secret is becoming avowable. As the defense of photography enters its present, retrospective phase, there is an increasing diffidence in its claims about the alert, knowing state of mind that accomplished picture-taking presumes. The anti-intellectual declarations of photographers, commonplaces of modernist thinking in the arts, have prepared the way for the gradual tilt of serious photography toward a skeptical investigation of its own powers, a commonplace of modernist practice in the arts. Photography as knowledge is succeeded by photography as—photography. Perhaps the most candid statement of photography's currently fashionable skepticism about its older ideals of authoritative representation has been made by Garry Winogrand, one of the most influential of younger American photographers, who rejects any ambition to previsualize and states as the purpose of his work: "to find out what things look like when photographed."

Where the claims of knowledge falter, the claims of creativity take up the slack. As if to refute the fact that many superb pictures are by photog-

raphers devoid of any serious or interesting intentions, the insistence that picture-taking is first of all the focusing of a temperament, only secondarily of a machine, has always been one of the main themes of the defense of photography. This is the theme stated so eloquently in the finest essay I know of in praise of photography, Paul Rosenfeld's chapter on Stieglitz in *Port of New York* (1924). By using "his machinery"—as Rosenfeld puts it—"unmechanically," Stieglitz shows that the camera not only "gave him an opportunity of expressing himself" but supplied images with a wider and "more delicate" gamut "than the hand can draw."

Similarly, Edward Weston insists over and over that photography is a supreme opportunity for self-expression, far superior to that offered by painting. For photography to compete with painting means invoking originality as an important standard for appraising a photographer's work, originality being equated with the stamp of a unique, forceful sensibility. What is exciting "are photographs that say something in a new manner," Harry Callahan writes, *"not* for the sake of being different, but . . . because the individual is different and the individual expresses himself." Paul Strand calls picture-taking "a record of your living," warning photographers to resist "insidious other people's ways" that "get between you and your own vision." For Ansel Adams "a great photograph" has to be "a full expression of what one feels about what is being photographed in the deepest sense," and "thereby, a true expression of what one feels about life in its entirety."[1]

Even when it is hard to take the claims of photographers literally, these hyperbolic and often naïvely stated claims are interesting for the ways in which they recapitulate traditional attitudes which radically oppose the self and the world. Photography is seen as an acute manifestation of the individualized "I," the homeless private self astray in an overwhelming world—mastering reality by a fast visual anthologizing of it. Or photography is seen as a means of finding a place in the world (still experienced as overwhelming, alien) by being able to relate to it with detachment—bypassing the interfering, insolent claims of the self. But between the de-

[1] The quotations from Callahan, Strand, and Adams, along with most of the quotations in the early part of this essay, come from the statements collected in *Photographers on Photography*, edited by Nathan Lyons (Englewood Cliffs, N.J.: Prentice-Hall, 1966).

fense of photography as a superior means of self-expression and the praise of photography as a superior way of putting the self at reality's service there is not as much difference as might appear. Both presuppose that photography provides a unique system of disclosures: that it shows us reality as we had not seen it before.

The revelatory character of photography generally goes by the polemical name of realism. From Fox Talbot's view that the camera produces "natural images" to Berenice Abbott's denunciation of "pictorial" photography to Cartier-Bresson's warning that "the thing to be feared most is the artificially contrived," most of the contradictory declarations of photographers converge in pious avowals of respect for things-as-they-are. For a medium so often considered to be merely realistic, one would think photographers would not have to go on as they do, exhorting each other to stick to realism. But the exhortations continue—another instance of the need photographers have for making something mysterious and urgent of the process by which they appropriate the world.

To insist, as Abbott does, that realism is the very "essence" of photography does not, as it might seem, establish the superiority of one particular procedure or standard; does not necessarily mean that "photo-documents" (Abbott's word) are better than "pictorial photographs."[2] Photography's commitment to realism can accommodate any style, any approach to subject matter. Sometimes it will be defined more narrowly, as the making of images which resemble, and inform us about, the world. Interpreted more broadly, echoing the distrust of mere likeness which has inspired painting for more than a century, photographic realism can be—is more and more—defined not as what is "really" there but as what I "really" perceive.

While all modern forms of art claim some privileged relation to reality,

[2] The original meaning of "pictorial" was, of course, the positive one popularized by the most famous of the nineteenth-century art photographers, Henry Peach Robinson, in his book *Pictorial Effect in Photography* (1869). "His system was to flatter everything," Abbott says in a manifesto she wrote in 1951, "Photography at the Crossroads" (pp. 17–21 in Lyons's *Photographers on Photography*). Praising Nadar, Brady, Atget, and Hine as masters of the photodocument, Abbott dismisses Stieglitz as Robinson's heir, founder of a "superpictorial school" in which, once again, "subjectivity predominated."

photography's claim seems to rest on particularly strong grounds. Yet photography has not, finally, been any more immune than painting has to the most characteristic modern doubts about any straightforward relation to reality—the inability to take for granted the world as observed. Even Abbott cannot help assuming a change in the very nature of reality: that it needs the selective, more acute eye of the camera, there being simply much more of it than ever before. "Today we are confronted with reality on the vastest scale mankind has known," she declares; and this puts "a greater responsibility on the photographer."

All that photography's program of realism actually implies is the belief that reality is hidden. And, being hidden, is something to be unveiled. Whatever the camera records is a disclosure, whether it is imperceptible, fleeting parts of movement, an order that natural vision is incapable of perceiving, or a "heightened reality" (Moholy-Nagy's phrase), or simply the elliptical way of seeing. When Stieglitz describes his "patient waiting for the moment of equilibrium," he makes the same assumption about the essential hiddenness of the real as Robert Frank does when he waits for the moment of revealing disequilibrium, to catch reality off-guard, in what he calls the "in-between moments."

It is not necessary for photographers to point up the mystery of the hidden with exotic or exceptionally striking subjects. When Dorothea Lange urges her colleagues to concentrate on "the familiar," it is with the understanding that the familiar, rendered by a sensitive use of the camera, will thereby become mysterious. Photography's commitment to realism does not limit photography to certain subjects as more real than others, but rather illustrates the formalist understanding of what goes on in every work of art: reality is, in Viktor Shklovsky's word, de-familiarized. What is being urged is an aggressive relation to all subjects. Armed with their machines, photographers are to make an assault on reality— which is perceived as recalcitrant, as only deceptively available, as unreal.

"The pictures have a reality for me that the people don't," Avedon has declared. "It is through the photographs that I know them." To claim that photography must be realistic is not incompatible with opening up an even wider gap between image and reality, in which the mysteriously ac-

quired knowledge (and the enhancement of reality) supplied by photographs presumes a prior alienation from or devaluation of reality.

As photographers describe it, picture-taking is both a limitless technique for appropriating the objective world and an unavoidably solipsistic expression of the singular self. Photographs depict realities that already exist, though only the camera can disclose them. And they depict an individual temperament, discovering itself through the camera's cropping of reality. For Moholy-Nagy the genius of photography lies in its ability to render "an objective portrait: the individual to be photographed so that the photographic result shall not be encumbered with subjective intention." For Dorothea Lange every portrait of another person is a "self-portrait" of the photographer, as for Minor White—promoting "self-discovery through a camera"—landscape photographs are really "inner landscapes." The two ideals are antithetical: insofar as photography is (or should be) about the world, the photographer counts for little; but insofar as it is the instrument of intrepid, questing subjectivity, the photographer is all.

Moholy-Nagy's demand for the photographer's self-effacement follows from his appreciation of how edifying photography is: it retrains and upgrades our powers of observation, it brings about "a psychological transformation of our eyesight." (In an essay published in 1936, he says that photography creates or enlarges eight distinct varieties of seeing: abstract, exact, rapid, slow, intensified, penetrative, simultaneous, and distorted.) But self-effacement is also the demand behind quite different, antiscientific approaches to photography, such as that expressed in Robert Frank's credo: "There is one thing the photograph must contain, the humanity of the moment." In both views the photographer is proposed as a kind of ideal observer—for Moholy-Nagy, seeing with the detachment of a researcher; for Frank, seeing "simply, as through the eyes of the man in the street."

One attraction of any view of the photographer as ideal observer—whether impersonal (Moholy-Nagy) or friendly (Frank)—is that it implicitly denies that picture-taking is in any way an aggressive act. That it can be so described makes most professionals extremely defensive. Cartier-Bresson and Avedon are among the very few to have talked honestly

(if ruefully) about the exploitative aspect of the photographer's activities. Usually, photographers feel obliged to protest photography's innocence, claiming that the predatory attitude is incompatible with a good picture, and hoping that a more affirmative vocabulary will put over their point. One of the more memorable examples of such verbiage is Ansel Adams's description of the camera as an "instrument of love and revelation"; Adams also urges that we stop saying that we "take" a picture and always say we "make" one. Stieglitz's name for the cloud studies he did in the late 1920s—"Equivalents," that is, statements of his inner feelings—is another, soberer instance of the persistent effort of photographers to feature the benevolent character of picture-taking and discount its predatory implications.

What talented photographers do cannot of course be characterized either as simply predatory or as simply, and essentially, benevolent. Photography's version of the ideology of realism seems inherently equivocal—sometimes it dictates an effacement of the self in relation to the world, sometimes it authorizes an aggressive relation to the world which celebrates the self. One side or the other of the connection is always being rediscovered and championed.

An important result of the coexistence of these two ideals is a recurrent ambivalence toward photography's *means*. Whatever the claims for photography as a form of personal expression on a par with painting, it remains true that its originality is inextricably linked to the powers of a machine: no one can deny the informativeness and formal beauty of many photographs made possible by the steady growth of these powers, like Harold Edgerton's high-speed photographs of a bullet hitting its target, of the swirls and eddies of a tennis stroke, or Lennart Nilsson's endoscopic photographs of the interior of the human body. But as cameras get ever more sophisticated, more automated, more acute, some photographers are tempted to disarm themselves or to suggest that they are really not armed, and prefer to submit themselves to the limits imposed by a premodern camera technology—a cruder, less high-powered machine being thought to give more interesting or expressive results, to leave more room for the creative accident. Not using fancy equipment has been almost a point of honor for many photographers, including Weston, Bill

Brandt, Walker Evans, Cartier-Bresson, Robert Frank—some sticking with a battered camera of simple design and slow lens that they acquired early in their careers, some continuing to make their contact prints with nothing more elaborate than a few trays, a bottle of developer, and a bottle of hypo solution.

The camera is indeed the instrument of "fast seeing," as one confident modernist, Alvin Langdon Coburn, declared in 1918, echoing the Futurist apotheosis of machines and speed. Photography's present mood of doubt can be gauged by Cartier-Bresson's recent statement that it may be *too* fast.[3] The cult of the future (of faster and faster seeing) alternates with the wish to return to a more artisanal, purer past—when images still had a handmade quality, an aura. This nostalgia for some pristine state of the photographic enterprise underlies the current enthusiasm for daguerreotypes, stereograph cards, photographic *cartes de visite*, family snapshots, the work of forgotten nineteenth- and early twentieth-century provincial and commercial photographers. (Publishers are now turning out compilation after compilation of such "primitive" photographs.)

But the reluctance to use the newest high-powered equipment is not the only or indeed the most interesting way in which photographers express their attraction to photography's past. The primitivist hankerings that inform current photographic taste are actually being aided by the ceaseless innovativeness of camera technology. For many of these advances not only enlarge the camera's powers but also recapitulate—in a more ingenious, less cumbersome form—earlier, discarded possibilities of the medium.

Thus the development of photography hinges on the replacement of the daguerreotype process, direct positives on metal plates, by the positive-negative process, whereby from an original (negative) an unlimited number of prints (positives) can be made. (Although invented simultaneously in the late 1830s, it was Daguerre's government-supported invention, announced in 1839 with great publicity, rather than Fox Talbot's positive-negative process, that was the first photographic process in general use.) But now the camera could be said to be turning back upon it-

[3] In an interview which appeared in *Le Monde*, September 5, 1974.

self. The Polaroid camera revives the principle of the daguerreotype camera: each print is a unique object. Not surprisingly, some of the most sophisticated photographers have been fascinated by this relatively crude image: Walker Evans in the last years before his death in 1975 was mainly taking color snapshots with the (then) new SX-70; Robert Frank, in his retreat in Nova Scotia, is reported to be working only with the Polaroid.

There are other examples of the inadvertent primitivism of photography's latest technical advances. The hologram (three-dimensional images created with laser light) could be considered as a variant on the heliogram—the first, cameraless photographs made in the 1820s by Nicéphore Niépce. And the increasingly popular use of the camera to produce slides—images which cannot be displayed permanently or stored in wallets and albums, but can only be projected on walls or on paper (as aids for drawing)—goes back even further into the camera's prehistory, for it amounts to using the photographic camera to do the work of the camera obscura.

"History is pushing us to the brink of a realistic age," according to Abbott, who summons photographers to make the jump themselves. But while photographers are perpetually urging each other to be bolder, a doubt persists about reality and the value of realism which keeps them oscillating between simplicity and irony, between insisting on control and cultivating the unexpected, between the eagerness to take advantage of the complex evolution of the medium and the wish to reinvent photography from scratch. Photographers seem to need, periodically, to resist their own knowingness and to remystify what they do.

Questions about knowledge are not, historically, photography's first line of defense. The earliest controversies all centered around the question whether photography's fidelity to appearances and dependence on a machine did not prevent it from being a fine art—as distinct from a merely practical art, an arm of science, and a trade. (That photographs give useful and often startling kinds of information was obvious from the beginning. Photographers only started worrying about what they knew, and what kind of knowledge in a deeper sense a photograph supplies, *after* photography was accepted as an art.) For about a century the de-

fense of photography was identical with the struggle to establish it as a fine art.

Against the charge that photography was a soulless, mechanical copying of reality, photographers asserted that it was a vanguard revolt against ordinary standards of seeing, no less worthy an art than painting. Now, photographers are choosier about what label they use. Since photography has become so entirely respectable a branch of the fine arts, they no longer seek the shelter that the notion of art has intermittently given the photographic enterprise.

Thus for all the important American photographers who have proudly identified their work with the aims of art (like Stieglitz, Minor White, Aaron Siskind, Harry Callahan, Dorothea Lange, Clarence John Laughlin), there are many more who disavow the question itself. Whether or not the camera's "results come under the category of Art is irrelevant," Strand wrote in the 1920s; and Moholy-Nagy declared it "quite unimportant whether the photographer produces 'art' or not." Photographers who came to maturity in the 1940s or later are bolder, openly snubbing art, equating art with artiness. "Most of my photographs are compassionate, gentle, and personal," Bruce Davidson has written. "They tend not to preach. And they tend not to pose as art." Photographers today generally claim to be finding, recording, impartially observing, witnessing, exploring themselves—anything but making works of art.

The fact that important photographers are no longer willing to debate whether photography is or is not a fine art, except to proclaim that their work is *not* involved with art, shows the extent to which they simply take for granted the concept of art imposed by the triumph of modernism: the better the art, the more subversive it is of the traditional aims of art. And modernist taste has welcomed this unpretentious activity that can be consumed, almost in spite of itself, as high art.

Even in the nineteenth century, when photography was thought to be so evidently in need of defense as an art, the line of defense was far from stable. Julia Margaret Cameron's claim that photography qualifies as an art because, like painting, it seeks the beautiful was succeeded by Henry Peach Robinson's Wildean claim that photography is an art because it can lie. In the early twentieth century Alvin Langdon Coburn's praise of

photography as "the most modern of the arts," because it is a fast, impersonal way of seeing, competed with Weston's praise of photography as a new means of individual visual creation. In recent decades the notion of art has been exhausted as an instrument of polemic; indeed a good part of the immense prestige that photography has acquired as an art form comes from its declared ambivalence toward being an art. When photographers now deny that they are making works of art, it is because they think they are doing something *better* than that. Their disclaimers tell us more about the harried status of any notion of art than about whether photography is or isn't one.

Despite the efforts of contemporary photographers to exorcise the specter of art, something lingers. For instance, when professionals object to having their photographs printed to the edge of the page in books or magazines, they are invoking the model inherited from another art: as paintings are put in frames, photographs should be framed in white space. Another instance: many photographers continue to prefer black-and-white images, which are felt to be more tactful, more decorous than color—or less voyeuristic and less sentimental or crudely lifelike. But the real basis for this preference is, once again, an implicit comparison with painting.

In the introduction to his book of photographs *The Decisive Moment* (1962), Cartier-Bresson justified his unwillingness to use color by citing technical limitations: the slow speed of color film which reduces the depth of focus. But with the rapid progress in color film technology during the last two decades—think of the tonal subtlety and high resolution of Helen Levitt's photographs of Harlem, Leni Riefenstahl's photographs of the Nuba, Stephen Shore's photographs of Main Street wastelands—Cartier-Bresson has had to shift his ground, and now proposes that photographers renounce color as a matter of *principle.* In Cartier-Bresson's version of that persistent myth according to which—following the camera's invention—a division of territory took place between photography and painting, color belongs to painting. He enjoins photographers to resist temptation and keep up their side of the bargain.

Those still involved in defining photography as an art are always trying to hold some line. But any attempt to restrict photography to certain subjects or certain techniques, however fruitful these have proved to be, is

bound to be challenged and to collapse. For it is in the very nature of photography that it be a promiscuous form of seeing and, in talented hands, an infallible medium of creation. (As John Szarkowski observes, "A skillful photographer can photograph anything well.") Hence, its long-standing quarrel with art, which (until recently) meant the results of a discriminating or purified way of seeing and a medium of creation governed by standards that made genuine achievement a rarity.

Understandably, photographers have been reluctant to give up the attempt to define more narrowly what "good" photography is. The history of photography is punctuated by a series of dualistic controversies—such as the straight print versus the doctored print, "pictorial" photography versus documentary photography—each of which proposes a different form of the debate about photography's relation to art: how close it can get while still retaining its claim to unlimited visual acquisition. Recently, it has become common to maintain that all these controversies are now outmoded, which suggests that the debate had been settled. But it is unlikely that the defense of photography as art will ever completely subside. As long as photography is not only a voracious way of seeing but one which needs to claim that it is a special, distinctive way, photographers will continue to take shelter (if only covertly) in the defiled but still prestigious precincts of art.

Photographers who suppose they are getting away from the pretensions of art, as exemplified in painting, by taking pictures in fact remind us of those Abstract Expressionist painters who imagined they were getting away from art, or Art, by the act of painting (that is, by treating the canvas as a field of action rather than as an object). And much of the importance photography has recently acquired as an art is based on claims similar to those of more recent painting and sculpture. The seemingly insatiable appetite for photography in the 1970s expresses more than the pleasures of discovering and exploring a relatively neglected art form; it derives much of its fervor from the desire to reaffirm the dismissal of abstract art, which was one of the messages of the pop taste of the 1960s. Paying more and more attention to photographs is a great relief to sensibilities tired of, or eager to avoid, the mental exertions demanded by abstract art. Classical modernist painting presupposes highly developed

skills of looking; it requires that viewers be knowledgeable about art. Photography, like pop art, reassures viewers that art isn't hard; it seems to be more about things than about art.

Photography is the most successful vehicle of modernist taste in its pop version, with its zeal for debunking the high culture of the past (focusing on shards, junk, odd stuff; excluding nothing); its conscientious courting of vulgarity; its affection for kitsch; its skill in reconciling vanguard ambitions with the rewards of commercialism; its pseudoradical patronizing of "art" as reactionary, elitist, snobbish, insincere, artificial, out of touch with the broad truths of everyday life; its transformation of art into cultural document.

At the same time, photography has gradually acquired all the self-consciousness of a classic modernist art. Many professionals are now worried that this populist strategy is being carried too far, and that the public will forget that photography is, after all, a noble and exalted activity. In short, an art. . . . The modernist promotion of naïve art always contains a joker: that one continue to honor its hidden claim to sophistication.

II

It cannot be a coincidence that just about the time that photographers stopped discussing whether photography is an art, it was acclaimed as one by the general public, and photography entered, in force, into the museum. The museum's promotion of photography as art is the conclusive victory of the century-long campaign waged by modernist taste on behalf of an open-ended definition of art, photography offering a much more suitable terrain than painting for this effort. For the line between "amateur" and "professional," "primitive" and "sophisticated" is not just harder to draw with photography than it is with painting—it has little meaning. Naïve or commercial or merely utilitarian photography is no different in kind from photography as practiced by the most gifted professionals: there are pictures taken by anonymous amateurs which are just as interesting, as complex formally, as representative of photography's characteristic powers as a Stieglitz or a Walker Evans.

That all the different kinds of photography form one continuous tradition is the once startling, now obvious-seeming assumption which underpins *Looking at Photographs: 100 Pictures from the Collection of The*

Museum of Modern Art, by John Szarkowski, the influential director of the museum's department of photography. As Szarkowski formulated his "thesis" in *The Photographer's Eye,* an earlier and more polemical anthology of photographs he published in 1966, "the medium's 'fine art' tradition and its 'functional' tradition [are] intimately interdependent aspects of a single history."

This thesis, which in the ensuing decade has become the ruling principle of contemporary photographic taste and authorizes the indefinite expansion of that taste, owes its plausibility mainly to the efforts of museum curators and to the ever-multiplying exhibition of photographs in museums and art galleries. What is most interesting about photography's career in the museum is that no particular style is rewarded; photography is presented as a collection of simultaneous but widely differing intentions and styles, which are not perceived as in any way contradictory.

Szarkowski's able and imaginative championing of photographic standards that reconcile functional and art photography has made him contemporary photography's leading tastemaker. But while his enterprise has been a huge success with the public, the response of photography professionals is mixed. Even as they welcome photography's new legitimacy, many of them feel threatened when the most ambitious images are discussed in direct continuity with *all* sorts of images, from photojournalism to scientific photography to family snapshots. Recently some of the younger photography critics have accused Szarkowski of reducing photography to something trivial, vulgar, a mere craft.

The real problem with drawing functional photographs, photographs taken for a practical purpose, on commercial assignment, or as souvenirs, into the mainstream of photographic achievement is not that it demeans photography, considered as a fine art, but that the procedure contradicts the nature of most photographs. In most uses of the camera, the photograph's naïve or descriptive function is paramount. But when viewed in the museum or gallery, photographs cease to be about their subjects in the same direct or primary way; they become studies in the possibilities of photography. Photography's adoption by the museum makes photography itself seem problematic, in the way experienced only by a small number of self-conscious photographers whose work consists precisely in

questioning the camera's ability to grasp reality. The eclectic museum collections reinforce the arbitrariness, the subjectivity of all photographs, including the most straightforwardly descriptive ones.

Museums now feature shows of photographs much as they feature exhibitions by individual painters. But a photographer is not like a painter, the role of the photographer being recessive in much serious picture-taking and virtually irrelevant in all the ordinary ("vernacular") uses. So far as we care about the subject photographed, we expect the photographer to be an extremely discreet presence. Thus the very success of photojournalism lies in the difficulty of distinguishing one superior photographer's work from another's, except in so far as he or she has monopolized a particular subject. The memorable photographs of Erich Salomon, Alfred Eisenstaedt, David Douglas Duncan, Robert Capa, Margaret Bourke-White, Marc Riboud, Edouard Boubat, Don McCullin, Inge Morath have their power as images (or copies) of interesting people and places, not of an individual artist's consciousness. And in the vast majority of photographs which get taken—for scientific and industrial purposes, by the press, by the military and the police, by families—any trace of the personal vision of whoever is behind the camera interferes with the primary demand on the photograph: that it record, diagnose, inform.

It makes sense that a painting is signed but a photograph is not (or it seems bad taste if it is). The very nature of photography implies an equivocal relation to the photographer as *auteur*; and the bigger and more varied the work done by a talented photographer, the more it seems to acquire a kind of corporate rather than individual authorship. Many of the published photographs by photography's greatest names seem like work that could have been done by any gifted professional of their period. It requires a formal conceit (like Todd Walker's solarized photographs or Duane Michals's narrative-sequence photographs) or a thematic obsession (like Thomas Eakins with the male nude or Clarence John Laughlin with the Old South) to make work easily recognizable.

For photographers who don't so limit themselves, their "body" of work does not have the same integrity as does comparably varied work in other art forms. Even in those careers with the sharpest breaks of period and style—think of Picasso, of Stravinsky—one can perceive the unity of

concerns that transcends these breaks and can (retrospectively) see the inner relation of one period to another. Knowing the whole body of work, one can see how the same composer could have written *Le Sacre du printemps,* the Dumbarton Oaks Concerto, and the late neo-Schönbergian works; one recognizes Stravinsky's hand in all these compositions. But there is no internal evidence for identifying as the work of Eadweard Muybridge his studies of human and animal motion, the documents he brought back from photo-expeditions in Central America, his government-sponsored camera surveys of Alaska and Yosemite, and the "Clouds" and "Trees" series. Even after knowing they were all taken by Muybridge, one still can't relate these series of pictures to each other (though each series has a coherent, recognizable style), any more than one could infer the way Atget photographed trees from the way he photographed Paris shopwindows, or connect Roman Vishniac's prewar portraits of Polish Jews with the scientific microphotographs he has been taking since 1945. In photography the subject matter always pushes through, with different subjects creating unbridgeable gaps between one period and another of a large body of work, confounding signature.

Indeed the very presence of a coherent photographic style—think of the white backgrounds and flat lighting of Avedon's portraits, of the distinctive grisaille of Atget's Paris street studies—seems to imply unified material. And subject matter seems to have the largest part in shaping a viewer's preferences. Even when photographs are isolated from the practical context in which they may originally have been taken, and looked at as works of art, to prefer one photograph to another seldom means only that the photography is judged to be superior formally; it almost always means—as in more casual kinds of looking—that the viewer prefers that kind of mood, or respects that intention, or is intrigued by (or feels nostalgic about) that subject. The formalist approaches to photography cannot account for the power of *what* has been photographed, and the way that distance in time and cultural distance from the photograph increase our interest.

Still, it seems logical that contemporary photographic taste has taken a largely formalist direction. Although the natural or naïve status of subject matter in photography is more secure than in any other representational art, the very plurality of situations in which photographs are looked at

complicates and eventually weakens the primacy of subject matter. The conflict of interest between objectivity and subjectivity, between demonstration and supposition, is unresolvable. While the authority of a photograph will always depend on the relation to a subject (that it is a photograph *of* something), all claims on behalf of photography as art must emphasize the subjectivity of seeing. There is an equivocation at the heart of all "aesthetic" evaluations of photographs; and this explains the chronic defensiveness and extreme mutability of photographic taste.

For a brief time—say, from Stieglitz through the reign of Weston—it appeared that a solid point of view had been established with which to evaluate photographs: impeccable lighting, skill of composition, clarity of subject, precision of focus, perfection of print quality. But this position, generally thought of as Westonian—essentially technical criteria for what makes a photograph good—is now bankrupt. (Weston's deprecating appraisal of the great Atget as "not a fine technician" shows its limitations.) What position has replaced Weston's? A much more inclusive one, with criteria which shift the center of judgment from the individual photograph, considered as a finished object, to the photograph considered as an example of "photographic seeing."

What is meant by photographic seeing would hardly exclude Weston's work but it would also include, as "an excellent example [of] pure photography," the photograph from Szarkowski's *Looking at Photographs:* the "scrofulous little picture," as he calls it, of a coachman and four people in a carriage, probably dating from the 1870s, taken by an unknown photographer. The composition of this picture, Szarkowski comments,

> —or what would at the time be regarded as its lack of composition—is characteristic of the kind of image structure that resulted when photographers left their studios to work with subject matter that could not easily be posed. The seemingly arbitrary cropping of figures by the picture edge, the unexpected shapes created by overlapping forms, the asymmetrical and centrifugal patterning, the juxtaposition of busy and empty masses—these qualities constitute a visual definition of what is meant, in large part, by the phrase "photographic seeing."

This new position, based on the notion of photographic seeing, aims to liberate photography, as art, from the oppressive standards of technical

perfection; to liberate photography from beauty, too. It opens up the possibility of a global taste, in which no subject (or absence of subject), no technique (or absence of technique) disqualifies a photograph.

While in principle all subjects are worthy pretexts for exercising the photographic way of seeing, the convention has arisen that photographic seeing is clearest in off-beat or trivial subject matter. Subjects are chosen because they are boring or banal. Because we are indifferent to them, they best show up the ability of the camera to "see."

"Today's best photographers," writes Szarkowski, "discover more and more within what would seem less and less." Less is supposed to be More, but Less is also Less. Thus Szarkowski commends what Joel Meyerowitz can coax from subject matter that is so "profoundly banal." (Meyerowitz, who was born in 1938, is the ninety-eighth of the hundred photographers in Szarkowski's chronological arrangement; the book begins with two photographs from the 1840s.) When Irving Penn, known for his handsome photographs of celebrities and food for fashion magazines and ad agencies, was finally given a show at The Museum of Modern Art (in 1975), it was for a series of close-ups of cigarette butts. "One might guess," Szarkowski commented, "that [Penn] has only rarely enjoyed more than a cursory interest in the nominal subjects of his pictures."[4]

Photography's adoption by the museum is now firmly associated with those important modernist conceits: the "nominal subject" and the "profoundly banal." But this approach not only diminishes the importance of subject matter; it also loosens the photograph from its connection with a single photographer. The photographic way of seeing is far from exhaustively illustrated in the many one-photographer shows and retrospectives that museums now put on. Understanding an *oeuvre* is not the main point, for approaching photographs in this way must necessarily favor the

[4] Professions of insouciance about subject matter have become a commonplace among younger photographers. One recent example: George Tice's *Urban Landscapes* (New Brunswick, N.J.: Rutgers University Press, 1975), photographs of urban and suburban New Jersey originally conceived as a documentary project. "As I progressed further with my project," Tice says in his preface, "it became obvious that it was really unimportant where I chose to photograph. The particular place simply provided an excuse to produce work . . . you can only see what you are ready to see—what mirrors your mind at that particular time."

new meanings that any one picture acquires when juxtaposed—in ideal anthologies, either on museum walls or in books—with the work of other photographers. Thus many of the pictures Szarkowski chose to include in *Looking at Photographs* are untypical of their author's work. (For example, the Boubat photograph on page 153.) But it was never Szarkowski's intention to educate his readers about the hundred photographers represented in this book. His compilation is meant to educate taste about photography in general; to teach a form of seeing which makes all subjects equivalent.

When Szarkowski describes gas stations, empty living rooms, and other bleak subjects as "patterns of random facts in the service of [the photographer's] imagination,"[5] what he really means is that these subjects are ideal for the camera. Szarkowski's ostensibly formalist, neutral criteria seem powerfully judgmental about subjects and about styles. The revaluation of naïve or casual nineteenth-century photographs, particularly those which were taken as humble records, is partly due to their sharp-focus style—a pedagogic corrective to the "pictorial" soft focus which, from Cameron to Steiglitz, was associated with photography's claim to be an art. Yet the standards of photographic seeing do not imply an unalterable commitment to sharp focus. Whenever serious photography is felt to have been purged of outmoded relations to art and to prettiness, it could just as well accommodate a taste for pictorial photography, for abstraction, for noble subjects rather than cigarette butts and gas stations and turned backs.

The language in which photographs are generally evaluated is extremely meager. Sometimes it is parasitical on the vocabulary of painting: composition, light, and so forth. More often it consists in the vaguest sort of judgments, as when photographs are praised for being subtle, or interesting, or powerful, or complex, or simple, or—a favorite—deceptively simple.

The reason the language is poor is not fortuitous: say, the absence of a rich tradition of photographic criticism. It is something inherent in photography itself, whenever it is viewed as an art. Photography proposes a

[5] From Szarkowski's introduction to *William Eggleston's Guide* (New York: The Museum of Modern Art, 1976).

process of imagination and an appeal to taste quite different from that of painting (at least as traditionally conceived). Indeed, the difference between a good photograph and a bad photograph is not at all like the difference between a good and a bad painting. The norms of aesthetic evaluation worked out for painting depend on criteria of authenticity (and falseness), and of craftsmanship—criteria that are more permissive or simply nonexistent for photography. And while the tasks of connoisseurship in painting invariably presume the organic relation of a painting to an individual body of work with its own integrity, and to schools and iconographical traditions, in photography a large individual body of work does not necessarily have an inner stylistic coherence, and an individual photographer's relation to schools of photography is a much more superficial affair.

One criterion of evaluation which painting and photography do share is innovativeness; both paintings and photographs are often valued because they impose new formal schemes or changes in the visual language. Another criterion which they can share is the quality of uniqueness, of presence, which Walter Benjamin considered the defining characteristic of the work of art. This was not, of course, what Benjamin said about photographs. In his famous essay "The Work of Art in the Age of Mechanical Reproduction" [see Benjamin selection in volume I—Ed.], he argued that precisely what distinguished a photograph from a painting was that a photograph, being a mechanically reproduced object, could not be authentic, could not have genuine presence. But it could be said that precisely the situation which now determines taste in photography, its exhibition in museums and galleries, has revealed to us that photographs do have a kind of authenticity. A daguerreotype from the mid-nineteenth century does have a "unique existence," and even a photograph existing in many copies can be—to use Benjamin's words—"testimony to the history which it has experienced."

Furthermore, although it is true that no photograph is an "original" in the sense that a painting always is, there is a large qualitative difference between what could be called "originals"—prints made from the original negative at the time, that is, at the same moment in the technological evolution of photography, that the picture was taken—and subsequent

generations of the same photograph. (What most people know of the famous photographs—in books, newspapers, magazines, and so forth—are no more than photographs of photographs; the originals, which one is likely to see only in a museum or a gallery, contain many visual pleasures which are not reproducible.) Technical reproduction, Benjamin says, "can put the copy of the original into situations which would be out of reach for the original itself." But to the extent that an old painting can still be said to possess an aura in a museum display, where it too has been wrenched from its original setting and, like the photograph, "meets the beholder halfway"—in the strictest sense of Benjamin's notion of the aura, it does not—then an Atget photograph, printed by him on the now unobtainable paper Atget used, can also be said to possess an aura.

The real difference between the aura that a photograph can have and that of a painting lies in the different relation to time. The depredations of time tend to work against paintings. But part of the built-in interest of photographs, and a major source of their aesthetic value, is precisely the transformations that time works upon them, the way they escape the intentions of their makers. Given enough time, many photographs do acquire an aura. (The fact that color photographs don't age in the way black-and-white photographs do may partly explain the marginal status which color has had until very recently in serious photographic taste. The cold intimacy of color seems to seal off the photograph from patina.) For while paintings or poems do not necessarily get better, more attractive simply because they are older, most photographs seems interesting as well as touching if they are old enough. It is not altogether wrong to say that there is no such thing as a "bad" photograph—only less interesting, less relevant, less mysterious ones. Photography's adoption by the museum only accelerates that process which time will bring about anyway: making all work valuable.

The role of the museum in forming contemporary photographic taste cannot be overestimated. Museums do not so much arbitrate what photographs are good or bad as offer new conditions for looking at all photographs. This procedure, which appears to be creating standards of evaluation, in fact abolishes them. The museum cannot be said to have created a secure canon for the photographic work of the past, as it has for painting. Even as it seems to be sponsoring a particular photographic

taste the museum is undermining the very idea of normative taste. Its role is to show that there are *no* fixed standards of evaluation, that there is *no* canonical tradition of work. Under the museum's attentions, the very idea of a canonical tradition is exposed as redundant.

That photography's Great Tradition is always in flux, constantly being reshuffled, is not because photography is a new art and, therefore, somewhat insecure; it is part of what photographic taste is about. There is a more rapid sequence of rediscovery in photography than in any other art. According to that law of taste given its definitive formulation in Eliot's "Tradition and the Individual Talent," each important new work necessarily alters our perception of the heritage of the past. Thus, new photographs change how we look at past photographs. (For example, Diane Arbus's work has made it easier to appreciate the greatness of the work of Lewis Hine, another photographer devoted to portraying the opaque dignity of victims.) But the swings in contemporary photographic taste do not only reflect such coherent and sequential processes of reevaluation, whereby like enhances like. What they more commonly express is the complementarity and equal value of antithetical styles and themes.

For several decades American photography has been dominated by a reaction against "Westonism"—that is, against contemplative photography, photography considered as an independent visual exploration of the world with no evident social urgency. The technical perfection of Weston's photographs, the calculated beauties of Minor White and Aaron Siskind, the poetic constructions of Frederick Sommer, the self-assured and elegant ironies of Cartier-Bresson—all these have been challenged by photography that is, at least programmatically, more naïve, more direct; that is hesitant, even awkward. But taste in photography is not that linear. Without any weakening of the current commitments to informal photography and to photography as social document, a perceptible revival of Weston is now taking place. For, with a certain distance of time, Weston's work also looks naïve.

Finally, there is no reason to exclude any photographer from the canon. Right now there are minirevivals of such long-despised pictorialists from another era as Oscar Gustav Rejlander, Henry Peach Robinson,

and Robert Demachy. As photography takes the whole world as its subject, there is room for every kind of taste. Literary taste does exclude: the success of the modernist movement in poetry elevated Donne but diminished Dryden. With literature, one can be eclectic up to a point, but one can't like everything. With photography, eclecticism has no limits. This is the real message of Szarkowski's book, which contains every kind of photograph and photographic style, and praises them all. The plain photographs from the 1860s of abandoned children admitted to a London institution called Doctor Bernardo's Home (taken as "records") are as moving as David Octavius Hill's brooding portraits of Scottish burghers (taken as "art"). The clean look of Weston's classic modern style is not refuted by, say, Benno Friedman's ingenious recent revival of pictorial blurriness.

This is not to deny that each viewer likes the work of some photographers more than that of others: for example, most cultivated viewers today prefer Atget to Weston. What it does mean is that, by the nature of photography, one is not really obliged to choose; and that preferences of that sort are, for the most part, merely reactive. Taste in photography tends to be, is perhaps necessarily, something global, eclectic, permissive, which means that in the end it must deny the difference between good taste and bad taste.

This is what makes the attempts of photography polemicists to erect a canon seem ingenuous or ignorant. For there is something fake about all photographic controversies—and the attentions of the museum have played a crucial role in making this clear. The museum levels upward all schools of photography. Indeed, it doesn't make much sense even to speak of schools. In the history of painting, movements have a genuine life and function: painters are often much better understood as part of the school or movement to which they belonged. But movements in the history of photography are fleeting, adventitious, sometimes merely perfunctory, and no first-rate photographer is better understood as a member of a group. (Think of Stieglitz and Photo-Secession, Weston and f-64, Renger-Patzsch and the New Objectivity, Walker Evans and the Farm Security Administration project, Cartier-Bresson and Magnum.) To group photographers in schools or movements seems to be a kind of misunderstanding, based (once again) on the irrepressible but invariably misleading analogy between photography and painting.

The leading role now played by museums in forming and clarifiying the nature of photographic taste seems to mark a new stage from which photography cannot turn back. Accompanying its tendentious respect for the profoundly banal is the museum's diffusion of a historicist view, one that inexorably promotes the entire history of photography. Small wonder that photography critics and photographers seem anxious. Underlying many of the recent defenses of photography is the fear that photography is already a senile art, littered by spurious or dead movements; that the only task left is curatorship and historiography. (While prices skyrocket for photographs old and new.) It is not surprising that this demoralization should be felt at the moment of photography's greatest acceptance. "It is one of the peculiarities of the imagination," as Wallace Stevens said, "that it is always at the end of an era."

PENINAH R. PETRUCK was born in New York, in 1951. She received an A.B. in art history from Barnard College in 1971; an A.M. in modern art and criticism from the Institute of Fine Arts at New York University in 1973; and a Ph.D. from the Institute of Fine Arts in 1979.

Ms. Petruck has taught art history at The New School for Social Research and Queens College in New York, and a course in twentieth-century photography at Ramapo College in New Jersey. Her curatorial experience includes working as a researcher for the exhibition "The Painter's America" (1974) and as an assistant in the Prints and Drawings Department at the Whitney Museum of American Art and researching the exhibition "American Impressionism" (1972–1973) for the National Gallery of Art. She is now employed as a Program Officer for Visual Arts Services of the New York State Council on the Arts.